Spellbinding
Bead Jewelry

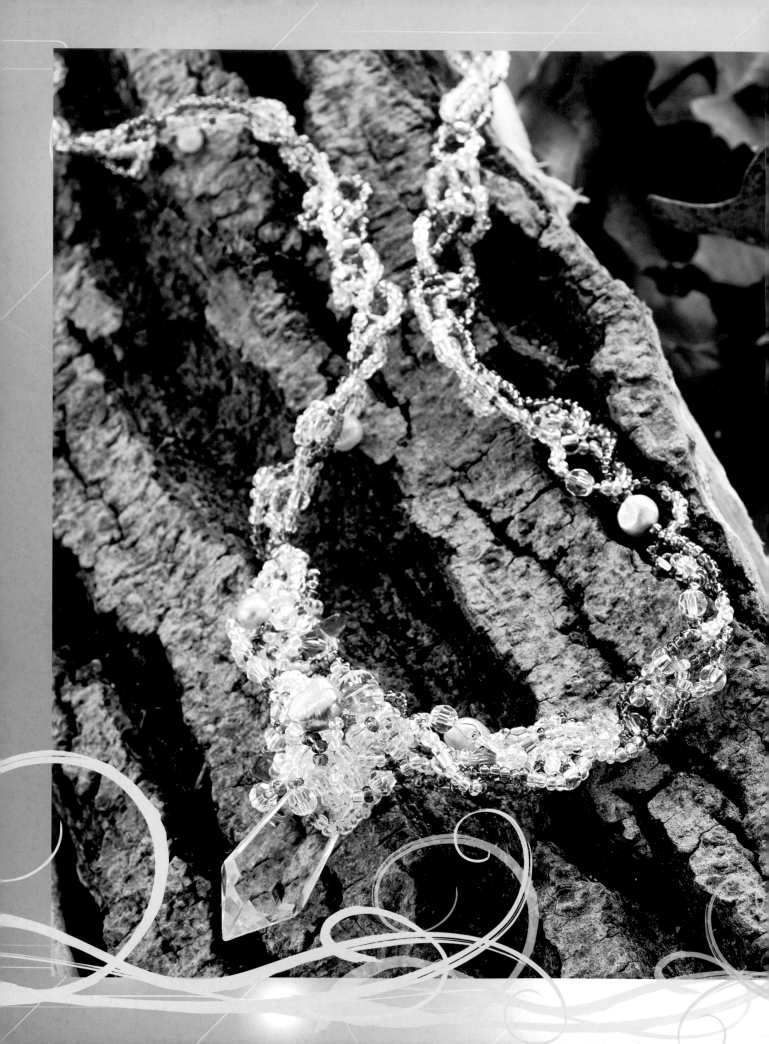

Spellbinding
Bead Jewelry

Julie & Christine Ashford

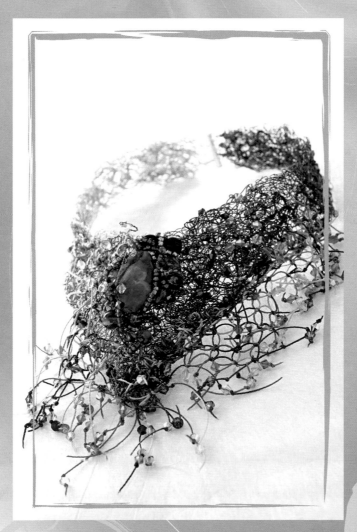

David and Charles

www.mycraftivity.com

A DAVID & CHARLES BOOK
Copyright © David & Charles Limited 2008

David & Charles is an F+W Publications Inc. company
4700 East Galbraith Road
Cincinnati, OH 45236

First published in the UK and US in 2008

Text and illustrations copyright © Christine Ashford and Julie Ashford 2008
Photography and layout copyright © David and Charles 2008

Christine Ashford and Julie Ashford have asserted their right
to be identified as authors of this work in accordance with
the Copyright, Designs and Patents Act, 1988.

A catalogue record for this book is available
from the British Library.

ISBN-13: 978-0-7153-2865-1 paperback
ISBN-10: 0-7153-2865-4 paperback

Printed in China
by SNP Leefung
for David & Charles
Brunel House Newton Abbot Devon

Commissioning Editor: Jane Trollope
Editor: Bethany Dymond
Designer: Mia Farrant
Project Editor: Betsy Hosegood
Production Controller: Bev Richardson
Photographer: Kim Sayer

Visit our website at www.davidandcharles.co.uk

David & Charles books are available from all good bookshops; alternatively
you can contact our Orderline on 0870 9908222 or write to us at FREEPOST
EX2 110, D&C Direct, Newton Abbot, TQ12 4ZZ (no stamp required UK only);
US customers call 800-289-0963 and Canadian customers call 800-840-5220.

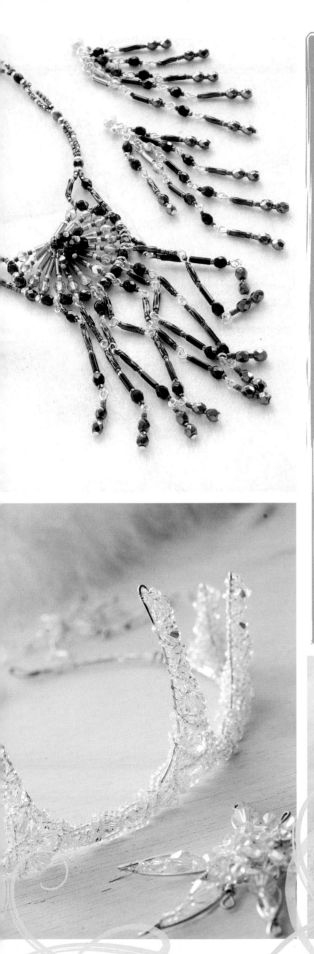

Contents

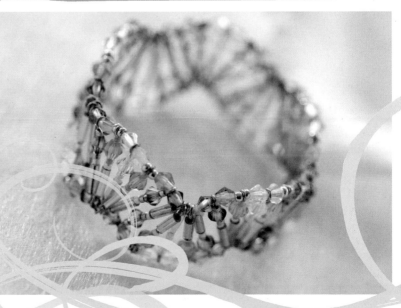

Simply Spellbinding...

*S*pellbinding Bead Jewellery is a journey through a mythical world where we have allowed our imaginations to roam free, exploring the design potential of the materials we use every day in our work in new and challenging ways that we hope will inspire you to develop your own beadwork.

We have been working with beads and other materials in jewellery making for many years now, and are well known in the UK beading world for our beading kits and workshops. This book has given us the chance to share some of our inspirations and designs: here we bring together our skills in small beadwork and wire work, combined with our other passions – extravagant and intricate jewellery and costumes from history, drama and art.

For each of the ten main chapters, we find inspiration from strong female figures from myth or fiction that have

fired imaginations for millennia. In the introduction to each chapter we give you a glimpse into our design process: how each character inspired a train of thought that led to the finished pieces of jewellery. We found that all of the characters suggested to us both a colour and a basic form for the main pieces. Later in each chapter we also show examples of some pieces worked in different colours as well as adaptations of the designs.

The projects cover a wide range of jewellery techniques, from structural wirework and macramé to small bead

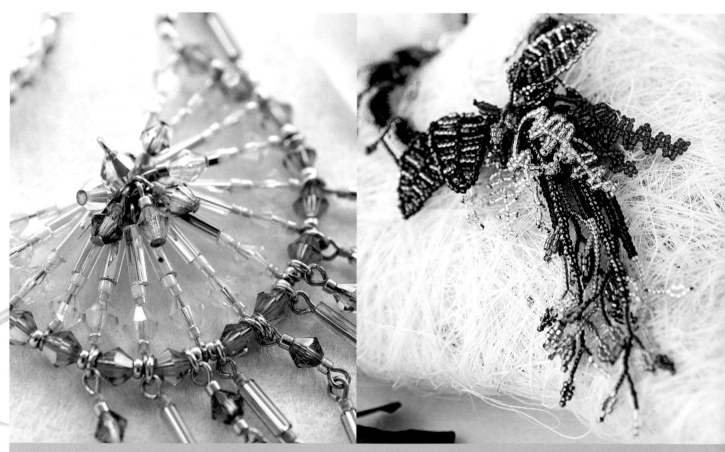

Aurora inspired us with the form of the rising sun and the colours of the dawn – yellow, apricot, rose, gold and clear crystal (see page 8).

For the Dryad pieces we were drawn to the greens and browns of the forest and to the forms of leaf and vine (see page 52).

weaving and embellishment. There are two or three main projects in each chapter and plenty of suggestions that we hope will inspire you further.

We have written all of the projects in this book in the same way that we approach our kits and workshops – from first principles. Due to the strong nature of the characters that we are representing, and therefore the complexity of the designs, some beadwork experience would be useful for the majority of the projects, although it is possible for a beginner to complete any of the designs.

All the main projects have full step-by-step instructions, but the additional projects at the end of the chapters are less specific to encourage you to make your own design decisions about the number of beads, symmetry of the piece, level of texture and so on. This is where the confidence gained from a little prior beading experience is most useful.

We have had a fantastic time exploring themes and characters, taking a design and moving it in different directions in a way that is not possible in other formats, and we hope that you enjoy making the projects just as much.

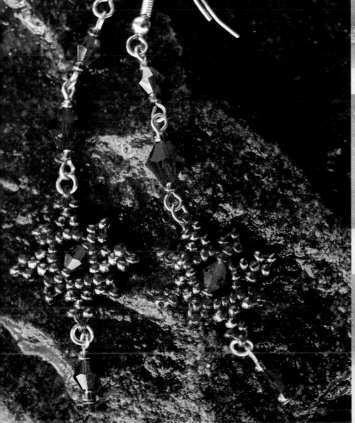

The colours of Persephone's jewellery are those of the pomegranates and its seeds, which she ate while in the underworld and which bind her to it forever (page 104).

Calypso lived on an island, so her jewellery (page 30) captures the colours and forms of the sea. Rocks, pebbles and netting are reproduced with beads and wire in blues, greens and silver.

Aurora
Bringer of dawn

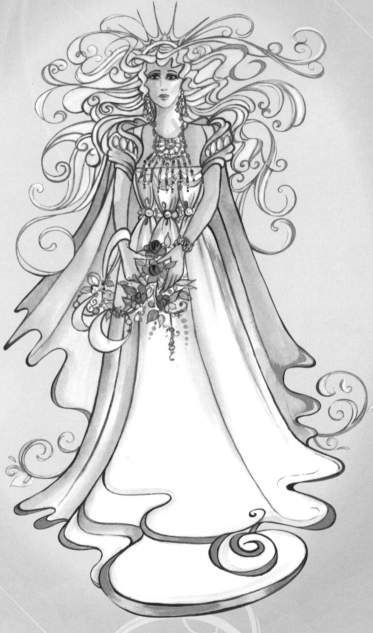

In Greek legend, Aurora is goddess of the dawn, and every morning she drives her four-horsed chariot across the sky to lead her brother Helios, the sun, into position. The clouds of night roll away and the horizon lightens before her as she brings light and hope to each new day.

The Aurora necklace, bracelet and earrings are three easy projects that, through the sophisticated use of soft colour graduations, belie the simplicity of the underlying technique. The designs are based around simple wirework that can be achieved with minimal experience of plier use.

To achieve the flow of colour for the rays of the dawn we have chosen quite a complex mix of colours and we will later demonstrate how, by using a simpler palette, you can achieve a completely different feel in the finished jewellery. We will also be exploring how an aspect of this design can be adapted to make a brooch (page 19).

With its wonderful sunrise colours, this sparkling necklace seems to exude warmth and life. Now all you need is the outfit to go with it.

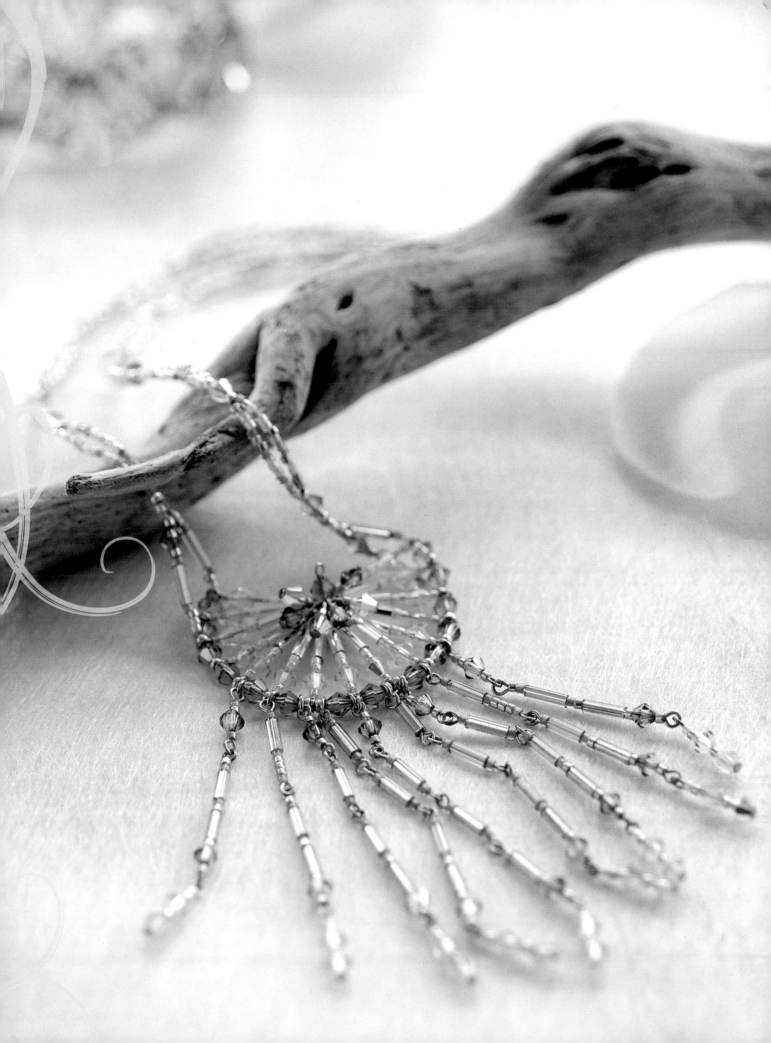

Aurora Necklace

This elegant necklace would look wonderful worn with a polo-neck top or a plunging neckline. It is made in several easy stages and the clear step-by-step diagrams help you at every stage – you really don't need a lot of experience with jewellery making to be successful. The fan, which represents the rising sun, is made first; then you add the fringing and side straps and finally create the cluster at the centre.

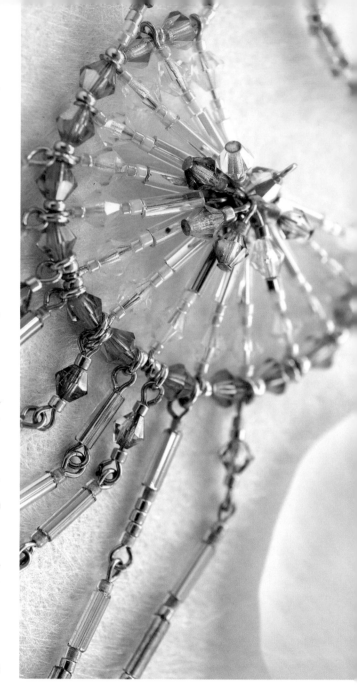

You will need

Bead Box

21 topaz AB crystal bicones, 4mm **A**
15 pale jonquil AB crystal bicones, 4mm **B**
25 pale pink AB crystal bicones, 4mm **C**
23 rose pink AB crystal bicones, 4mm **D**
2.5g of Delica beads DB411 (galvanized apricot gold) **E**
2g of Delica beads DB070 (lined rose pink AB) **F**
2g of Delica beads DB233 (lined crystal/yellow lustre) **G**
2g of Delica beads DB1531 (opaque pale yellow Ceylon) **H**
3g of size 3 silver-lined crystal bugles **J**
3g of size 3 silver-lined gold bugles **K**
3g of size 3 silver-lined pink bugles **L**
3g of size 10/0 metallic gold-coloured seed beads **M**

Fabulous Findings

6mm (¼in) corrugated spacer bead **N**
39 gilt eyepins, 5cm (2in)
16 gilt headpins
12cm (4¾in) of 0.6mm (22-gauge) half-hard gilt wire
Ten 3.8mm (³/₁₆in) gilt jump rings
1.5m (60in) of very fine 0.010 flexible beading wire
Two French crimps
Lightweight clasp set

Tools

Round-nosed pliers
Wire cutters
Crimping pliers or snipe-nosed pliers

Make it easy on yourself
Read on
Before you begin each section, read through all the instructions for that part. This may sound boring when you are keen to get going but believe us, everything runs much smoother when you know what you are going to be doing next.

Making the fan

The fan section, representing the rising sun, is the foundation of the whole design. It comprises 13 beaded eyepins that are strung onto a loop of wire. This loop is then finished on each end with the same beading arrangement, creating 15 beaded wires in all. Its colours are those of the sun's rays – yellows and clear crystal.

1 Thread 1G, 1B, 1G, 1H and 1J onto an eyepin. Trim the pin to 6mm (¼in) from the top bead and make a loop parallel to the loop at the bottom of the pin as shown in **fig. 1**. Repeat to make a total of 13 prepared pins.

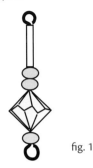

fig. 1

2 Using the widest part of the round-nosed pliers, make a circle 6mm (¼in) in diameter in the middle of the 12cm (4¾in) length of 0.6mm wire so the two ends of the wire make a shallow V shape, as shown in **fig. 2**.

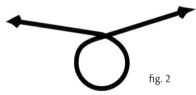

fig. 2

3 Onto one end of the wire thread 1J, 1H, 1G, 1B and 1G. Push the beads down to the edge of the circle in the middle of the wire – if necessary make a small kink in the wire so the first bugle bead (J) does not start to pass around the circle. Trim the excess wire above the G bead to 6mm (¼in) and make a loop at 90° to the angle of the large circle in the middle of the wire, as shown in **fig. 3**.

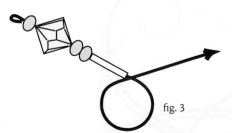

fig. 3

4 Thread the 13 prepared pins from step 1 onto the free end of the 0.6mm wire, pushing them around the circle to make the fan shape – it will be a tight fit. When all the prepared pins are threaded on add 1J, 1H, 1G, 1B and 1G, giving you a total of 15 strands. As before, push these beads down to the edge of the circle, making a little kink in the wire, if necessary, to stop the first bugle bead from pushing onto the circle. Trim the excess wire and make a loop (**fig. 4**) as in step 3.

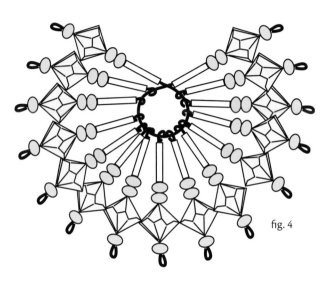

fig. 4

Did you know?
The Northern Lights

Aurora gives her name to the Aurora Borealis, or Northern Lights, a phenomenon seen only in the northern hemisphere of the world. It manifests itself as a strange light, often green or red or a mix of colours that swirls and shimmers in the autumn sky. The AB crystal bicone beads used for the jewellery here have been coated so that they reflect colour like the Aurora Borealis, hence the letters AB.

Making the fringe

The nine-stranded fringe at the bottom of the fan depicts the warm colours of the dawn spreading across the sky. The strands are created by beading headpins and eyepins and linking them together. Refer to fig. 5 as you work.

1 To make the links at the bottom of each strand, take a headpin and thread on 1C, 1E, 1C, 1E and 1G. Trim the wire to 6mm (¼in) above the last bead and make a loop. Repeat to make a total of nine links.

2 Slip one of the nine links onto the bottom of an eyepin. Thread on 1E, 1D, 1E, 1L, 1E, 1F, 1K, 1F and 1E. Trim the wire to 6mm (¼in) above the last bead and make a loop. Repeat with seven more of the links made in step 1 (the second link of the central strand is different).

3 Complete two of the links made in step 2 by linking each one to an eyepin and threading on 1E, 1D, 1E and 1F; trim the wire and make a loop as before. Take another two links and thread on 1F, 2E, 1F, 1K and 1F. Trim and loop as before.

4 Complete two more of the links made in step 2 by linking each one to an eyepin and threading on 1F, 1K and 1F; trim the wire and make a loop as before. Link onto a third eyepin and thread on 1E, 1D and 1E; trim and loop.

5 Complete the two remaining links made in step 2 by linking each one to an eyepin and threading on 1F, 1K and 1F; trim and loop. Link onto a third eyepin and thread on 1F, 1K and 1F; trim and loop.

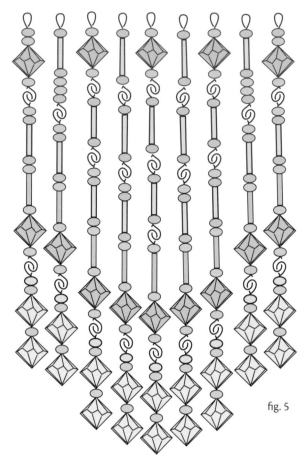

fig. 5

6 Take the last link and attach it to an eyepin. Thread on 1E, 1D, 1E, 1L and 1E; trim and loop. Attach a second eyepin and thread on 1F, 1K and 1F; trim and loop. Attach a third eyepin and thread on 1F, 1K and 1F; trim and loop. Attach a fourth eyepin and thread on 1E, 1D and 1E; trim and loop. Add a 3.8mm (³⁄₁₆in) jump ring to the top of each strand. Add a second jump ring to the loop at the top of the longest strand (see fig. 6).

Make it easy on yourself
Mistakes happen

If you spot a mistake in the beaded fringe you can easily remove the offending section and insert a replacement. However it may not matter. Was that really a mistake or just your inner designer taking over?

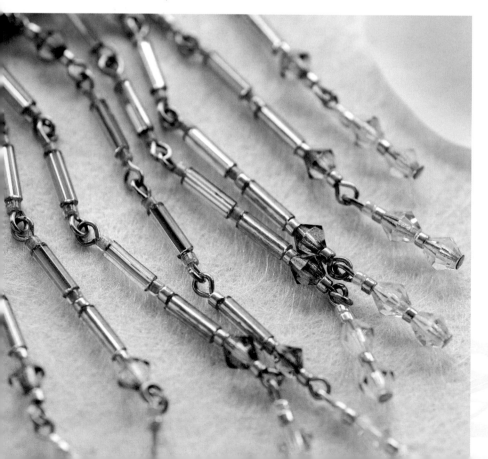

Threading the necklace

The fringe strands are cleverly attached to the fan using the same beading wire that continues on to make the side straps.

1 Cut the flexible beading wire in half. Separate the two jump rings on the top of the longest fringe strand and position one on each side of the bottom loop of the eighth (middle) pin on the fan. Thread both pieces of wire through both jump rings and the loop, as shown in **fig. 6** below. Centre the wires.

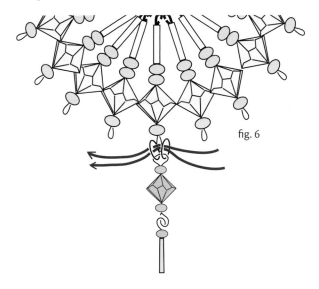

fig. 6

2 Working up one side of the fan, thread 1A onto both wires. Pass the two ends through the jump ring at the top of the next fringe strand and thread on 1M. Pass the wires through the loop of the next pin on the fan and thread on 1M. Referring to **fig. 7** below, continue to attach the beads and fringe strands to the fan. Separate the two wires at the positions shown below. Repeat on the other side of the fan.

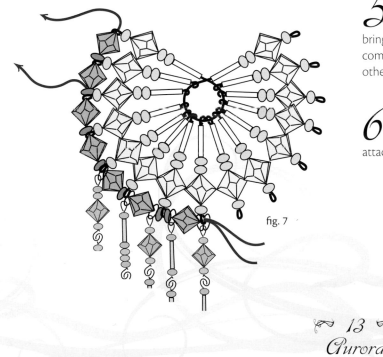

fig. 7

3 Take the wire at the top left-hand side of the fan and thread on 2G, 1E, 1F, 1K, 1F, 1E, 1G, 1E and 1F. Take the wire at the bottom left-hand side of the fan and thread on 2G, 1E, 1F, 1K, 1F, 1E, 1D, 1E, 1F and 1G. Thread both wire ends through 1M, 1A and 1M (see **fig. 8**). Repeat on the right-hand side of the necklace.

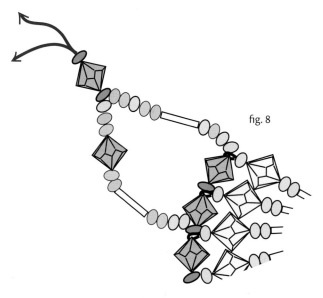

fig. 8

4 Mix together the remaining Delica beads to make a pastel assortment. Separate the two wires on the left-hand side of the necklace and thread 15 assorted Delica beads onto each one. Bring the two ends together and thread on 1M, 1C and 1M. Separate the wires and thread 15 Delica beads onto each end. Pass both ends through 1M, 1D and 1M.

5 Separate the wires once more and thread on 15 Delicas. This time bring the wires together through 1M, 1A and 1M. Repeat to make three more stretches of 15 Delicas, bringing the wires together through first a M/C/M bead combination, then M/D/M and finally M/A/M. Repeat at the other side of the design.

6 Tension the wires through the design so that the fan lies flat and the straps out to each side are soft and flexible. Finish the wire ends, making a loop on each side and attach to the clasp set (see Techniques, page 123).

Making the crystal cluster

A crystal cluster sits in the middle of the fan, adding texture to this focal point and covering the loop at the centre of the 0.6mm wire.

1 Thread three headpins with 1C and 1E. Trim the end of the wire 6mm (¼in) from the top bead and make a loop. Thread three headpins with 1D and 1F; trim the wire and form a loop. Open a 3.8mm (³/₁₆in) jump ring and thread all six pins onto the ring. Close the ring tightly.

2 Thread 1N onto the last headpin. Pass the pin through the 6mm (¼in) loop in the centre of the fan and thread on the jump ring from step 1. Slide the last A bead onto the headpin and down into the centre of the jump ring, drawing the N bead up tightly to the back of the fan. Trim the wire and loop as tightly as possible.

Aurora Earrings

Long dangling earrings have a glamorous look that will put you in the mood for an evening out. They are made from strands of beaded headpins and eyepins in the same way as the fringe on the necklace, and they are cleverly joined together at the top using a series of jump rings – it's really very simple.

Make it easy on yourself
Bit daunted?

If you haven't done much jewellery making before and think that the necklace is looking a little complicated for you, start with the earrings here. These are much simpler but use the same technique as for the necklace fringe, giving you an opportunity to practice. Make sure that you study the Techniques section on pages 118–125 as well.

You will need
Bead box

8 topaz AB crystal bicones, 4mm **A**
4 pale jonquil AB crystal bicones, 4mm **B**
20 pale pink AB crystal bicones, 4mm **C**
10 rose pink AB crystal bicones, 4mm **D**
1g of Delica beads DB411 (galvanized apricot gold) **E**
1g of Delica beads DB070 (lined rose pink AB) **F**
1g of Delica beads DB233 (lined crystal/yellow lustre) **G**
1g of Delica beads DB1531 (pale yellow Ceylon) **H**
2 size 3 silver-lined crystal bugles **J**
6 size 3 silver-lined gold bugles **K**
10 size 3 silver-lined pink bugles **L**

Fabulous findings

22 gilt eyepins, 5cm (2in)
10 gilt headpins
10 gilt jump rings, 3.8mm (³/₁₆in)
Pair of ear fittings

Tools

Round-nosed pliers
Wire cutters
Second pair of pliers to assist with the jump rings

1 Thread each headpin with 1C, 1E, 1C, 1E, 1G, 1L and 1G. Trim the wire extending above the final bead to 6mm (¼in) and make a loop (see Techniques, page 123).

2 Link each prepared pin onto an eyepin. Onto each eyepin thread 1E, 1D and 1E. Trim the wire and form a loop, as before. Set two of these strands aside for now.

3 Attach an eyepin to each of the remaining eight strands. Onto the first two thread 1F, 1A and 1F. Trim the wire and form a loop. Set these two strands aside. Onto the remaining six pins thread 1F, 1A, 1F, 1K and 1F. Trim the wire and form a loop. Set aside two of these strands.

4 Attach an eyepin to the top of the four remaining strands and thread on 1H, 1B and 1H. On two of these trim the wire and form a loop. Take the remaining two pins and add a further 1J and 1H. Trim the wire and form a loop, as before.

5 Separate the strands into two identical sets and arrange them from longest to shortest within each set. Attach a jump ring to the top of the longest strand in the first set. Twist open a second jump ring and thread it onto the ring at the top of the longest strand and the next longest strand of the set. Close the ring.

6 Twist open a third ring and thread on the ring just completed and the next longest strand of the set. Close the ring. Repeat to add a fourth ring. Open a fifth ring and thread on the ring just completed, the final strand of the set and the loop of the first ear fitting. Close the ring (see **fig. 9**). Assemble the second earring in the same way.

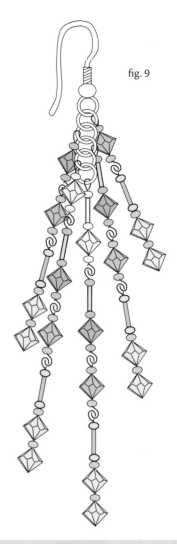

fig. 9

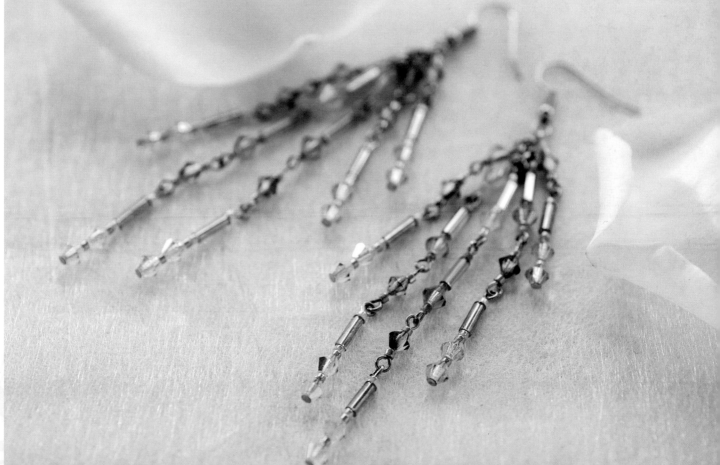

Aurora Bracelet

This stunning bracelet has a wonderful slinky design that captures the ebb and flow of the Aurora Borealis. It is cleverly made by stringing beads onto eyepins, which are then strung together with elastic. This provides greater comfort to the wearer and means that there's no need to fiddle about making a clasp.

You will need

Bead Box

40 topaz AB crystal bicones, 4mm **A**
30 pale jonquil AB crystal bicones, 4mm **B**
40 rose pink AB crystal bicones, 4mm **D**
1g of Delica beads DB411 (galvanized apricot gold) **E**
1g of Delica beads DB070 (lined rose pink AB) **F**
1g of Delica beads DB233 (lined crystal/yellow lustre) **G**
1g of Delica beads DB1531 (opaque pale yellow Ceylon) **H**
10 size 3 silver-lined crystal bugles **J**
20 size 3 silver-lined gold bugles **K**
20 size 3 silver-lined pink bugles **L**
3g of metallic gold-coloured seed beads **M**

Fabulous findings

50 gilt eyepins, 5cm (2in)
50cm (20in) of 0.7mm diameter beading elastic
Small amount of clear-drying nail polish

Tools

Round-nosed pliers
Wire cutters

1 Onto the first eyepin thread 1J, 1H, 1G, 1B and 1G. Trim the wire 6mm (¼in) above the last bead and make a loop parallel to the loop at the other end of the pin. Repeat to make a total of 10 identical pins. We'll call these pins X.

2 Thread 1K, 1H, 1F, 1A and 1F onto 20 eyepins and finish as before. Call these pins Y. Now thread 1L, 1H, 1E, 1D and 1E onto 20 eyepins. Again, finish as before. Call these pins Z.

3 Cut the elastic in half. Make a loose temporary knot at the end of one of the pieces. Thread on 1D. Pass the elastic through the loop at the bugle ends of 1Z, 1Y, 1X, 1Y and 1Z. Thread on 1D. Pass the elastic through the loop at the crystal end of 1Z. Thread on 1A and 1M. Pass the elastic through the loop at the crystal end of 1Y and thread on 1M and 1B. Pass the end of the elastic through the crystal end of 1X and thread on 1B and 1M. Pass the elastic through the crystal end of 1Y and thread on 1M and 1A. Pass the end of the elastic through the crystal end of 1Z (fig. 10).

Make it easy on yourself
Want different colours?
See the alternative versions of this bracelet on page 18. These versions use cheaper beads and fewer colours but they still look great.

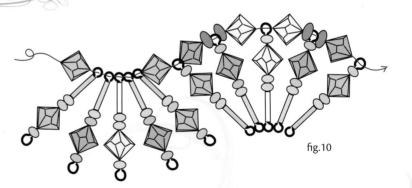

fig.10

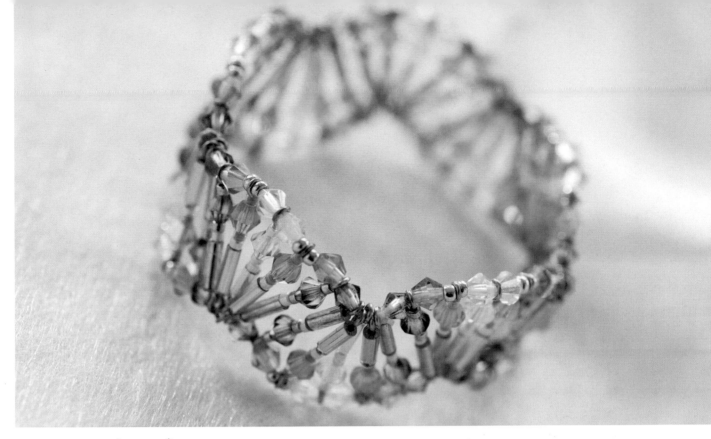

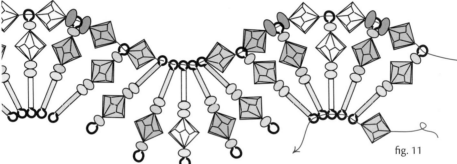

fig. 11

Did you know?

A reef knot

The reef knot is used by sailors to tie down part of a sail to reduce its surface area in high winds – reefing the sails. It is a simple knot, ideal for joining two ends of a single line. Simply form one end into a loop; thread the other end through the loop, around the back and then back through the loop. Pull tight.

4 Repeat the beading in step 3 until you have used all the pins (10 repeats). Tie a loose knot at the end of the elastic to stop the beads from falling off.

5 Take the second length of elastic. This length threads through the loops at the other ends of the pins. Start with a loose knot at the end and thread on 1D. Pass the elastic through the five bugle end loops of the last Z/Y/X/Y/Z pins threaded onto the first row to draw this end of the pins together and make a fan shape, as shown in **fig. 11**.

6 Thread on 1D. String the next five pins together with beads in between, using the same beading order as the second half of step 3. Repeat the beading in step 3 to the end of the row.

7 Tension the elastic through the two rows, pulling the pins into fan shapes so that the bracelet undulates along the length. Remove the loose knots from the ends of the elastic and bring around into a bracelet. Tie the ends together with a reef knot (see Did you Know? left). Seal the knots with a dab of clear nail polish and trim when completely dry.

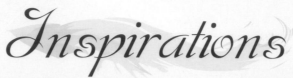

Inspirations

To create the radiant effects of the dawn, the Aurora set uses quite a complex palette, including cut crystal beads. The inspirations on these pages have been made with reduced colour palettes and, in some of them, fire-polished facets instead of crystal. The faceted beads come in a wonderful range of colours and make a lovely, less expensive alternative to the crystals. We have used acid brights and dramatic black to contrast with the Aurora set, but the design will work equally well in any colourway. Why not try crystal and pearl for a bride or ambers and browns for an autumnal set? You'll also find an exciting addition to the set here – a dramatic brooch, which could be worn on a lapel, on a hat or used to secure a shawl or wrap.

Green Goddess ◈◈

This striking set in shades of green would suit any sea goddess or nymph, such as one of the spectacularly beautiful Oceanids. It would look wonderful worn with a rich fabric, such as velvet, silk or brocade. Both the bracelet and matching earrings use 4mm round fire-polished AB beads, size 10/0 gold-lined seed beads and silver-lined green bugles.

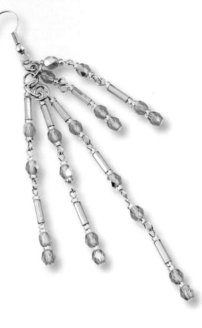

◈◈ Pink Princess

Set free your inner princess with this frivolous fuchsia-pink set. Combine it with a full-length dress in white, silver or toning pinks to fulfil the dream, or wear clashing reds, oranges and other hot colours and be a rebel princess. This is a simplified version of the Aurora set, using 4mm fire-polished AB bicone crystal beads, size 10/0 pink-lined crystal seed beads and silver-lined pink bugles, but you could, of course, use different tones of pink, if desired. Follow the instructions for the Aurora pieces, but use this simplified palette of beads instead.

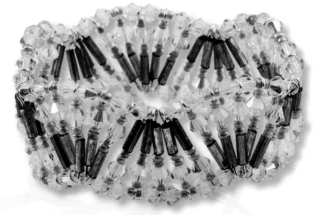

Nemesis ◆◇

This wonderful version of the Aurora set has a very dramatic look that might appeal to Nemesis, the Greek goddess of retribution and vengeance. In scarab blue, Bermuda blue, black and silver, this necklace uses fewer colours but in stronger contrasting hues of fire-polished facets, bugles and Delicas to make a real statement. Both earrings and necklace are made in the same way as the Aurora set, just with different colours, and for the earrings we have used a stud fitting instead of the longer fish-hook ear wires. The 4mm crystal beads are replaced with black, Bermuda-blue and clear fire-polished glass beads and there is also a smaller range of Delicas.

Making the brooch

For the brooch, make the fan at the centre of the necklace using 0.8mm half-hard silver wire and 4mm fire-polished beads (see page 11). Finish each end of the wire, at the top of the fan, with a small loop. Next make and attach the crystal cluster to go in the centre, following steps 1 and 2 on page 14.

The brooch is completed with a lapel pin, which is threaded through the wire loops at the top of the fan. If your lapel pin is a little bit longer than the fan, you can finish it with a filigree bend, using jewellery pliers to bend the pin into a coil or triangle, for example. Alternatively, you can string on some beads, securing them with a French crimp (see Techniques, page 125). Our lapel pin was quite a bit longer than the fan, so we added beads and then coiled the end.

Mermaid
Mystical sea-maiden

The mermaids of myth live in the deep waters of the oceans, calling seafarers on storm-ravaged ships to join them. Their beauty and eloquence combine to make them inescapably bewitching, so wear this wonderful creation to enhance your powers of verbal and physical seduction.

When we think of the sea, we think of water, seaweed and fishing nets. In these pieces, the blues of the beads represent the sea, the long beaded strands are the tendrils of seaweed or mermaid hair and the fishing net is cleverly created from knitted wire. Knitting with wire is easy, and you'll find it a useful addition to your repertoire of jewellery-making skills.

Alternative versions of the necklace and bracelet are shown on pages 28 and 29, and there's also a quick-and-easy project to try – a ring that is based on a simple strip of knitted wire that is formed into a ring shape and then decorated with beads.

Created in the colours of the deep, this sinuous necklace suggests the forms of seaweed or mermaid hair. It is based on a clever framework of knitted wire.

Mermaid Necklace

This alluring necklace is a clever combination of beaded strands and knitted wire that's great fun to make. It is centred around a knitted triangle of wire, which is decorated with beaded strands and then supported on three-string straps. A simple bead-and-loop fastening secures the necklace around your neck.

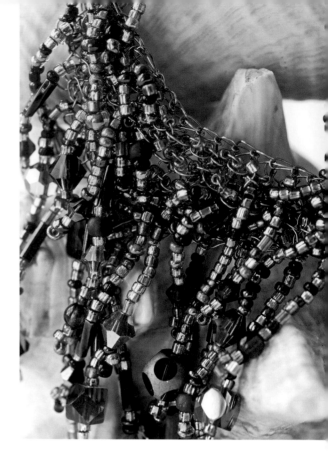

You will need

Bead Box
15g of size 10/0 AB pale blue silver-lined seed beads **A**

12g of mixed blue seed beads and bugles **B**

30 assorted feature beads to tone with the seed beads, 4mm, 6mm and 8mm **C**

Fabulous Findings
20m (22yd) of soft 0.315mm (28-gauge) coloured wire in Supa Blue

Nymo beading thread in Dark Blue

Tools
Pair of 2.75mm (US size 2) metal knitting needles

Wire cutters

Size 10 beading needle

Make it easy on yourself
Knit wise
Knitting with wire is a wonderful craft for jewellery making, so if you can't knit, now's the time to learn. You'll find instructions in books but even better are the free video clips available on the Internet, or you can enlist the help of a friend or relative. For this project you only need to learn to cast on, cast off and to work knit stitch.

Knitting the triangle

Start the necklace with the wire triangle at the centre front. This is knitted from the long edge at the top down to the point at the bottom. To begin the embellishment process, some silver-lined seed beads are knitted into the triangle as it progresses. This is a simple and useful technique, which is fully explained here.

1 Unravel the end of the wire and thread on a 60cm (23½in) length of seed beads A. Push these beads down towards the reel to free up the end of the wire.

2 Cast on 25 stitches using the metal knitting needles.
Row 1: Knit.
Row 2: K2tog, * slide up 3A beads from the end of the wire and knit the next stitch, incorporating the beads. Repeat from * to the last two stitches; K2tog.
Row 3: Knit. (Do not use any beads.)
Repeat rows 2 and 3 until you have three stitches remaining. K3tog and cast off the last stitch.

3 Gently tease the knitted wire into a triangle with the cast-on row at the top. Weave the loose ends of the wire back into the knitting and trim closely.

Adding the strands

The long strands at the front of the necklace are threaded onto the knitted framework using beading thread. The strands should be different lengths (see the tip, below right) and can be threaded with a random selection of beads, but each one should have a feature bead close to the end to weight it properly. Use more than one feature bead on some strands to create a random texture.

1 Thread the needle with a 1.5m (60in) length of beading thread and knot the ends together leaving 10cm (4in) tails. Pass the needle underneath one of the wire stitches close to the point at the bottom of the triangle. Pull the thread through, but just before it has all gone through completely, pass the needle through the loop of thread formed at the knot, as shown in **fig. 1**, to secure the thread end to the wire.

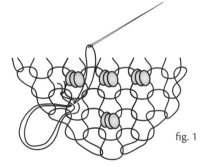

fig. 1

2 Put aside one 4mm and two 6mm feature beads for the clasp. Mix the A and B beads together and thread on sufficient beads plus at least one feature bead to make the first strand, finishing with three or more seed beads.

3 Turn the needle and pass it back up through the fourth bead from the end and through the remaining beads of the strand, as shown (**fig. 2**). This pulls the last three beads into an anchor. Make a small stitch through the knitted wire at the top of the strand, bringing the needle out in the position where you want the next strand.

fig. 2

4 Make up to 22 more strands of various lengths along the bottom margins of the triangle and two or three additional rows at the front to build up a waterfall of strands. If necessary, the needle can pass through some of the A beads that were knitted in, to anchor the thread securely at the top of some of the strands.

5 To add further embellishment and to cover any threads showing at the tops of the strands, work running stitches incorporating four to six A/B beads across the tops of the strands, as shown in **fig. 3**. Knot the thread securely to the wire framework and hide the thread ends in the beads.

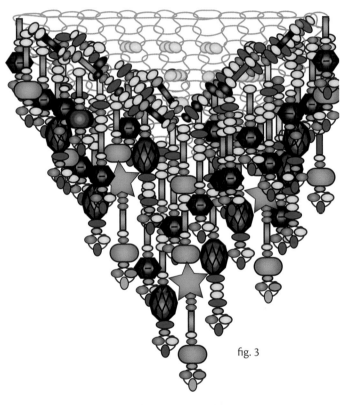

fig. 3

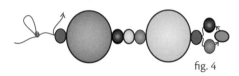

Making the straps and clasp

The side straps, which extend outwards from the front section, are made of three beaded strands that are secured together at the back with a bead-and-loop clasp. The apparently random selection of beads on each strand adds to the textural effect of the necklace.

1 Start a new 1.5m (60in) single thread and tie a slipknot 10cm (4in) from the end. Thread on a seed bead, one of the 6mm feature beads put aside for the clasp, three seed beads, the second 6mm clasp feature bead and four seed beads. Turn the needle and pass it back through the seed bead just before the 6mm feature bead and then through the remaining beads on the strand to emerge alongside the slipknot, (**fig. 4**).

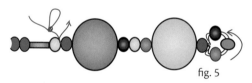

fig. 4

2 Thread on sufficient A/B beads to make the strand 17cm (6¾in) long. Pass the needle through the knitted wire at the left-hand corner. Bring through to the front of the work and make a small embellishing stitch with four to five A/B beads to anchor the thread. Turn the needle and work back through the embellishing stitch and back into the beads at the end of the strand. Run the needle back through the strand, around the loop and back up to emerge at the slipknot (**fig. 5**).

fig. 5

3 Thread on sufficient A/B beads to make a second strand parallel to the first. Attach this to the corner of the triangle 3–4mm (⅛in) from the first strand. Anchor the strand and run the needle back up the beads just threaded, as before. Make and attach a third strand; secure the thread (**fig. 6**).

fig. 6

4 Start a new 1.5m (60in) single length of beading thread and tie a slipknot 10cm (4in) from the end. Thread on the 4mm feature bead put aside for the clasp. Thread on sufficient seed beads to make a loop that will just fit over the 6mm feature beads on the end of the first strap. Pass the needle back through the 4mm bead to emerge alongside the slipknot and draw up the bead loop (see **fig. 7**). Thread on sufficient A/B beads to make the first strand of the strap for the second side of the necklace. Attach it to the right-hand corner of the knitted triangle in the same way as for the first strap; anchor the thread with an embellishing stitch and run the needle back up the beads of the new strand. Turn the needle through the beads of the loop and make a second and third strand to match the other side of the design. Finish off the thread end securely.

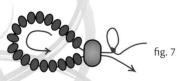

fig. 7

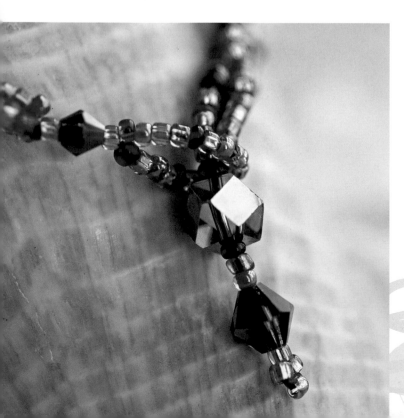

Mermaid Bracelet

This sumptuous bracelet is so encrusted with beads and beaded strands that it will draw many admiring glances, especially if you include some striking feature beads.

You will need

Bead Box

18g of size 10/0 AB pale blue silver-lined seed beads **A**

15g of mixed blue seed beads and bugles **B**

60 assorted feature beads to tone with the seed beads, 4mm, 6mm and 8mm **C**

Fabulous Findings

30m (33yd) of soft 0.315mm (28-gauge) coloured wire in Supa Blue

Nymo beading thread in Dark Blue

Small black haberdasher's press-stud closure

Tools

Pair of 2.75mm (US size 2) metal knitting needles

Wire cutters

Size 10 beading needle

1 Unravel the end of the wire and thread on a 1.2m (47in) length of A beads. Push these beads down towards the reel to free up the end of the wire.

2 Cast on five stitches using the metal knitting needles.
Rows 1 and 2: Knit without utilizing any of the beads.
Row 3: Knit 1, * slide up three A beads from the end of the wire and knit 1. Repeat from * three more times to the end of the row. Repeat rows 2 and 3 until the strip is the correct length for your wrist. Work four rows of plain knit. Cast off and weave the wire ends back into the work to secure them, trim neatly.

Make it easy on yourself
Comfort and style
Make sure that all of the embellishing stitches and the strands are attached to the front of the bracelet, where they can be seen – any on the reverse will make the bracelet uncomfortable to wear.

3 Attach a 2m (79in) thread to the start of the strip as explained in Adding the Strands, step 1, page 23. Mix the A and B beads together and make the first three fringe strands as for the necklace (see page 23), spacing them equally across the width of the knitting between the first two rows of A bead embellishment. The strands should be 15–25mm (½–1in) long – vary the length for the best effect. Now work two A/B bead-embellishing stitches four to five beads long over the A beads across the width of the bracelet. This secures the strands and helps to build up more texture. Repeat the process of working three strands followed by two embellishing stitches to the end of the strip, leaving the final four rows of plain knit unadorned.

4 Stitch one part of the press-stud fastener to the top of the plain end of the strip and the other part to the underside of the decorated end to make a concealed closure.

Little Mermaid Necklace

This simplified version of the Mermaid Necklace might suit a mermaid with a quieter personality. It is made in the same way as its bigger sister, but with a smaller knitted triangle. It also has fewer tassels and just two strands running back to the bead-and-loop clasp. It's made in a splendid combination of pinks and purples.

You will need

Bead Box

15g of assorted purple and pink seed beads and bugles

9 purple AB glass drops, 6 x 4mm

2 toning glass beads for the clasp, 6mm

1 toning glass bead for the clasp, 4mm

Fabulous Findings

20m (22yd) of soft 0.315mm (28-gauge) coloured wire in Supa Violet

25cm (10in) of 0.9mm (19-gauge) coloured wire in Supa Pink

Nymo beading thread in Purple

Tools

Pair of 2.75mm (US size 2) metal knitting needles

Wire cutters

Size 10 beading needle

Did you know?
Mermaid manatees

It is thought that mermaids were really manatees. Rising through seaweed, these seal-like creatures may have resembled ladies with long flowing locks. On his travels to discover the New World, Christopher Columbus wrote in his log that he had seen some mermaids, but commented that he thought they would be prettier!

1 Starting with just 15 stitches of Supa Violet wire on the needle, knit a triangle using the shaping method of the Mermaid Necklace (page 22) — do not add any beads to the knitting wire for this project. Leave the wire ends attached when the triangle is complete.

2 Make a scroll to go at the front by wrapping 0.9mm wire in a contrast colour around a pen, as shown in **fig 8**. Use the ends of the wire on the knitting to attach the scroll onto the front of the triangle.

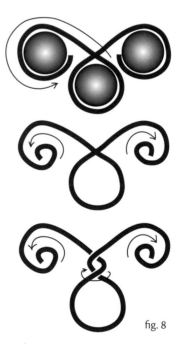

fig. 8

3 Make a simple cluster of short strands from mixed seed beads, positioning them to spill from the middle of the central scroll loop. Each strand should end with a 4 x 6mm AB glass drop. Make two-stranded straps and a clasp following the instructions on page 24.

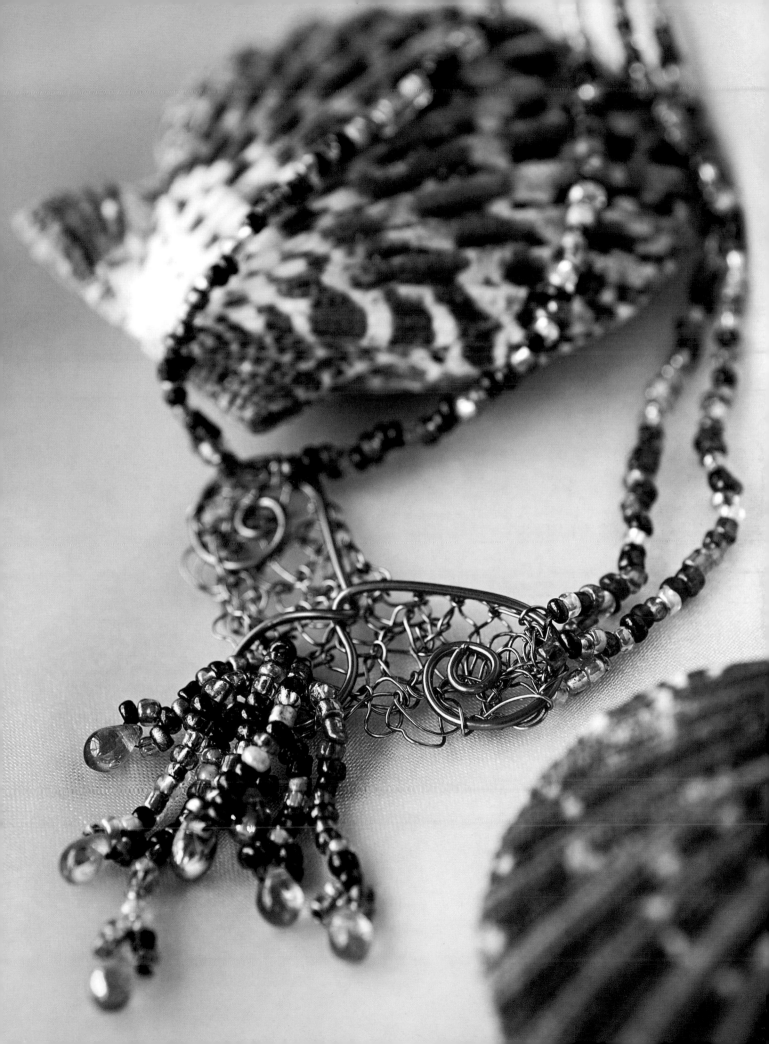

Inspirations

Because there are many different ways of beading strands, the Mermaid necklace and bracelet are easily adaptable. Not only can you change the feature beads or alter their positions, but you can adjust the number of strands used and the types of beads as well. The pieces here take advantage of beads with unusual shapes – leaves, flowers, butterflies, donut shapes and more – to create items with a frivolous air.

If you want a really quick project that uses knitting with wire, you might want to have a go at making a ring. There are endless decorative variations you could try, and three very different alternatives are shown here. The red ring uses loops of small beads to make a flower, the green version takes advantage of an unusual shape of bead, while the purple one is decorated with short beaded strands. See how many other variations you can think of.

Hot Spice ◆◆

This necklace sizzles with silver-lined orange and yellow size 10 rocailles and orange and yellow seed and bugle beads. You could imagine it being worn to an evening of fun somewhere in the Caribbean. It's made in the same way as the Mermaid Necklace (page 22), but the knitted triangle at the centre front is pulled into more of a point and there are fewer strands of beads. Between the strands more beads are applied to the knitting to fill the gaps and add texture. Only two strands are used for each of the side straps. Use wire in Vivid Red and incorporate themed feature beads including leaves, flowers and pretty butterflies.

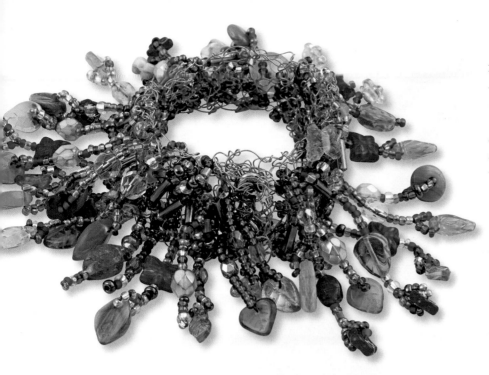

Summer Meadow Bracelet ◈◈

Knitted in Emerald Green wire, this bracelet is embellished with strands of assorted bright green seed beads and a selection of feature beads in the form of leaves, flowers, butterflies and faceted rounds that recall the colours and patterns of a hot summer. It's made in the same way as the Mermaid bracelet on page 25, but uses fewer strands. Instead of the many strands, flower and butterfly beads have been applied directly onto the knitted surface to make this a multi-layered bead extravaganza. Make this bracelet and the necklace in the same colours and be a gypsy queen for the day.

Ring the Changes ◈◈

A simple knitted framework can be used in all sorts of ways to make exciting jewellery. Here, a knitted strip makes a basic ring that can then be embellished in a variety of ways. Note that the beads are attached where the knitted ends are overlapped and joined to conceal the means of construction. Using 0.315mm (28-gauge) wire and 2.75mm (US size 2) knitting needles, cast on four stitches and knit a stretched strip long enough to go around your finger. Overlap the ends by 2mm (⅛in) and stitch together firmly with one of the wire ends. Weave the wire ends into the knit and trim closely.

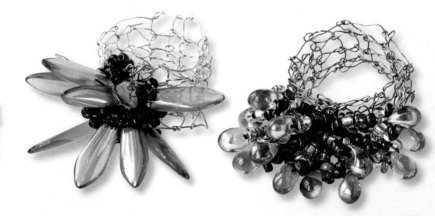

Poppy princess

This version features a flamboyant flower made from seed beads and bicones and is great for a feminine look. Make the ring as explained above using Warm Gold wire. Attach a double length of beading thread to the seam and make seven or eight loops from 17 red size 10/0 seed beads. Make six loops from 13 red seed beads in the middle of cluster. Finish with five or six black crystal bicones, 4mm in size, for the centre of the flower.

Blue rays

This space-age ring makes good use of a handful of striking dagger beads. Make the ring as explained above using Warm Gold wire, but this time attach a double length of beading thread to the seam and stitch 10 or 11 dagger beads, 13 x 6mm in size, very firmly in a cluster. Make small stitches with brown seed beads around the base of the cluster until the dagger beads are held securely.

Purple passions

This ring is decorated with a cluster of short strands – a great way of utilizing leftovers. Make the ring as explained above from 0.315mm Purple wire. Attach a double length of beading thread to the seam and create 12–16 short strands from the middle of the seam, each with a 6 x 4mm drop at the end. Knot the thread end securely and trim.

Calypso
Passionate seductress

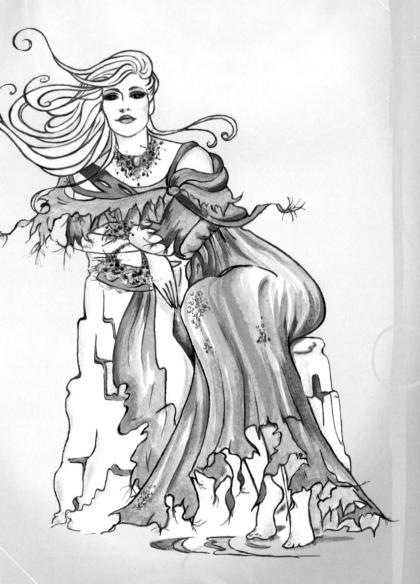

Calypso was a naiad (water sprite) or nereid (sea nymph) of Greek mythology. Like all nereids, she helped sailors in trouble, so when Odysseus was shipwrecked on her shore she went to his aid, only to fall passionately in love with him. Like all water sprites, she could not leave her water source, so she tried to persuade Odysseus to stay with her, even offering him immortality in return. Her passion was not returned and after seven years Zeus ordered Calypso to let Odysseus go.

Associated with abundance and beauty, Calypso is represented at the meeting of the sea and the shore, where rocks meet waves and the jewels of the sea become ensnared in torn netting.

Calypso's necklace will appeal to the glamorous and unconventional; with its wild, twisting fronds, multiple layers, rich colours and asymmetric form it will take a strong personality to wear it – but what an impact you'll make. There's also a bag and bracelet, and see pages 40–41 for some alternatives.

A passionate piece for a passionate person, this powerful twisting of metal and cord, encrusted with jewelled beads captures Calypso's complicated emotions as well as the turbulence of the sea and its symbols.

Calypso Necklace

This dramatic necklace is all about impact. Wear it with something long, flowing and flattering and hold your head up high, for you are queen of all your survey. This is one of the most time-consuming necklaces in the book, but the stages are actually quite straightforward and if you work through them carefully you should have no problem. (See also the photograph on the title page.)

Knitting the necklace

The basic necklace shape is made by knitting two double-sided shaped pieces and joining them at the centre front. The shaping instructions need to be followed carefully to make the necklace fit the base of the neck, however the point at which the colours grade into one another can be adjusted to suit your taste.

1 Measure 1m (40in) from the end of the Vivid Green (VG) wire and cast on 22 stitches.
Row 1: *Knit to the end of the row.
Row 2: K2tog, knit to the end of the row.
Repeat from * three more times (18 stitches).
Row 9: Knit.
Row 10: Change to Opaque Green (OG) and K2tog; knit to the end of the row (17 stitches).
Row 11: Change to VG and knit the row.
Row 12: K2tog, knit to the end of the row (16 stitches).
Row 13: Change to OG, K2tog; knit to the end of the row (15 stitches).
Row 14: Change to VG and knit the row.
Row 15: Change to OG, K2tog; knit to the end of the row (14 stitches).
Row 16: K2tog, knit to the end of the row (13 stitches).
Row 17: Change to VG and knit the row.
Row 18: Change to OG, K2tog; knit to the end of the row (12 stitches).
Row 19: Knit.
Row 20: K2tog, knit to the end of the row (11 stitches).
Row 21: Change to Dark Blue (DB) and knit to the end of the row.
Row 22: Change to OG and K2tog; knit to the end of the row (10 stitches).
Row 23: Knit.
Row 24: Change to DB and K2tog; knit to the end of the row (9 stitches).
Row 25: Knit.
Row 26: Change to OG; knit.
Row 27: Change to DB; knit. Continue in DB on these nine stitches until this half of the necklace is the required length, allowing 1–2cm (½in) for the clasp at the centre back. Do not cast off.

You will need

Bead Box

Flat semi-precious bead approximately 20 x 30mm in blue or green (we used moss quartz)
22 assorted beads in toning colours, 4–8mm
150 crystal bicones in toning colours, 4mm
5g each of 3 or 4 colours of size 8/0 seed beads to match the other beads

Fabulous Findings

20m (22yd) each of 0.315mm (28-gauge) soft wire in 5 colours: Vivid Green, Dark Blue, Opaque Green, Ice Blue and Silver Plate
C-Lon macramé cord in 5 colours: 8m (8¾yd) of Teal (the dominant colour), 5m (5½yd) of Sea Foam and 3m (3¼yd) each of Pale Heather, Purple and Blue Lagoon
Necklace clasp (3-row sterling silver fastener)

Tools

Pair of 3.75mm (US size 5) metal knitting needles
Wire cutters
Macramé T-pins
Cork board or similar to secure the macramé
Darning needle

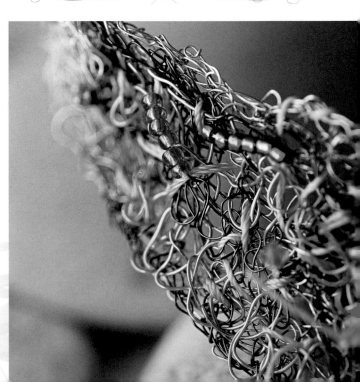

2 Mark the last row knitted (the centre back) with a twist of contrast wire. Starting with the nine stitches on the needle, and still using DB, begin a second layer, working back towards the centre front and reversing the shaping to make two layers that will lie back to back perfectly. To increase a stitch, knit into the front and then the back of the same stitch on the needle. As you knit, bring in patches of the other wire colours to show through to the front as flashes but keep it predominantly DB by the time you reach the centre front. Cast off loosely to match the cast-on row. Leave 1m (40in) of wire attached.

3 Measure 1m (40in) from the end of the Dark Blue (DB) wire and cast on 22 stitches to begin the second side of the necklace. The colours on this side fade from DB through Vivid Green (VG) and Ice Blue (IB) to Silver (SP). Working in mirror image, repeat the instructions for the first side in step 1 but using DB, VG and IB. Fade to SP wire in row 30. Make this side of the necklace up to the correct length at the centre back and mark the end of the row with coloured wire as before. Now repeat step 2 using the second set of colours to complete the second layer.

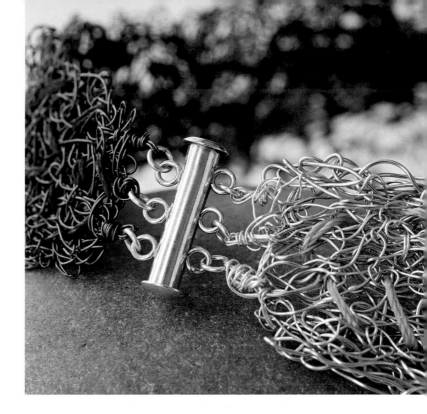

fig. 1

When in their final position, the two sides of the necklace fully overlap at the bottom.

4 Lay out the two halves of the necklace so the centre fronts overlap and the more heavily decreased edges lie on the outside of the design, as shown in **fig. 1**. Decide which side of the work you want to show to the front and whether or not you want the four layers at the front to interleave or the two layers of one side to sit on top of the other. You may need to manipulate the edges of the knitting so that they fit neatly – the knitting will push in and pull out quite easily.

5 Tease the centre front of the two pieces into a point and stitch together firmly with a length of VG or DB wire. Use the remaining ends of the wire to slipstitch the edges of the layers together, making an additional few random stitches across the widest part of the knitting to bring the two layers into one.

Make it easy on yourself
Scrunch to length
It is easy to adjust the length of the necklace by knitting the straight sections longer or shorter, but if in doubt, knit it longer than you think you need and then scrunch the wire to fit – this adds pleasing texture too. The necklace in the photograph was knitted roughly 6cm (2³⁄₈in) longer than required and then gently scrunched and loosely stitched in place when the two necklace halves were brought together at step 4.

Making the macramé fringe

The knitted necklace base is symmetrical but the macramé fringe is asymmetrical, being heavier and potentially longer on one side than on the other. These instructions make the right-hand side heavier than the left but you can swap them over if you prefer.

1 Cut 20 lengths of assorted macramé cord colours, each approximately 20cm (8in) long. Using macramé T-pins, secure the right-hand side of the necklace front to the cork board. Attach each cord to the right-hand edge of the knitting, working from the tip of the centre front up the side about halfway. Use a lark's head knot to attach each cord (see Techniques, page 125).

2 Starting with the furthest four cords from the centre front, make a half knot (see page 125), pulling the knot up closely to the edge of the knitting. Take any two cords from the first knot and the next two cord ends and make a second half knot. Repeat down to the point of the necklace, forming a ripple of linked knots close to the knitted edge (**fig. 2**).

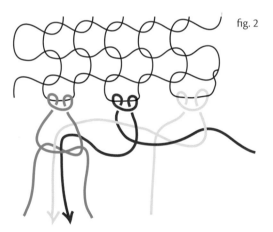

fig. 2

3 Work back in the opposite direction to make a second layer of linked half knots.

4 To ensure that the half knots will not come undone, finish with a row of square knots (see page 125). Start at the furthest cord ends from the point once more and make a square knot with the first four cords. Use the two left-hand cords of this completed knot and the next two cords to the left along the edge to make a second square knot. Continue in the same way to the point. These cords will now be left as a fringe. Fold the cord ends up onto the top surface of the necklace, out of the way while you add the second layer of cords for the net.

Make it easy on yourself
Wire needle

If you are finding it difficult tying the lark's head knots to the dense knitting, fold a 5cm (2in) length of wire in half around the centre of the 20cm (8in) cord. Push the points of the wire together and use the wire like a needle to thread the cord fold through the knitting.

5 Cut 30 lengths of macramé cord 30cm (12in) long in assorted colours. Using lark's head knots attach 20 lengths to the right-hand edge of the necklace and 10 lengths to the left. Attach the cords at 6–8mm (¼–⅜in) intervals from the point at the centre front. On the right-hand side the lark's head knots can attach to the knitting beneath the first layer of knots or straight over the knotted edge created in step 2. Run a series of half knots down to the point on each edge of the necklace but do not join the left-hand threads to the right-hand threads at the point. On the right-hand (20 thread) side run a second series of half knots from the point back up the edge.

6 To start the net effect down each edge you will need to make a row of square knots. Take the two left-hand cords from one half knot and the adjacent two cords to the left and make a new square knot with these four cords, as shown in **fig. 3**. Position extra T-pins into the board to space the new knots out into the desired netted effect, pulling the threads tightly against the placed pins to ensure that each knot is very tight.

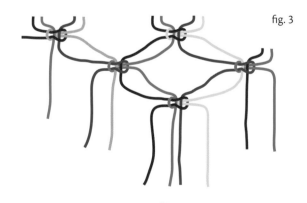

fig. 3

Make it easy on yourself
Adding colour

This necklace is worked in light and dark toned wire. If desired, you can introduce a mid-tone too. We suggest Supa Blue, as used in the Mermaid projects, and Supa Green (the main colour of the Gaia project).

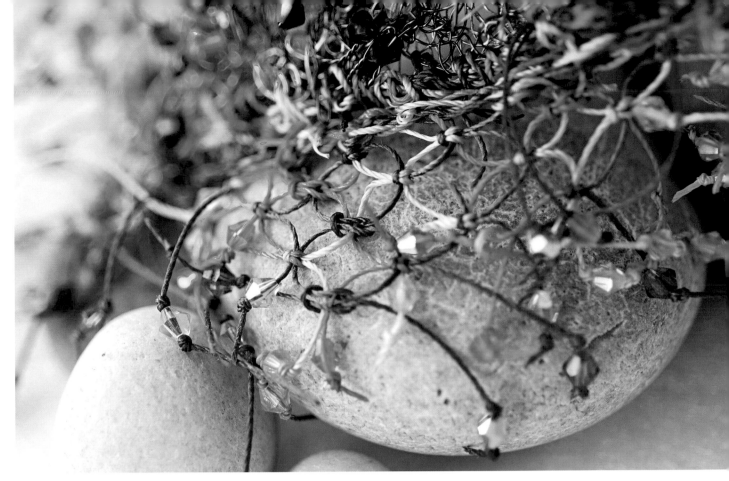

7 Continue working in the same way. **Fig. 4** below shows the pattern of knots as little blocks along the edge of the sample. You do not need to follow this pattern exactly – the overall effect when you finish should be a little ragged and random-looking.

8 The cords should be longer at the front than at the sides and the fringe row made in step 2 should be a little shorter than the netting underneath, but before the cords are trimmed they should be decorated with a crystal bead. Think about the final length of the cord while positioning each bead. If you push the bead right up to the bottom of the macramé, a single knot beneath the bead will hold it in place. If you want the bead to be further down the cord, place a simple knot above and below it. Put two or three beads on some of the longer strands at the centre front.

9 When all the beads are in place, trim the cords to length, as desired, leaving at least a 1cm (⅜in) tail of thread beneath each knot.

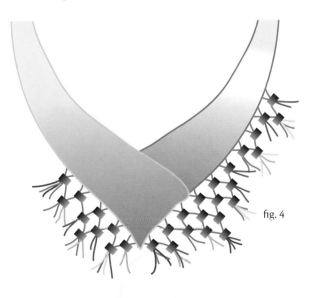

fig. 4

Did you know?
All at sea

Knitting and macramé were both once practised by sailors, who needed something to do during the quiet times on long voyages. Indeed, it is thought that they helped to spread the techniques around the world, having learnt the crafts in Egypt and Arabia.

Encrusting the necklace

Now you can attach the beads to the knitted framework with your various coloured wires. This is the time to use your creativity to create a unique and magical piece of jewellery. Use a dark wire to attach the stone to the centre front and brighter colours where you want the wire twists and stitches to show.

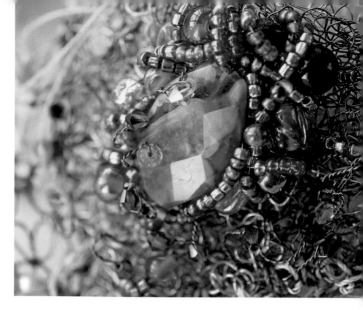

1 Cut 1m (40in) of dark wire and attach the middle of the wire to the middle of the centre front of the necklace with a twist. Position the semi-precious stone at the centre front of the design and stitch it into place with the wire ends. Stitch an assortment of the remaining larger beads around the stone and scattered loosely on each side, as shown in **fig. 5**.

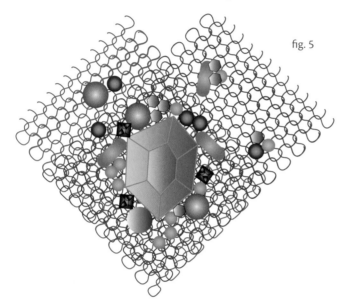

fig. 5

2 Bring a wire end up adjacent to the large stone and thread on 6–12 seed beads. Make a stitch to bring the beads into a long curve around the edge of the stone. Repeat to make a series of curling lines of seed beads in and around the central stone and the scattered feature beads. Make a few similar stitches stretching out to the side of the design and up into the strap (**fig. 6**).

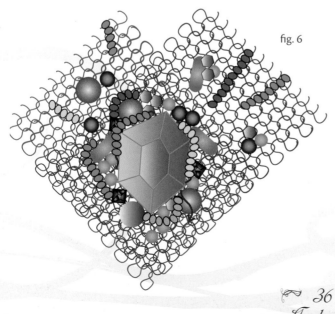

fig. 6

3 To add a little more depth to the centre front you can add a few wire twists. Bring the end of the wire through to the front of the work close to the feature stone. Thread on a crystal bead, making a loop 3cm (1¼in) long with the crystal bead in the middle. Twist the bead to form a wire rope between the bead and the knitted surface, as in **fig. 7**. Make a stitch with the end of the wire and repeat. As you proceed, curl the twists into little spirals and coils.

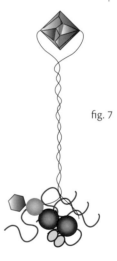

fig. 7

4 Try the necklace for size and then push and pull it into shape, as desired. Use a short length of wire to bind the clasp onto each end at the centre back (see the photograph on page 33).

5 To secure the necklace in position, run a few lengths of macramé cord through the knit. Use a darning needle and make small, random stitches down each side of the necklace and across the centre front. To finish off the thread ends, knot a crystal bead tightly into the knit and leave the thread end hanging loose, adding another tassel to the design.

Calypso Bracelet

This striking bracelet should be worn around the lower arm with the stranded fringe of macramé cord stretching out across the back of the hand. Heavily beaded, this is a real show-stopper but the design could be adapted to make a narrower band with smaller, more delicate beads, if desired. The macramé cords can be swapped for embroidery threads or fine silk ribbons to give a softer edge.

You will need

Bead Box

Approximately 70 beads in blues, teals, purples, greens, cream and clear colours, mainly 5–8mm with a few larger beads and 7 or 8 glass fish-shaped beads

Fabulous Findings

10m (11yd) each of 0.315mm (28-gauge) soft wire in Silver Plate, Opaque Green, Dark Blue and Vivid Green

About 3m (3¼yd) of C-Lon macramé cord in each of 3 colours to coordinate with the wire and beads

2 or 3 press studs to fasten the bracelet

Nymo thread in Dark Blue

Size 10 beading needle

Tools

Pair of 3.75mm (US size 5) metal knitting needles

Wire cutters

Macramé T-pins

Cork board or similar to secure the macramé

1 Measure your wrist and decide on the required size of your bracelet. Cast on ten stitches and knit five rows as a tension square so you can calculate how many stitches you need to cast on to stretch around your wrist – the bracelet will need to overlap by about 1.2cm (½in).

2 Thread 15 beads onto each colour of wire. It looks nice if you zone the beads and thread, for example, the green beads onto the blue wire and paler beads onto the silver wire. Start with the silver wire and cast on sufficient stitches for your wrist measurement. Knit one row. On the next row bring a bead up into every fourth or fifth stitch. Knit the next row without beads, then the next row with beads. Change to Opaque Green wire and repeat the last four rows. Work the same rows in Dark Blue wire and then Vivid Green wire. Cast off loosely.

3 Stitch the remaining beads to the knit with the ends of the wires to fill in the gaps. Following the macramé instructions for the necklace, make a simple fringe on the lower edge of the bracelet. Stitch the press studs into place.

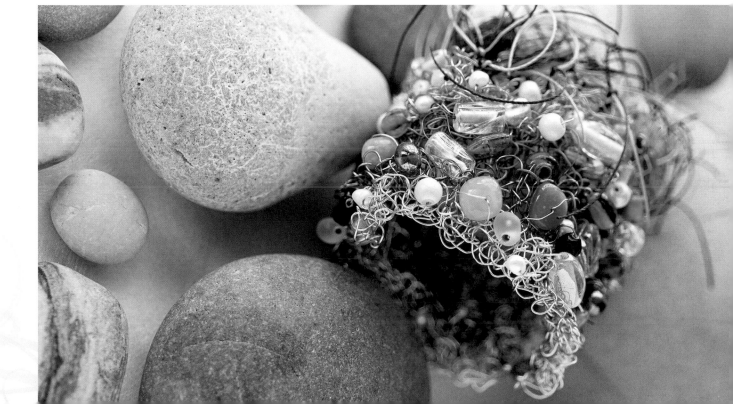

Calypso Handbag

Rippling with knitted wire and encrusted with beads, this gorgeous bag isn't just for fun – the fabric lining ensures that it's practical too. Made in simple steps, it's also surprisingly easy to make. And if you look on page 41, you'll see that it looks just as good in other colours.

Make it easy on yourself
Softer version
0.5mm wire can be tough on your fingers, particularly if you work with a tight tension. 0.315mm wire will also work for this bag; just add in an extra couple of rows to maintain the overall length.

And if you look on page 41

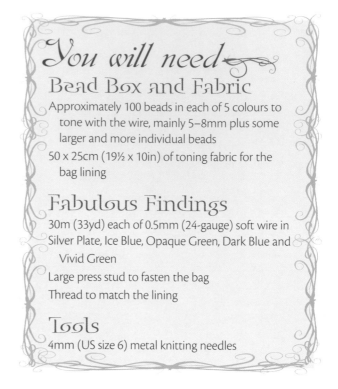

You will need
Bead Box and Fabric
Approximately 100 beads in each of 5 colours to tone with the wire, mainly 5–8mm plus some larger and more individual beads

50 x 25cm (19½ x 10in) of toning fabric for the bag lining

Fabulous Findings
30m (33yd) each of 0.5mm (24-gauge) soft wire in Silver Plate, Ice Blue, Opaque Green, Dark Blue and Vivid Green

Large press stud to fasten the bag

Thread to match the lining

Tools
4mm (US size 6) metal knitting needles

1 Cast on 70 stitches in Silver Plated (SP) wire and knit five rows. Change to Ice Blue (IB) wire and knit five rows. Change to Dark Blue (DB) wire and knit five rows. Cast off loosely and set aside.

2 Thread approximately 60 of the assorted beads in each colourway onto the matching five colours of wire. Cast on 70 stitches in SP.
Row 1: Knit.
Row 2: Knit, pulling one bead into roughly every third stitch and pushing it to the front (small beads can be two stitches apart, large beads four stitches apart).
Row 3: Knit.
Row 4: Change to IB and knit, pulling one bead into every third stitch or so (see row 2).
Row 5: Knit.
Row 6: Knit, pulling one bead into every third stitch or so.
Row 7: Change to Opaque Green (OG) and knit to the end of the row.
Row 8: Knit, pulling one bead into every third stitch or so.
Row 9: Knit.
Row 10: Change to Vivid Green (VG) and knit, pulling one bead into every third stitch or so.
Row 11: Knit.
Row 12: Knit, pulling one bead into every third stitch or so.
Row 13: Change to DB and knit to the end of the row.
Row 14: Knit, pulling one bead into every third stitch or so.
Row 15: Knit.
Row 16: Knit, pulling one bead into every third stitch or so. Cast off loosely.

3 For the handle, pre-thread the five reels of wire with approximately 40 toning beads. Cast on 50 stitches in SP. Repeat rows 1–15 in step 2. Cast off in DB.

4 Place the beaded layer made in step 2 bead side down. Arrange the plain layer made in step 1 so that the DB rows at the top of the plain layer overlap the SP rows at the bottom of the beaded layer. Take a 1m (40in) length of SP wire and use it to stitch the top DB row of the plain layer to the top SP row of the beaded layer, making an overlap on the front side of approximately 2cm (¾in).

5 With the wrong sides together, fold the knitted bag in half and stitch the seam neatly with a length of wire to form a tube.

Make it easy on yourself
Bead by tension
If you knit loosely you'll find it easier to incorporate larger beads; if you knit with a tight tension, consider using a larger number of smaller beads or switch to some larger knitting needles.

6 Referring to the photograph below, tease and squeeze the bottom of the plain layer into a series of gentle scallops. Use a piece of toning wire to catch the top of each wave into place. Finish the wire ends by twisting the wire once around an adjacent stitch to secure it; pass the wire through an adjacent bead and trim it neatly at the far side, close to the bead.

7 Measure the internal dimensions of the bag and make a square fabric lining to fit inside – make sure that the lining comes just short of the scalloped bottom edge. Stitch a press stud just inside the top edge of the lining. Hand stitch the lining to the top row of the knitted bag with the thread you used to assemble the lining.

8 Roll the handle, worked in step three, into a long tube. Starting at one end with a new length of wire, stitch the seam firmly to approximately halfway along the length. Gently fan out the rest of the tube to make a wider anchor point at this end of the handle.

9 With two new lengths of wire, firmly stitch the rolled end of the handle to one side of the beaded bag and the wider end of the handle to the other side. If necessary, add a few beads onto the stitching wire to cover the join between the handle and the bag. Finish the wire ends as before.

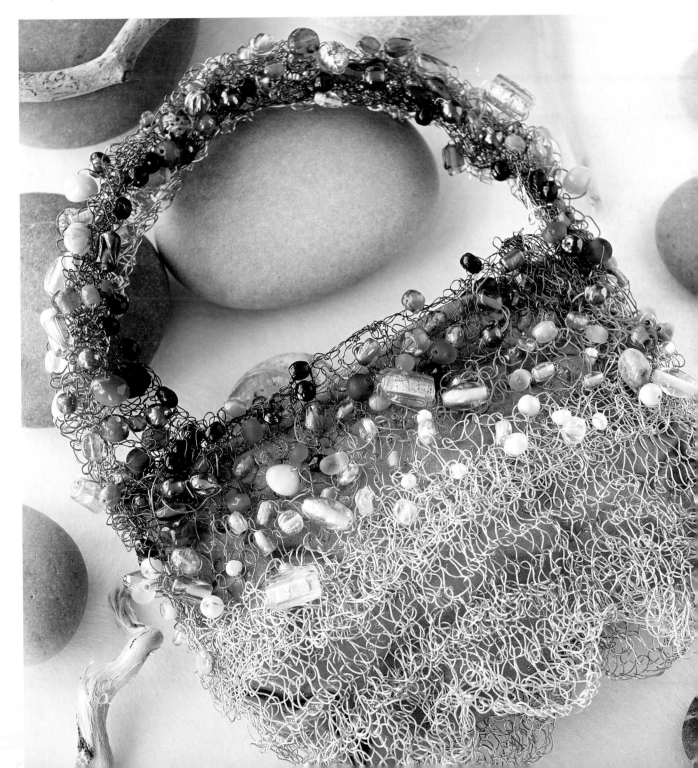

Inspirations

As we explored the potential of knitting with wire to make the Calypso necklace, bag and bracelet, we realized that there was plenty of scope for creating different effects using more or fewer colours of wire and altering the size and amount of beads used for the decorations. The bridal-inspired necklace, below, is a simplified version of the Calypso necklace (page 32), using just two wire colours worked together. Having simplified the necklace, we decided to adapt it again, this time adding beads to make it more ornate, and in particular using seed beads as an edging and around the feature beads. The result is shown opposite, along with a coordinating bag.

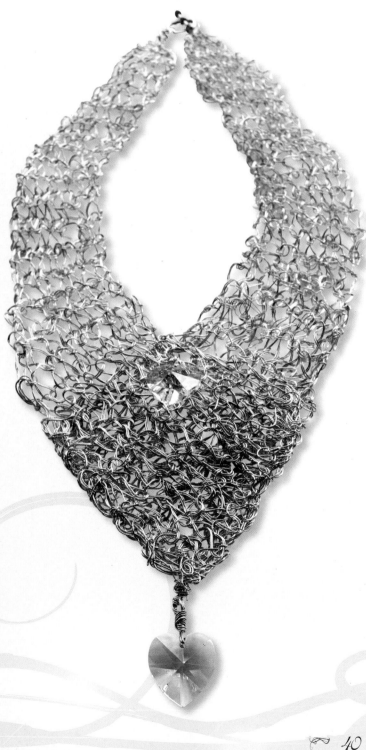

Bridal Necklace ◈ ◈

This elegant necklace is made with silver and gold-coloured 0.315mm (28-gauge) wire. Knitting two strands of wire together around the neck creates a subtle, soft tone, and this has been enhanced with minimal beading for a very sophisticated look. This necklace was designed with a bride in mind but would suit any occasion at which you want to give a classical impression – Athena herself might wear this at a meeting of the gods.

Making the necklace

Using 4mm (US size 6), needles, cast on 15 stitches with the first colour. Join in the second coloured wire and knit four rows. Continue as follows, knitting the two colours together.

Row 5: K2tog; knit to the end of the row.
Row 6: Knit.
Repeat rows five and six until eight stitches remain.
Knit eight rows.
Next row: K2tog; knit to the end of the row.
Knit four rows.
Next row: K2tog, knit to the end of the row.
Continue knitting on these six stitches until this side of the necklace is 2cm (¾in) short of the finished length.
Next row: K2tog, knit 2, K2tog.
Next row: Knit.
Next row: K2tog twice.
Next row: K2tog. Cast off leaving a generous tail of wire.
Repeat to make a second identical length.
Lay the pieces on top of each other so that the cast-on edges overlap completely to form a double layered point at the front of the design and then bind the two layers together with small, neat stitches of wire. Bind a clasp onto the centre back – a toggle clasp will work well. Add any beads as desired. This design was completed with two 10mm (⅜in) crystal hearts, one hanging from the point and one applied to the bottom of the centre V.

❖❖ Posy Bag

This stunning bag would grace any special occasion – it would make a wonderful alternative to a posy for a maid of honour, for example. Make it using the same pattern as the Calypso bag (page 38), but with six colours of wire to allow for a more gradual grading of the tones – use Supa Lilac, Dark Purple, Bright Violet, Pink, Baby Pink and Silver Plate. Try slightly bigger beads but fewer of them; the bag shown uses about 300. You could also try knitting the bag in 0.315mm (28-gauge) wire – this gauge is easier to knit and will give you a softer, more pliable bag.

Pretty in Pink ❖❖

This vibrant version of the Bridal necklace opposite is made using Supa Pink and Dark Purple wire on 4mm (US size 6) needles. It is decorated with a collection of amethyst chips, flowers, faceted beads and freshwater pearls that were left over from other projects, together with a small assortment of matching glass beads. Three closely toning shades of magenta and cerise seed beads weave up the edges of the knit and ruffle between the larger beads to bring all the elements into one.

Gaia
Earth goddess

This early Earth goddess came from Chaos, the great void, and with her came Eros, god of love. She was mother to sea (Pontus) and sky (Uranus) and was worshipped by the Greeks as the mother of all the gods. Our interpretation of Gaia was inspired by a tropical lagoon where water, solid ground and lush foliage come together.

Combining the blue-greens of the lagoon with flower forms and swirling tendrils, the Gaia necklace is ideal for any woman who wants to express her sensual inner nature. The sinuous shape of the necklace is cleverly created using knitted tubular wire. The coordinating bracelet ripples with chunky beads, and there is also a pair of flower earrings to complete the set.

You'll also find alternative versions in dramatic black and red (see pages 50–51) plus a pair of lovely flower earrings for Aphrodite, goddess of love and beauty, re-created in pretty pinks and purples.

With its soft, blue-green colours, flowing threads, and lily forms, the Gaia jewellery speaks of the essence of life.

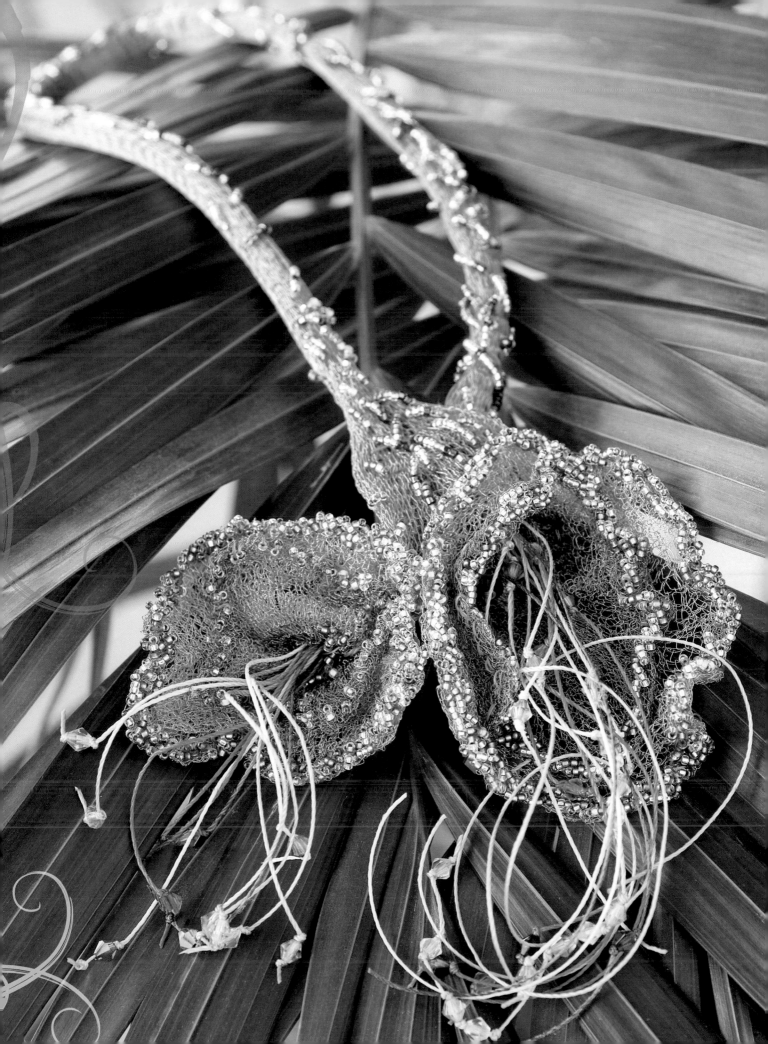

Gaia Necklace

This unusual design has a relaxed feel and could actually be worn with quite casual clothing – it combines particularly well with knitwear. Don't worry, you won't be knitting it yourself – you'll be using tubes of knitted wire, stretching and bending them into shape around macramé cords that spill out at the ends to swing and catch the eye. The necklace clasps at the front and is 41cm (16in) around the neck.

You will need

Bead Box

5g each of three contrasting 15/0 seed beads – the sample colours are the matching shades to Miyuki Delica TM numbers 041, 059 and 697

35 assorted 4mm crystal bicones in toning colours of teal, jonquil, pale grey, pale amethyst and pale blue

Fabulous Findings

50cm (20in) of 80mm (3in) wide tubular wire in each of Vivid Green and Supa Green, 0.1mm tight knitted

14 lengths, 1m (40in) long, of C-Lon or Superlon macrame cord: three in Teal; five in Sea Foam; three in Lavender and three in Purple

Two small haberdasher's hook-and-eye fasteners

Superlon AA beading thread in Teal

Tools

Size 10 beading needle

Scissors

Make it easy on yourself
Test length

If you are worried about the process of shaping the wire tubing, try it first on a short length, making just one flower-shape at the end. Remember, your necklace doesn't have to look exactly like the one shown. Each piece should be as individual as its maker.

Preparing the foundation

The basic form of the necklace is made by stretching two layers of wire tubing over macramé cords and shaping the ends. The ends of the tubing are then neatened and reinforced with small rolled hems.

1 Place the tube of Vivid Green wire inside the tube of Supa Green wire to make a two-layered tube. Bring all the lengths of macramé cord together and tie them at one end in a loose knot. Pass the knot through the centre of the Vivid Green wire tube so the wire tubes lie centrally along the length of the macramé cords, as shown in **fig. 1**.

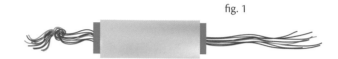

fig. 1

2 Starting at the centre of the wire tubes, begin to stretch the wire knit along the length – work out a little to each side, pulling quite hard so that the wire stretches lengthwise and compresses onto the cords, as shown in **fig. 2**. Work out to about 8–10cm (3–4in) from each end of the wire.

fig. 2

3 Gently pull and tease the ends of the wire out into slim trumpet-shaped flowers – they will feel very soft and insubstantial at this stage. These trumpets need to be stiffened and strengthened. Working at one end of the necklace at a time, carefully turn back a 3mm (⅛in) hem all the way around the cut edge of the Supa Green tube. Roll the hem back three more times to start to stiffen the edge and conceal all the raw wire ends. Repeat with the Vivid Green wire but this time roll back the hem six or seven times so the Supa Green trumpet shows all the way around the edge, as shown in **fig. 3**. Gently scrunch the hems into a more undulating profile to give movement and a naturalistic form to the trumpet edges.

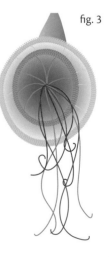

fig. 3

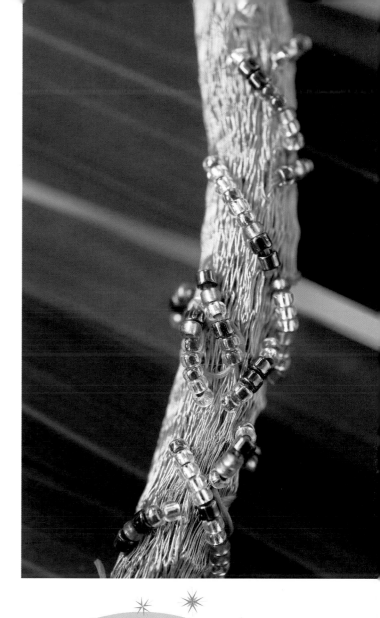

4 Check that the necklace is long enough and if not extend the pulled and stretched length of wire closer to the flare of the trumpets. Gently flatten the throats of the flowers from the end of the stretched wire rope to the beginning of the trumpet flares, giving a small area behind each flower to attach the clasp.

5 Drape the stretched wire rope around your neck and cross over the flowers at the front. The hook-and-eye fasteners will be attached onto the flattened throats of the flowers where they cross over at the centre front so adjust the position of the flowers on the neck until one falls just below the other, as shown in **fig. 4**. Mark the position where they cross with a little length of thread. Remove the necklace and stitch the two hooks for the clasp to the underside of the top trumpet throat, making sure that the whole of each hook is concealed from the front of the design. Stitch the two loops to the top surface of the other trumpet throat to correspond. Take the stitches through all the layers of wire of the flattened trumpets to make sure that the fasteners are firmly held in position (these stitches can be covered with beads later).

fig. 4

Did you know?
Gaia theory

Gaia has given her name to a scientific hypothesis developed in the 1960s by James Lovelock, a NASA scientist – the Gaia Theory. When considering whether there was life on Mars, Lovelock looked at what constituted life on Earth. He couldn't understand why the Earth had stayed stable despite its cocktail of gasses and despite the fact that the sun's heat had increased by 25% since life began here. His theory was that Earth was a type of super-organism, and every living and non-living thing played a part in maintaining the balance.

Adding embellishment

The stitches made during the embellishment of the necklace help to support the edges of the flowers and consolidate the layers of wire and cord around the neck. Make the stitches small and neat, taking the needle through all the layers of wire on the flower edges and occasionally right through the necklace rope along the length.

1 Mix a pinch of each of the size 15/0 seed beads together ready to use at random for most of the embellishment stitches. First take a double thread and attach it to one of the outer Supa Green hems, taking a double stitch. Make random stitches, three or four beads long to encrust an area 3–5mm (⅛-¼in) deep, as shown in **fig. 5**. Finish each thread with a double stitch. Repeat the embellishment on the other trumpet. On the Vivid Green hems use two to three beads per stitch. Sprinkle a few darker beads singly around the throat of the flowers. Use all the colours of the size 15/0 beads, selecting the paler shades to highlight the edges of the flowers and a sprinkling of darker tones right in the throat of the flowers.

fig. 5

2 Move onto the outside of the flattened trumpet of the uppermost flower. Make stitches four to eight beads long randomly along the grain of the work, taking care to conceal the stitches pushed through to this surface from the attachment of the hooks. Continue the stitches up the rope of the necklace at 3–4mm (⅛-³/₁₆in) intervals, as shown in **fig. 6** and the photograph on page 45. Take care not to pull the thread too tightly or the rope will pucker. When the needle reaches the far end, turn and work back along the rope, adding a second pass of beads to fill in any large gaps along the length. Add a third pass, if required.

fig. 6

3 Lay the necklace down and check that you are happy with the fall of the flowers – you can make small adjustments now if you wish before you decide on the final length and decoration of the cords. If the flowers are heavily encrusted and fall forward, make a few stitches to hold the top edge of the flower trumpet back against the start of the necklace rope. You may wish to adjust the final shape of the flowers with a few gentle scrunches or stretches or to add a few extra beads.

4 Untie the loose knot at the end of the macramé cords. Thread some (but not all) of the cords with one or two crystal beads. Hold the crystals in place with a simple knot in the cord above and below it. Try to keep the crystals either very close to the inside of the flower trumpet or towards the end of the cords. When you are happy with the effect, trim the cord ends, making sure you leave at least 8mm (⁵/₁₆in) of cord below the lowest knot on each one. Leave some cords quite long.

Make it easy on yourself
Final cut

Do not cut any of the C-Lon cords in the necklace until the crystal beads are knotted into place and you are happy with the distribution of the beads. This is because when you knot on the beads the cords will get shorter so you won't know the final length until you have finished the beading.

Gaia Bracelet

The Gaia bracelet is a bold and striking piece that's bound to be a talking point. This time the tubes of wire are manipulated into folds to hold feature beads, while smaller beads decorate the single trumpet-shaped flower that conceals the clasp. This bracelet is 18cm (7in) around the wrist, but you can easily adjust the length.

Making the foundation

The bracelet is fashioned out of the same double layer of knitted metal tubing as the necklace, and the flower is formed in the same way. However, instead of working around cords, you will pleat the tubing in preparation for making the beaded pockets.

1 Place the Vivid Green tube inside the Supa Green tube. Now make three concertina folds along the length of the tubes to form two V-shaped grooves, as shown in **fig. 7**. Hold both tubes together at one end and start to stretch out the wire tube from this anchor point along the length until you are 6cm (2¼in) from the other end; leave this to form the flower.

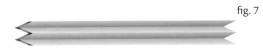

fig. 7

2 Cut 1m (40in) of 0.5mm wire. Thread a jump ring onto the end of the wire and hold it in place 15mm (⅝in) from the end by twisting the wire tight up against the ring (**fig. 8**).

fig. 8

3 Fold the stretched end of the tubing over by 1cm (⅜in) twice to conceal the raw ends. Place the wire and jump ring over the fold, as shown in **fig. 9**, so that the jump ring just falls over the end of the knitted wire. Cross the short and long ends of the wire inside the fold on the tubing and trim the short end so it is concealed within the fold.

fig. 9

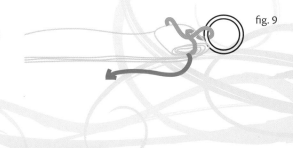

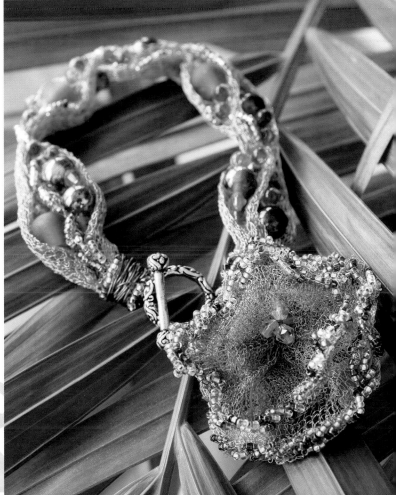

4 Now bind the long end of the 0.5mm wire over the hem of the tube to secure the jump ring and make a neat connection point for the clasp. Trim away any excess 0.5mm wire and tuck the end under the bindings (**fig. 10**).

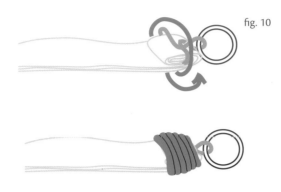

fig. 10

5 Try on the bracelet for size: the narrowest part of the flower trumpet needs to just touch the jump ring at the other end of the design. Trim and adjust the position of the flower, if necessary, by opening the stretched portion of the wire up a little to move the flower further back along the design. Following Preparing the Foundation, step 3, page 44, open up and sculpt the flower, rolling the hems along the cut edges.

6 Take 50cm (20in) of 0.5mm wire and attach a jump ring 15mm (⅝in) from the end as in step on page 47. Offer the jump ring up to the bracelet at the base of the flower. Wind the short tail of the wire over the knitted tube to hold the jump ring in place. Now bind the long end of the 0.5mm wire over the knitted wire eight to ten times to conceal the short end of the 0.5mm wire and to strengthen the connection. Trim off the excess wire and tuck the end under the bindings, out of sight.

Beading the bracelet

The flower on the end of the bracelet is beaded in the same way as the lilies on the Gaia necklace, but the length of the bracelet is formed into little pockets, or peapods and then beaded with an assortment of larger beads.

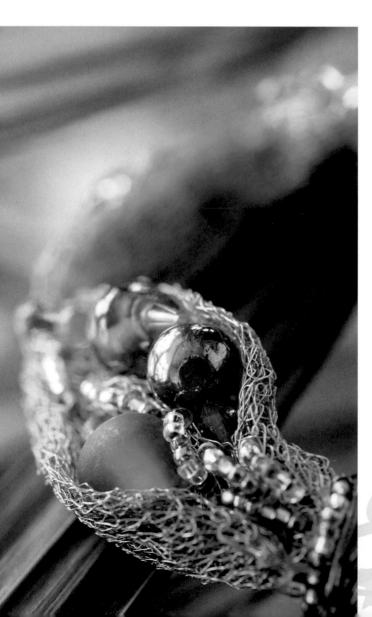

1 Bead the flower in the same way as the necklace (see page 46), adding three small drop or crystal beads pulled into the centre of the flower to complete it.

2 Tease open the concertina folds in the main bracelet and pinch the folds into shorter pockets or peapods. Starting at one end of the bracelet with a double stitch and a 1m (40in) length of double thread, thread on the beads for the first pod and lay them into the groove. Stitch through to the back of the pod and turn the needle. Now stitch the folds of the tubing together in a vertical seam between this pod and the next, as shown in **fig. 11**.

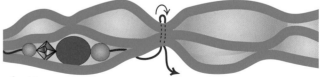

fig. 11

3 Bring the thread through from the underside of the seam up into the corner of the next pod. Work to the end of the bracelet, adding beads into the pods as you go, then turn and work back along the bracelet, opening up further pods as you go. At the far end, run a line of 15/0 beads around each side of the 0.5mm wire wrappings to neaten them.

4 Now turn the needle to make a final pass along the top of the bracelet. On this final pass add small embellishing stitches of size 15/0 beads along the pod edges where required and ensure that all the larger embellishment beads are held securely. At the far end, fold the edge of the flower back onto the length of the bracelet and hold it in place with a few stitches – this will conceal the clasp binding. Attach the clasp to the jump rings to complete the design.

Gaia Earrings

If you are drawn to Gaia's earthy side and her symbolism as a source of life, you'll love these pretty earrings in the shape of flowers that seem to exude life. As you move, the beaded cord stamens will swing and sway to catch the eye and create a greater sense of energy. These earrings are cleverly shaped simultaneously from one length of double tubing, which speeds up the whole process.

You will need

Bead Box

14 crystal bicones, 4mm

15cm (6in) of 80mm (3in) wide tubular wire, each in Vivid Green and Supa Green, 0.1mm tight knitted

Fabulous Findings

8 lengths of C-Lon macramé cord 30cm (12in) long

1.50m (60in) of Vivid Green 0.5mm (24-gauge) wire

2m (2¼yd) of 0.2mm or 0.315mm wire (22–32-gauge) to match the knitted wire

Pair of ear wires or other earring fittings

Tools

Wire cutters

1 Take a 15cm (6in) length of Vivid Green knitted wire and slip it inside a piece of Supa Green knitted wire the same length. Slip eight lengths of C-Lon macramé cord 30cm (12in) long through the centre in the same way as for the necklace (page 44). Stretch out the central 5cm (2in) of tubing, making the middle quite thin. Now cut the piece in half to give two equal parts for the earrings.

2 Working on one earring at a time, take 75cm (30in) of 0.5mm wire and pass the end through the wire knitting 20mm (¾in) from the stretched end. Fold the last 12mm (½in) of the cut end of the knitted wire over.

3 Slip an ear fitting onto one end of the 0.5mm wire and bring this wire end over the fold in the tube just made to position the ear fitting at the top of the earring – put a little twist into the wire to hold the ear-fitting in place and trim the excess length. Pick up the other end of the wire and bind the top of the trumpet to cover all of the knitted fold and the other end of the 0.5mm wire. Trim the excess wire and tuck the end under the bindings.

4 Fan out the other end of the knitted wire to form the flower, rolling a simple narrow hem on each layer, as before. If you want to leave the edges of the flower undecorated, as shown, run a simple running stitch of fine wire through the edges to prevent them from unravelling. Otherwise embellish the edges with beads as on the necklace (page 46). Slip a crystal bicone onto some of the cord ends, placing one knot before the bead and one after it to hold it in place. Trim the cords as desired.

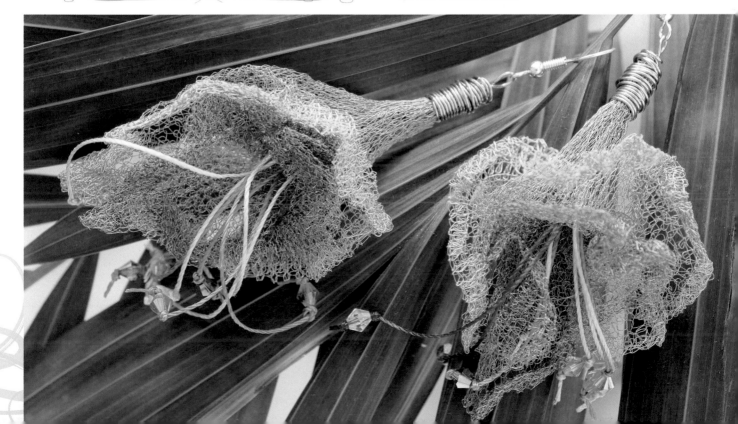

Inspirations

The blue-green colours of the Gaia jewellery capture the sense of creation and growth that we wanted to express, but that shouldn't stop you making it in other colours, if desired. The dramatic black and red combination used here, for example, looks very elegant and would look great with that little black dress. You'll also notice the quick alternatives to the Gaia earrings, made in pink and lilac wire, which don't have the cord stamens but instead have a few larger beads to suggest the internal workings of the flower.

Eris Necklace ◈ ◈ ◈

Eris was the goddess of strife and the personification of discord who indirectly started the Trojan War after someone forgot to invite her to a wedding but she turned up anyway…. She would appreciate this dramatic black and red combination made by placing a Vivid Red wire tube inside a Black one, with black and dark red C-Lon cord in the centre.

Making the necklace

Follow the instructions for the Gaia necklace, Preparing the Foundation on pages 44–45 and then decorate the ends of the cord at one end of the design. About 8cm (3in) back from the decorated ends knot all of the cords together. Gently pull the cords back up into the throat of the trumpet until the large knot is concealed. At the other end of the design fold back the wire trumpet so you can make a knot in these cords as close as possible to the inside of the trumpet. Fold the flower back into place and decorate these cord ends to finish around 8cm (3in) long.

This necklace will only need one hook-and-eye clasp, as it is not as heavy as the main Gaia project. Attach the clasp and decorate the back of the trumpets and the necklace rope with small stitches of size 10/0 black seed beads.

Eris Bracelet ❖❖❖

The Eris bracelet does not feature the flower of the Gaia bracelet, but the bold colour combination of red and black makes this equally, if not more, eye catching. Both ends are bound in wire and we have used a beautiful sterling-silver toggle fastener to complete it. We used a number of drop-shaped beads, both 4 x 6mm and 10 x 6mm as they give an impression of depth to the pods. Make sure that you have a few lustred or AB beads in there as well for extra sparkle and then finish with size 10/0 seed beads for surface texture.

❖❖ Aphrodite Earrings

Aphrodite was the Greek goddess of love and beauty, though she was also unfortunately extremely vain and sometimes jealous. She would love this pink version of the Gaia earrings made with Pink and Supa Lilac wire and decorated with size 15/0 seed beads, equivalent in colour to DB902, DB071 and DB056 Delica beads. These earrings don't have the cord stamens like the Gaia version. Instead, a few tanzanite crystal bicones are pulled up into the throat of the flower as a focal point.

Dryad
Tree nymph

A dryad is a tree nymph from Greek mythology associated specifically with oak trees. Beautiful and elegant, she is the feminine to the oak tree's masculine. She symbolizes beauty and harmony with nature and all the qualities we associate with trees – tranquillity, longevity, endurance and fertility. These are also the qualities you'll be expressing when you wear this necklace or the simpler pendant (see page 60).

The Dryad Necklace uses many small beads formed into leaf and fern shapes and utilizes the colours of the oak – greens and autumnal reds, browns and golds.

If the Dryad colours don't express your lively personality or mood, turn to page 62 where you'll find a tropical colourway to set you sizzling. Here you'll also find instructions for making a tropical flower to adorn the pendant or other items as well as instructions for making a quick pair of fern earrings.

Let this magical necklace transport you to a woodland grove where sunlight plays over the leaves of the oaks and other trees, where birds softly call to each other and you can feel an absolute peace.

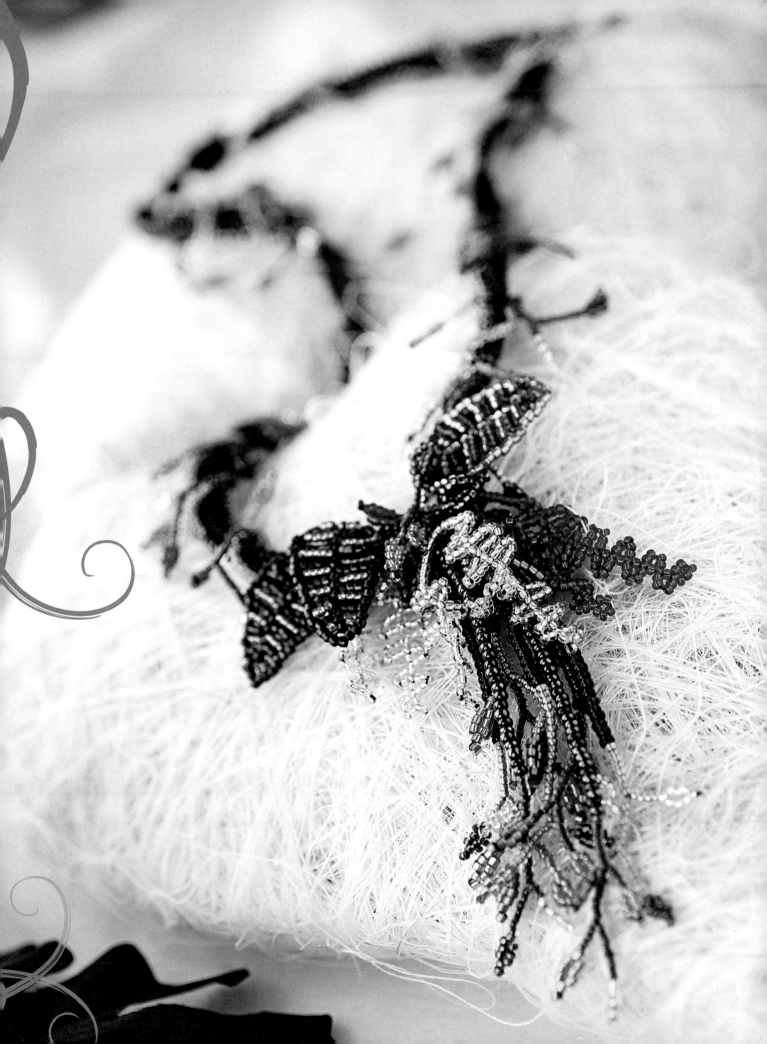

Dryad Necklace

You'll feel like a woodland queen in this verdant necklace, alive with stems, leaves, buds and tendrils. It is formed around a central rope that is then entwined with a leafy vine, embellished with budding strands and finally adorned with some beautiful leaf shapes at the front. Wear it with casual or party clothes whenever you want to express your connection with nature or to suggest your mystical side.

Making the rope

The Dryad Necklace is formed around a central herringbone-stitch rope, which is worked in two halves that meet at the centre front and are joined to form short twig-like tassels. You'll use only the first two seed beads, A and B.

1 Prepare the needle with 1.5m (60in) of single thread and tie a slipknot 15cm (6in) from the end. Thread on 1A, 1B, 1A and 1B. Pass the needle through the first A bead once more to bring the four beads into a ring, as shown in **fig. 1**.

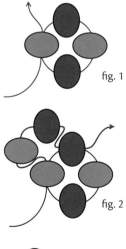

fig. 1

2 Thread on 1A and 1B. Pass the needle through the following B bead on the ring to bring the new beads into the gap (**fig. 2**).

fig. 2

3 Pass the needle through the next A bead around the ring and thread on 1A and 1B. Pass the needle through the following B bead, as shown in **fig. 3**. This completes the first row around the ring – at the moment the beads lie flat – the next row will bring them up into the start of the rope.

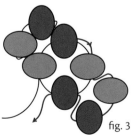

fig. 3

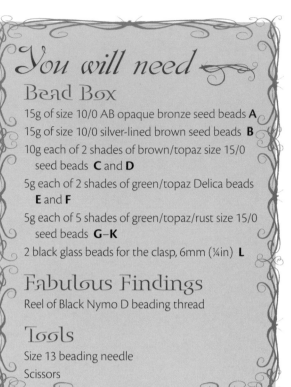

You will need

Bead Box

15g of size 10/0 AB opaque bronze seed beads **A**

15g of size 10/0 silver-lined brown seed beads **B**

10g each of 2 shades of brown/topaz size 15/0 seed beads **C** and **D**

5g each of 2 shades of green/topaz Delica beads **E** and **F**

5g each of 5 shades of green/topaz/rust size 15/0 seed beads **G–K**

2 black glass beads for the clasp, 6mm (¼in) **L**

Fabulous Findings

Reel of Black Nymo D beading thread

Tools

Size 13 beading needle

Scissors

Did you know?
The mighty oak

The oak tree was once the most revered of all trees. It was sacred to the Greeks and druids, while the Celts habitually gathered under an oak to administer justice. Because oak trees often got struck by lightening and yet survived, the Norse people believed that they channelled the power of the gods, especially Thor, god of thunder. It is even said that the oak was the first tree created by God and in the past preachers would make their sermons beside one, hence the term 'gospel oak'.

4 Pass the needle through the first A bead of the previous row and thread on 1A and 1B. Pass the needle through the following B bead of the previous row, as shown in **fig. 4**; pull the thread quite firmly to bring the two sides of the rope up together.

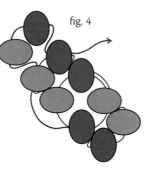

fig. 4

5 Pass the needle through the following A bead of the previous row and thread on 1A and 1B. Pass the needle through the last B bead of the previous row to complete this row. Repeat steps 4 and 5 until the rope reaches from the centre back of the neck to the centre front, allowing a drop of four or five rows. Leave the thread end attached.

6 Start a second rope. Referring to **fig. 5** below, make this second rope a few rows longer than the first rope. Three rows back from the centre-front end of the shorter rope link the two ropes together with a few stitches. Leave the thread end attached, as before.

7 To add the clasp, return to the slipknot at the start of the first rope. Re-attach the needle to this end and thread on 1B, 1A, 1L, 1A, 1B, 1A, 1L, 1A and 3B. Turn the needle and pass it back down the last A bead threaded and the following seven beads to emerge at the end of the rope, as shown in **fig. 6**. Pass the needle into the beads of the rope and finish the thread securely.

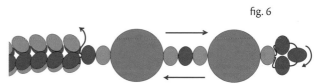

fig. 6

8 Attach the needle to the start of the second rope and thread on 1B, 1A and sufficient B beads to make a loop that will just fit over the L beads of the other end (approximately 16B). Pass the needle through the last A bead threaded and the following B bead to pull up the loop, as shown in **fig. 7**. Finish the thread securely as before.

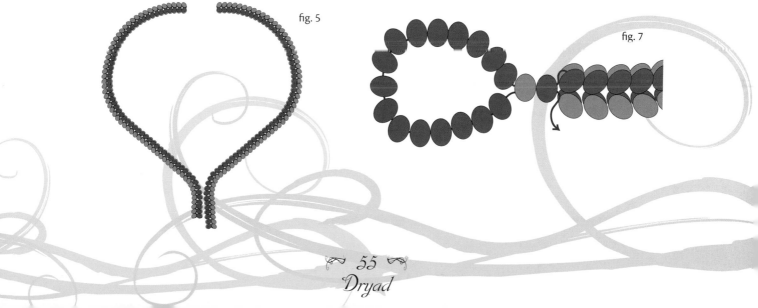

fig. 5

fig. 7

Creating the vine

The vine twines around the rope in a series of leaves and twigs. Use C and D beads for the twigs and E, H and I beads for the leaves – or choose your own colour combinations. Put J and K aside for now.

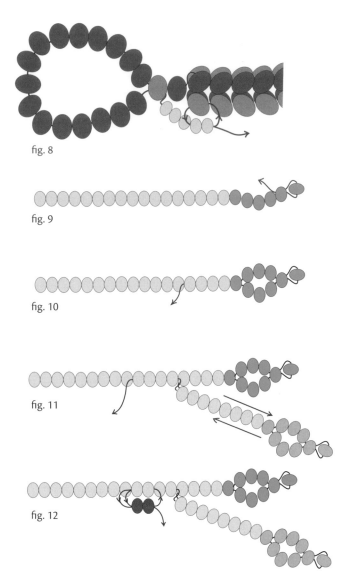

fig. 8

fig. 9

fig. 10

fig. 11

fig. 12

1 Prepare the needle with 1.5m (60in) of single thread and attach it to the rope so that the needle emerges pointing towards the centre front through the A bead just below the bead loop. Thread on 5C. Turn the needle and pass it through the first A bead at the end of the rope. Turn the needle back and pass it through the last 2C of the 5C just added, as shown in **fig. 8**.

2 Thread on 20C and 6E. Turn the needle and pass it back up through the fifth E bead threaded to bring the end bead up into an anchor (**fig. 9**).

3 Thread on 3E. Pass the needle up through the first E bead of the sequence and the next 4C beads (**fig. 10**).

4 Thread on 8C and 6F. Complete the leaf as before, bringing the needle back up through the 8C beads of the leaf stem and a further 4C beads of the main stem (**fig. 11**).

5 Thread on 2D. Pass the needle through the last 2C beads threaded through once more and the 2D beads just added, as shown in **fig. 12**, to bring the two sets of beads parallel to one another. These 2D beads will link back to the main necklace rope before the vine grows further.

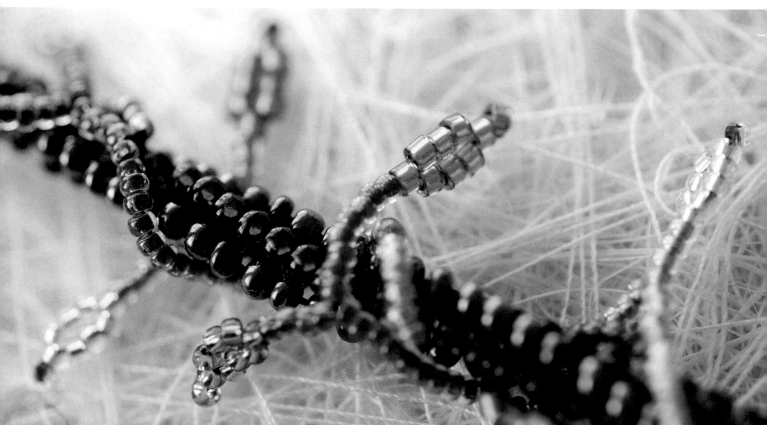

6 Count 6A beads down the rope and two beads around the rope to locate the second A bead on this row of the rope. Following **fig. 13** below, turn the needle and pass it through the located A bead on the rope. Turn the needle back and pass through the 2D beads to point in the direction of the work.

fig. 13

7 Repeat steps 2–6 using D beads instead of C beads and substituting G and H for the E and F beads used previously. Make the two-bead link stitch in C beads instead of D beads and link back to the necklace rope 6A along and two beads around the rope to continue to wind the vine around the rope. Work down the rope, alternating the C and D beads and working through the leaf beads from E to I.

8 Work the vine up to the join at the front of the necklace, finishing with a looped stitch as at the end of step 6. Finish off the thread end securely. Repeat from the other side of the clasp to bring a second vine down to meet the first at the centre front.

Adding the long strands

Eight long strands hang from the end of the two necklace ropes at the centre front to create a focal point and to add weight and form. A leaf of any colour, E–K, hangs from each branch of the strands.

1 Re-attach the needle to one of the threads left hanging at the centre front of the design. If necessary, pass the needle through the beads of the rope to emerge through an A or B bead at the very bottom of the rope. If the needle emerges through an A bead, thread on 20A (or a B bead 20B), 24C and six leaf-colour beads of your choice. Referring to **fig. 14**, make the leaf as before, bringing the needle back up through 8C beads above the top of the leaf. Make a side branch here 4C long with a leaf at the end. Make a second side branch 8C further up the main stem 4C long using a third-colour leaf at the end. Pass the needle back up to the top of the beads added and into the end of the rope.

fig. 14

Make it easy on yourself
Start smaller

The Dryad Necklace is one of the more complicated projects in the book. If you aren't feeling confident, make the matching bracelet (page 61) first. This combines the rope and vine elements of the necklace and once you have made this, you'll find making the necklace much easier.

2 Pass the needle down an adjacent column of A or B beads to begin a second tassel strand. Make this strand with 15A or 15B (depending on where you start) and 24D, adding three leaves of assorted colours as in step 1.

3 Repeat from the final two beads at the end of this rope, starting one with 10A or 10B beads and the other with 5A or 5B beads. Finish off the thread end securely. Repeat at the bottom of the other rope. If desired, you can now add further leaves to the front, as described on pages 58–59.

Applying the leaves

The leaves that sit at the throat of the necklace come in three forms: fern shapes, leaf clusters and broad leaves. It's great fun making these different leaves in various colours – your problem will be knowing when to stop.

1 To make **fern-like leaves**, choose a colour of 15/0 beads and prepare the needle with 1m (40in) of single thread. Tie a slipknot 10cm (4in) from the end; thread on 26 beads. Turn the needle and pass it back up through the next bead back to bring the last bead up into an anchor, as shown in **fig. 15**.

2 Thread on four beads. Pass the needle back up through the next but one bead of the main strand (**fig. 16**).

3 Thread on four beads and pass the needle up through the next but one bead up the main strand to make a lobe to the other side of the main strand. Thread on five beads and repeat (**fig. 17**). Repeat the last stitch on the other side of the main strand. Continue up the main strand to make two stitches with six beads, two with seven beads and two with eight beads. Taper the top of the shape with a six-bead and a four-bead stitch. Bring the needle out of the top bead of the main strand.

4 If desired, make a second frond from the top of this one. Thread on 15–30 beads depending on how long you want the frond to be. Work back up the frond adding side lobes, as before. A third and fourth frond can be added in the same way. Leave the thread attached.

5 To make a **leaf cluster**, prepare the needle with 1m (40in) of single thread and tie a slipknot 10cm (4in) from the end. Thread on 9C and 8 beads from the selection E–K. Turn the needle and pass it back up the seventh leaf bead to pull the end one into an anchor, as shown in **fig. 18**.

6 Thread on six matching beads. Pass the needle down the last six beads of the central stalk, as shown in **fig. 19**, to emerge beside the anchor bead at the bottom.

7 Turn the needle and pass it through the anchor bead and back through the next bead; thread on six matching beads. Pass the needle up the first leaf bead threaded and the following 9C beads up to the top of the strand, as shown in **fig. 20**. Make a second strand with 4–15D beads and a different colour leaf bead. Make up to five or six strands in a spray. Leave the thread end attached.

8 To make a **broad leaf**, use one colour of Delica bead (E or F) and a contrast size 15/0 (G to K). Prepare the needle with 1m (40in) of thread and tie a slipknot 10cm (4in) from the end. Thread on 18E (or 18F). Turn the needle and pass it back up the fourth and fifth beads from the end to pull the last three beads into an anchor (**fig. 21**).

9 Thread on 2E. Turn the needle and pass it back through the first E bead just added and the next E bead back along the main strand, as shown in **fig. 22**.

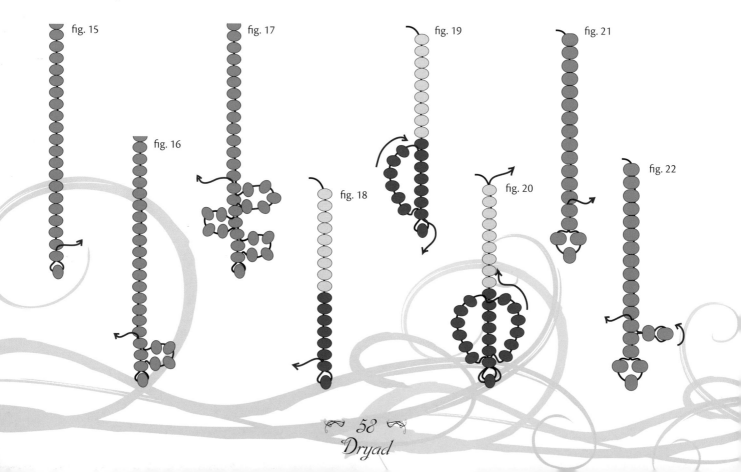

fig. 15

fig. 16

fig. 17

fig. 18

fig. 19

fig. 20

fig. 21

fig. 22

10 Work further leaf veins following **fig. 23**, right, bringing the needle out through the top E bead.

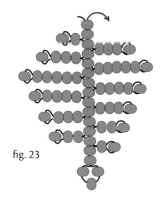

fig. 23

11 Referring to **fig. 24** below, thread on 4E and pass the needle through the end E bead of the last 4E vein. Thread on 2E and pass the needle down the end E bead of the next vein along. Repeat, threading 2E between each vein down this side of the leaf but use 3E between the last side branch and the anchor at the bottom of the leaf. Run the needle through the 3E beads of the anchor, thread on 4E and pass the needle up through the end bead on the lowest branch on the second side of the leaf. Thread 2E between each branch on this side of the leaf, finishing with 3E. Finally, pass the needle down the top 2E beads of the main stem.

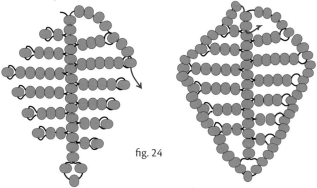

fig. 24

12 To fill the gaps between the veins thread on 3G (or H, I, J or K) and pass the needle through the E beads either side of the end of the branch and the E bead at the end of the branch, as shown in **fig. 25**. Following the arrows in the diagram, thread on 5G and pass the needle through the two E beads either side of the other end of the next branch along. Thread on 5G for the next gap; 4G for the next; 3G for the next; 2G for the next and 1G for the last gap, passing the needle through the E bead above the three anchor beads. Pass the needle around the beads of the anchor and up through the next 2E.

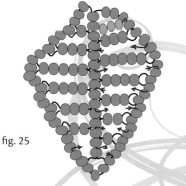

fig. 25

13 Now work back up the other side. Thread on 2G and pass the needle up through the E beads on the main stem either side of the next side branch. Fill the next gap with 3G; the next with 4G; the next with 5G; the next with 4G; the next with 2G and the last gap with 1G, bringing the needle up through the last E beads of the main stem. Leave the thread ends attached.

14 Make several versions of the three types of leaves in different colours. Arrange them along the top edge of the centre front of the design, layering the leaf clusters of different lengths one on top of another. When you are happy with the effect, slipstitch the leaves into place and finish off all the ends neatly.

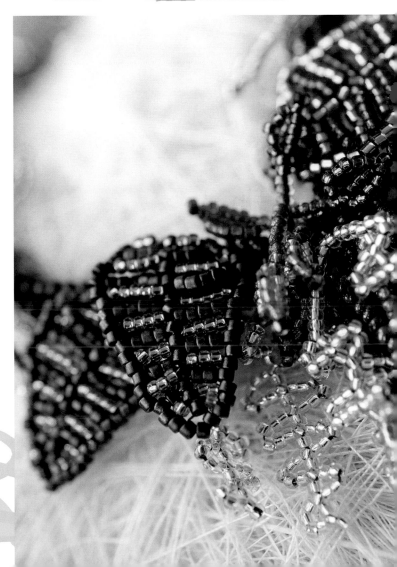

Dryad Pendant

If you like the Dryad Necklace but want something that's quicker and easier to make, then look no further than this pretty pendant. It's attached to a plaited cord in three contrasting colours, which can either match the colours of the beads or your favourite outfits. You can incorporate any of the leaf shapes from the necklace, choosing just one type or more to make a truly personalized item.

You will need

Bead Box

4g of size 10/0 AB opaque bronze seed beads **A**

4g of size 10/0 silver-lined brown seed beads **B**

3g each of 2 shades of brown/topaz size 15/0 seed beads **C** and **D**

3g each of 2 green/topaz shades of Delica beads **E** and **F**

3g each of 5 shades of green/topaz/rust size 15/0 seed beads **G–K**

Fabulous Findings

11cm (4½in) of 0.8mm (20-gauge) half-hard wire

6 lengths of C-Lon macramé cord in 1–3 contrasting colours, each 1m (40in) long

2 medium-sized box-shaped lace ends

Clasp

Reel of Black Nymo D beading thread

Tools

Size 13 beading needle

Scissors

Round-nosed pliers

Make it easy on yourself
Change the cord

The pendant is attached to a pretty plaited cord made from C-Lon macramé cord, but you can easily substitute other materials – what about suede or leather thonging or organza ribbon? You could even buy a finished neck cord so that you don't have to bother about adding the ends and clasp.

1 Make 9cm (3½in) of herringbone rope following steps 1–5 on pages 54–55. Now make long strands attached to each end of the rope as explained on page 57, making them shorter than on the necklace with just two leaves on each strand.

2 Make a small loop at the end of the half-hard wire. Thread the unlooped end through the centre of the rope, pulling the loop up snugly to one end of the rope and concealing it within the strands. Trim any excess wire from the other end and make a loop. Conceal this loop in the end of the rope. Curl the rope around to make an upside down drop shape, crossing the two ends over so the strands fall as a fringe, as shown in **fig. 26**. Make a few stitches to secure the rope together where the two sides cross over one another.

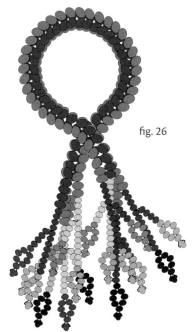

fig. 26

3 Make an assortment of leaf shapes in various colours as explained on pages 58–59. Arrange the leaves on the rope and stitch into place where the rope crosses, building up the density of forms by lying one cluster of leaves on top of another.

4 Pass the macramé threads through the top of the pendant loop. Bring the cords together above the pendant to make a bundle of 12 strands.

5 Prepare the needle with 60cm (24in) of single thread and tie a slipknot 10cm (4in) from the end. Thread on 9A. Wrap the thread around the bundle of macramé cords and pass the needle through the first A bead of the 9A just added to bring the beads into a tight ring around the cords. Run the needle through the following 8A to bring the needle alongside the slipknot. Untie the slipknot and tie a secure double knot between the two ends of the thread. Neaten the ends by passing them through a few beads of the ring and trim. Make a second ring in B beads and a third in A beads to stack up above the pendant.

6 Divide the bundle of threads into two groups of six. Make a three-strand plait (3 x 2 cords on each side) out to each side of the pendant to form the neck cord. When the cord is the required length, bind the end of the plait tightly with a small length of beading thread. Attach a box lace end to each side over the bindings (see page 125), trim the excess thread length and add a clasp.

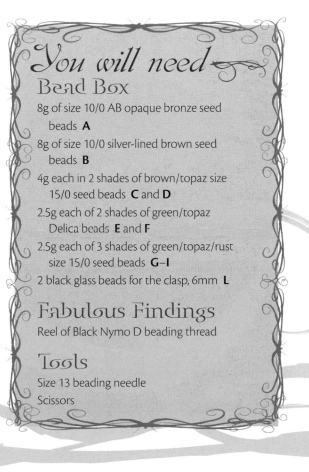

Dryad Bracelet

This lovely bracelet would suit a budding wood nymph of any age, and it's a delight to make. The colours are those of a spring woodland, but you can easily choose autumnal reds, browns and gold for the leaves if that suits you better or even introduce silver and blues for a wintry effect. Alternatively, see the tropical version on page 63.

1 Make a length of herringbone rope to fit your wrist following the instructions for the necklace beginning on page 54 – you will only need one rope. Make the clasp at the end following steps 7–8 on page 55.

2 Make the vine as explained on pages 56–57, alternating the C and D beads and using the E, F, G, H and I beads in rotation down the length.

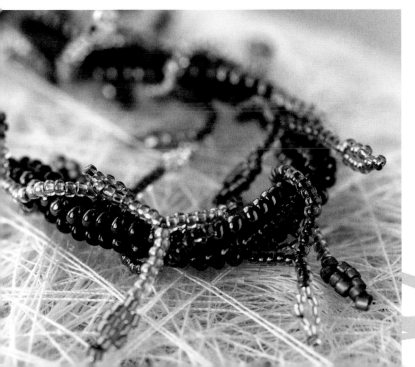

You will need

Bead Box

8g of size 10/0 AB opaque bronze seed beads **A**

8g of size 10/0 silver-lined brown seed beads **B**

4g each in 2 shades of brown/topaz size 15/0 seed beads **C** and **D**

2.5g each of 2 shades of green/topaz Delica beads **E** and **F**

2.5g each of 3 shades of green/topaz/rust size 15/0 seed beads **G–I**

2 black glass beads for the clasp, 6mm **L**

Fabulous Findings

Reel of Black Nymo D beading thread

Tools

Size 13 beading needle

Scissors

Inspirations

When you are in a party mood or feel uplifted and energized you'll want to express it in colour. These tropical variations of the Dryad jewellery suggest liveliness, enthusiasm and a vivacious personality. They make great party wear and will brighten up even the darkest of winter days.
Exotic flowers flourish in tropical conditions, so we have included a pretty flower on the pendant and hairpin, made by adapting the large leaf pattern from the Dryad Necklace.

Tropical Pendant ◆◆◆

Take yourself to the Tropics with this sizzling pendant in lime green, emerald orange, pink and red. It is made in the same way as the Dryad Pendant (page 60), using two shades of silver-lined lime green size 10/0 beads (one is a plain finish and the other is AB) for the rope, and silver-lined gold and emerald size 15/0 seed beads for the strands. The leaves shown are made from silver-lined bright orange, bright pink and bright lime Delica beads and silver-lined red size 15/0 seed beads, with bright pink Delica beads for the two fern fronds. The cord is not plaited but the cord ends do need to be bound with beading thread before attaching a clasp to ensure that all of the threads are held firm.

Making the flower

For each petal make the broad leaf (page 58) in a slimmer shape, as shown. Make the veins in orange Delica beads but use size 15/0 red seed beads to join up the edge of the petals and use the same beads to fill in the gaps between the ribs. Make five petals then slipstitch the bottom four beads on each petal edge to its neighbouring petal to stabilize the shape and finish off all but the longest of the thread ends. Use this long thread to make a few stitches across the hole in the centre of the flower to partially close the space. Add six stamens of size 15/0 seed beads and 4mm crystal bicone beads, pulling the thread quite tightly to make the stamens form straight rods.

◈ Fern Earrings

Using just three colours of size 15/0 silver-lined seed beads, these elegant earrings are very quick to make. Artistic and unusual, they are ideal for many occasions. Wear them on their own or team them with any of the other Dryad pieces.

Making the earrings

Starting with a 1.5m (60in) thread, tie a 4mm (³/₁₆in) jump ring 10cm (4in) from the end. Thread on sufficient seed beads to make the longest strand and fern leaf, adding a 4mm crystal bead just above the top of the 26 leaf beads. Make the fern leaf as on page 58, bringing the needle back up through the 4mm crystal to the top of the strand. Pass the needle through the jump ring and thread on the beads for the second strand and leaf. Anchor the top of this leaf strand by passing the needle through the jump ring at the top once more before making the third strand. Finish off both ends of the thread securely. Link the jump ring onto the ear-fitting using an eyepin and a fourth 4mm crystal bead.

Tropical Hairpin ◈

The flower used in the Tropical Pendant, opposite, could be used to embellish all sorts of items. Here one has been attached to a hairpin, but it would also work well as a brooch or charm or used for a lapel pin or hat decoration.

Tropical Bracelet ◈◈◈

This vibrant bracelet is made in the same way as the Dryad Bracelet but using the colours of the Tropical Pendant, left. You could also try substituting some of the woven leaves with small flower-shaped glass beads or bug-shaped charms for a jungle feel.

Morgan le Fay
Healer & sorceress

Morgan le Fay, half-sister of the legendary King Arthur, was insightful, passionate, complex, contradictory and caring, and had a notorious love-hate relationship with her brother. Inspired by the beautiful paintings of the Pre-Raphaelites, we wanted to evoke thoughts of the richly coloured and highly decorated pieces of the courtly world of Arthurian and Medieval legend.

The fabulous necklace, bracelet and cloak brooch are made from deep jewel-coloured fire-polished beads encircled by seed beads for a lavish effect. You'll certainly feel like royalty wearing them, and although they are the most challenging pieces in the book, the reward is jewellery that is a joy to hold and wear that will always make a strong statement.

At the end of this chapter we have included some additional pieces inspired by the Morgan jewellery. These can be found on pages 72–73.

This stunning jewel-bright necklace will be the Crown Jewels of your collection. Wear it to summon your dark, passionate side and to feel like royalty.

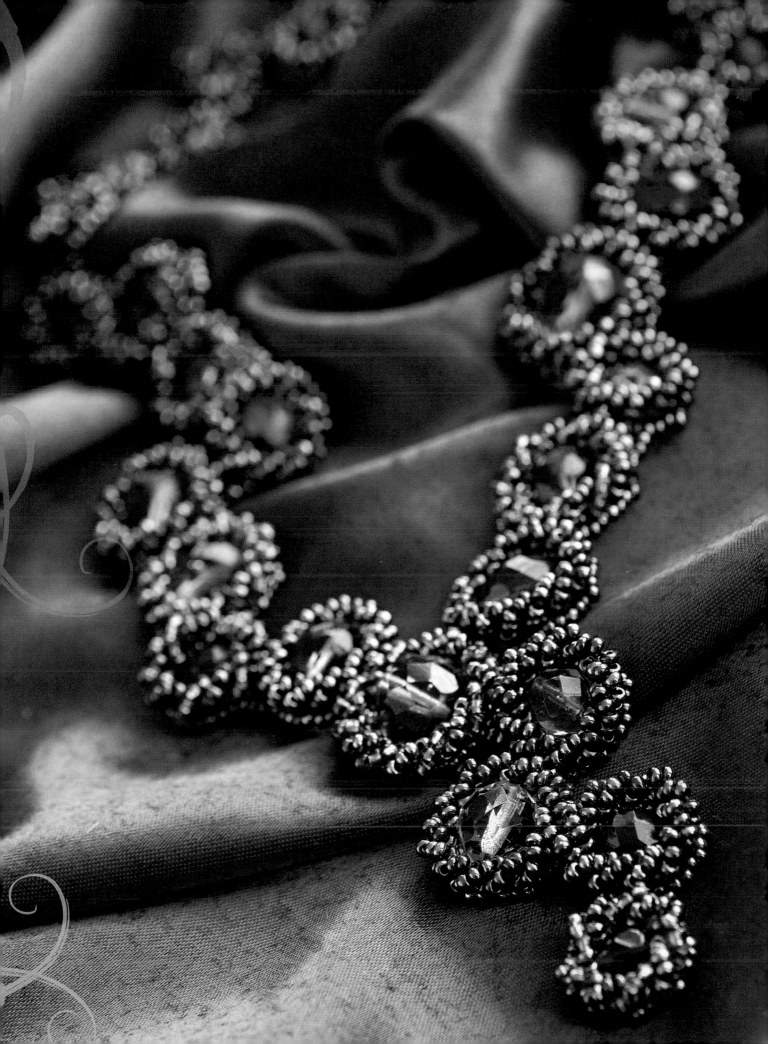

Morgan le Fay Necklace

Made from deep, jewel-coloured, fire-polished beads encircled by seed beads, this regal necklace encases the neck exquisitely. It is constructed from an undulating series of beadwork rondelles that are simply joined together to make the shape. Wear it whenever you want to be queen of the moment.

You will need

Bead Box

Approximately 35 assorted 6mm, 8mm, 10mm and 12mm fire-polished beads in jewel colours (we used 9 at 6mm, 10 at 8mm, 10 at 10mm and 2 at 12mm for a finished length of 41cm (16in)

25g of size 10/0 AB opaque bronze seed beads **A**

10g of size 10/0 AB opaque purple seed beads **B**

5g of size 10/0 dark gold silver-lined seed beads **C**

Fabulous Findings

Small haberdasher's hook-and-eye fastener

Reel of Black Nymo D beading thread

Tools

Size 13 beading needle

Scissors

Paper and pencil

Did you know?
A woman's revenge

Morgan le Fey is often depicted as trying to plot the downfall of King Arthur and the Knights of the Round Table. In fact, her main fight was with queen Guinevere who told the king of Morgan's love affair with Giomar, the king's nephew, thus breaking up the relationship. Later, when she got the chance, Morgan paid Guinevere back in kind by telling Arthur about his wife's affair with Lancelot.

Making the rondelles

A rondelle is a bead shaped like a flattened round bead. You'll be making your own rondelles from round beads surrounded by rings of seed beads. Work one rondelle using each size of fire-polished bead so you can see what they are going to look like, then make more and join them together to create the undulating necklace.

1. Decide on the finished length of the necklace. Draw a life-size outline of the necklace onto a piece of paper, as shown in **fig. 1**. As you make the rondelles, place them down onto the outline to assess the arrangement of the different sizes and colours in relation to one another.

fig. 1

2. To make a rondelle from a 6mm bead, first prepare the needle with 1m (40in) of single thread. Thread on one 6mm fire-polished bead and hold it 10cm (4in) from the end of the thread. Thread on 8A. Pass the needle through the large bead again to bring the 8A beads into a strap around the side of it, as shown in **fig. 2**. Thread on 8A and then pass the needle through the large bead once more to make a second strap on the other side of the bead (**fig. 3**).

fig. 2

fig. 3

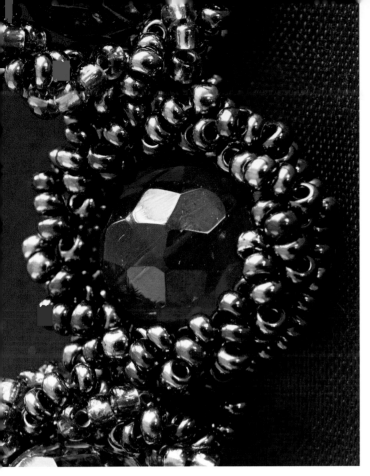

6 Thread on 3A. Referring to **fig. 7** below, pass the needle back through the first of the 3A beads added in the previous stitch, turn the needle and pass it through the second A bead of the 2A beneath this bead and the following four beads. Repeat around the remainder of the ring (27A).

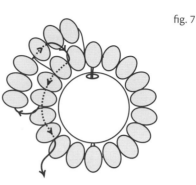

fig. 7

7 To close up the ring, pass the needle back through the first 3A beads of this round, but if there is a gap, as shown in fig. 8, add 1A or 2A to fill it first.

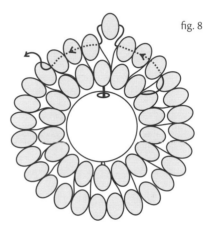

fig. 8

3 Pass the needle through the 8A beads on the first side of the large bead and thread on 1A. Pass the needle through the first A bead of the other side to bring the new A bead in to sit in the gap between the ends of the two straps (**fig. 4**).

fig. 4

4 Pass the needle through the remaining 7A beads of this strap and thread on 1A. Pass the needle through the next 2A, as shown in **fig. 5**, to complete a circle of 18A beads around the central 6mm bead.

fig. 5

5 Thread on 3A. Pass the needle through the first 2A beads of the first ring once more to bring the new 3A beads to sit parallel to the 2A beads (**fig. 6**). Pass the needle through the next 2A beads of the first ring.

fig. 6

8 Pass the needle forward through the adjacent A bead on the inner ring. Thread on 5A. Referring to the diagram below, count 3A beads back around the first ring. Pass the needle through this bead and the following 4A of the inner ring to emerge 2A past the start position for this stitch (**fig. 9**).

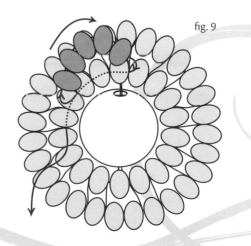

fig. 9

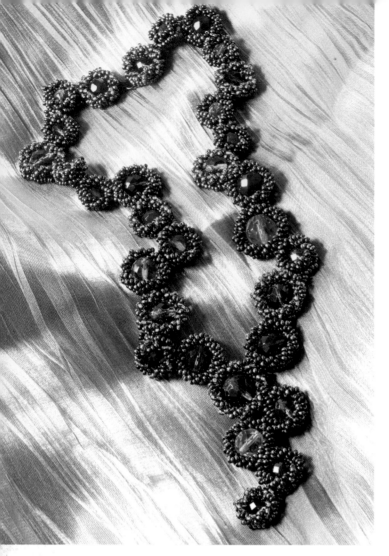

10 **To work around an 8mm bead**, start as for the 6mm bead but make the strap around each side 10A long. You will need 2A beads to sit between the straps at each end of the 8mm bead to make the first ring 24A around. Start the second ring as for the 6mm bead with two 3A stitches. Make the third stitch with 2A only. Repeat these three stitches to the end of the ring (32A). Finish off the ring as before, adding a few extra A beads, if necessary, to fill any gap. Make the rope effect on the inner ring as before but substitute the B beads for C beads. (The ropes around the 8mm bead will alternate properly around the completed ring. The two larger sizes will work out in a similar fashion.)

11 **To work around a 10mm bead**, start as for the 6mm bead but make the strap around each side 12A long. Use 2A beads to sit between the ends of the straps as for the 8mm rondelle. Make the second ring as for the 8mm rondelle. Make the rope effect on the inner ring but increase the bead count to 6A for the first stitch and 6C for the second stitch – this increase deepens the rope around the larger bead.

12 **To work around a 12mm bead**, start as for the 6mm bead but make the strap around each side 14A long and fill in with 2A at each end. Make the second ring as for the 8mm and 10mm rondelles. Make the rope effect on the inner ring as for the 10mm rondelle.

13 Work through half of the fire-polished beads in your selection. Make approximately one third of the rondelles with A and C bead rope edges and the rest with A and B bead rope edges.

14 Lay the prepared rondelles out on the paper pattern made earlier – offset the rondelles slightly from the smooth line of the pattern to give an irregular profile to the necklace. You should now be able to assess which colours and sizes of rondelles you need to complete from the remainder of your selection to give a balanced design. The two halves of the necklace do not have to be symmetrical but try to keep the majority of the larger rondelles towards the front of the design. Complete the sequence with one 8mm rondelle at each side of the centre-back position.

9 Thread on 5B. Referring to **fig. 10** below, count 3A beads back around the first ring. Pass the needle through this bead and the following 4A to emerge 2A past the start position for this stitch. Make sure that this stitch lies to the outside of the previous stitch. Repeat the process from 'Thread on 5A' in steps 8 and 9 three more times. The last stitch is a repeat of the 5A stitch – make sure that the needle starts on the inside edge of the rope and finishes on the outside edge to complete the twist effect right around the central bead. Finish off the thread ends without blocking the holes in the beads of the outer ring. (When completed, the first and last rope stitches will be in the same colour.)

fig. 10

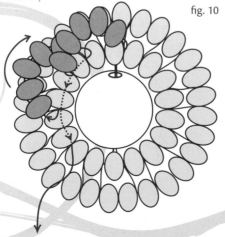

Linking the rondelles

Now that you've made the rondelles and you have them laid out on your paper pattern, it's time to link them together. Take your time over this stage and follow your plan carefully.

1 Start at the top of the pendant portion of the design. Prepare the needle with 1.5m (60in) of single thread and attach it to the outer ring of A beads on the reverse of the rondelle at the top of the pendant. Place the rondelle back on the paper pattern and rotate the rondelle until the needle position corresponds with an adjacent rondelle. Pick up both rondelles and place them back-to-back. Make a secure stitch between the two outer rings of the two rondelles (fig. 11) to link the two rondelles together closely. Repeat the stitch between the next 2A beads around the outer rings.

fig. 11

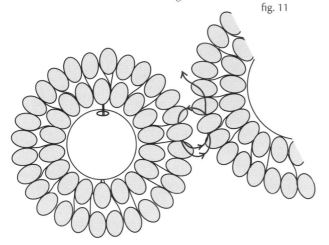

2 Pass the needle through the next A bead around the rondelle ring. Thread on 2A. Pass the needle through the corresponding A bead on the other rondelle to strengthen the link. Repeat at the other side of the join, as shown in **fig. 12**. Run the needle through the stitches of the join once more to reinforce the link.

fig. 12

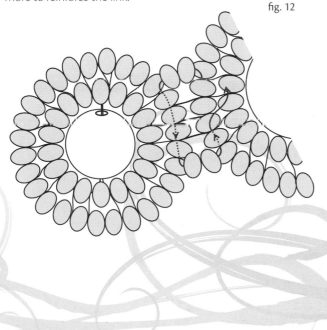

3 Place the linked rondelles back in place on the paper pattern. Note where the needle needs to be to link to the next rondelle around the necklace. Run the needle around the A beads of the second ring on the reverse of the rondelle into the correct position and link to the next rondelle in the sequence in the same way as before. Repeat to the centre back of this side of the design. Do not trim off the thread end.

4 Attach a new thread to the centre front of the design and work up the other side of the necklace in a similar fashion; again, leave the thread end attached. Attach a third thread to assemble the pendant below the centre-front bead. Assemble the remaining rondelles and then finish off this thread end.

5 Use the thread ends still attached to each side of the design to sew the hook-and-eye fastener into place on the underside of the 8mm rondelles.

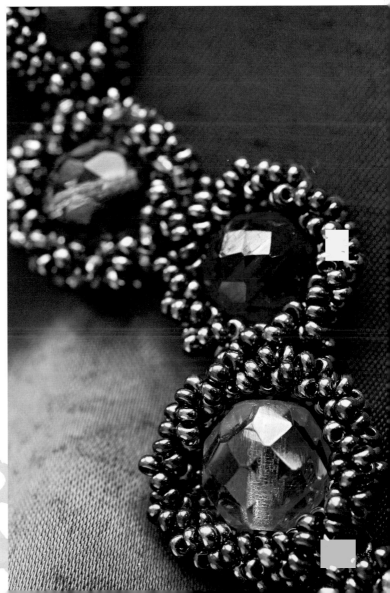

Morgan le Fay Cloak Brooch

Although you could readily imagine this striking cloak brooch clasped at the neck of a medieval cloak, it would work equally well on a modern-day shawl or wrap. It features a circle of rondelles reinforced by a wire support to create a richly ornate piece redolent of England's past.

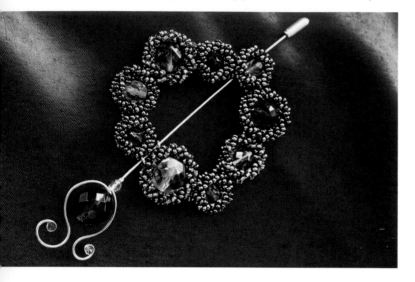

You will need

Bead Box

Approximately 10 assorted 6mm, 8mm, 10mm and 12mm fire-polished beads in jewel colours

One 4mm fire-polished bead

10g of size 10/0 AB opaque bronze seed beads **A**

5g of size 10/0 AB opaque purple seed beads **B**

3g of size 10/0 dark gold silver-lined seed beads **C**

Fabulous Findings

12cm (4¾in) hatpin with a pin guard

French crimp

40cm (16in) of 1.2mm (16-gauge) half-hard wire to match the hatpin

Two 4mm jewel-coloured chatons

Reel of Black Nymo D beading thread

Tools

Size 13 beading needle

Round-nosed pliers

Wire cutters

2cm (¾in) former, e.g. piece of dowel

PVA glue

1 Set aside one larger fire-polished bead and the 4mm bead for the pin. Make the rest of the fire-polished beads into rondelles as for the necklace as explained on pages 66–68. Arrange the prepared rondelles into an undulating circular shape roughly 8cm (3in) across, using a pattern as a guide. Link the rondelles in the same way as for the necklace (see page 69).

2 Form 30cm (12in) of wire into a rough circle to fit the back of the rondelle circle, overlapping the ends of the wire at the top of the circle where the top two rondelles are linked together. Using the tips of the round-nosed pliers, bend the wire ends at this point to 90° from the flat plane of the wire circle. Push these ends through the link between the rondelles at this point to emerge at the front of the brooch; bring the ends through so they sit 6–8mm (¼–⁵/₁₆ in) apart across the width of the link, as shown in **fig. 13**. Stitch the wire circle into place onto the back of the rondelle circle – a few stitches from the back of each rondelle will suffice. Trim the excess wire ends to 10mm (⅜in) and roll into two separate and parallel loops to guide the pin.

3 Wrap the remaining 10cm (4in) of wire around a circular former to make a circle 2cm (¾in) in diameter. Referring to **fig. 14**, left, make a small outward-facing loop in the centre of the wire to take the pin, and scroll the ends of the wire, ending in a 4mm (³/₁₆ in) loop at each end.

4 Thread the reserved large fire-polished bead onto the pin then thread on the scrolled wire made in step 3 and the 4mm fire-polished bead. Thread on the French crimp and push it up against the threaded beads. Squash the crimp flat to secure the beads. Now use a small dab of PVA glue to secure the chaton stones into the loops at the end of the scrolls and leave to dry. Thread the completed pin through the two wire loops at the top of the rondelle circle and replace the pin guard.

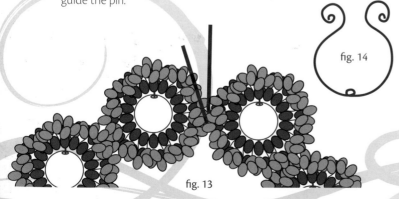

fig. 14

fig. 13

Morgan le Fay Bracelet

Based on an undulating line of rondelles in different sizes, this bracelet captures the glamour and rich colour of the Arthurian period. The random arrangement of rondelles softens the formality of the piece, making it suitable to wear whenever the mood takes you, or take a look at the alternative versions on pages 72 and 73.

You will need

Bead Box

Approximately 25 assorted 6mm, 8mm, 10mm and 12mm fire-polished beads in jewel colours

18g of size 10/0 AB opaque bronze seed beads **A**

8g of size 10/0 AB opaque purple seed beads **B**

4g of size 10/0 dark gold silver-lined seed beads **C**

Fabulous Findings

Two small haberdasher's hook-and-eye fasteners

Reel of Black Nymo D beading thread

Tools

Size 13 beading needle

Scissors

Paper and pencil

1 Make a paper pattern for your bracelet, drawing a simple rectangle the desired length by the width of about two rondelles. (If you haven't made the necklace already, make up some rondelles as described on pages 66–68 in every size to get an idea of the width.) Now make as many rondelles as you need to fit the pattern and lay them in place, creating an undulating double row with some rondelles in the centre to bridge the gaps. Position a pair of 8mm or 10mm rondelles side by side at each end.

2 When you are happy with the arrangement, join the rondelles together as explained on page 69. Add two hook-and-eye closures to the rondelles at the end (see **fig. 15**).

fig. 15

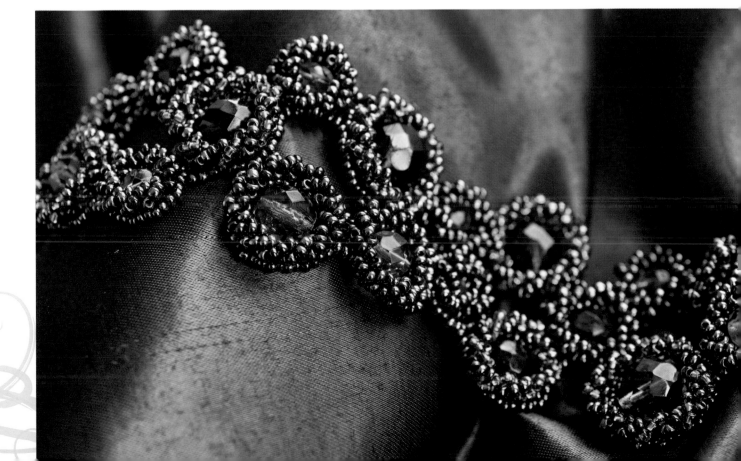

Inspirations

The combination of fire-polished facets and seed beads means that there is no limit to the colours and shapes you can create with the Morgan le Fay designs – you can go as broad, long, slim or delicate as you wish. You can even use other bead types, as shown here.

The Guinevere set below uses a simplified version of the rondelle form. Using a flat disc bead for the centre, it is light, elegant and easier to make than Morgan le Fay. Alternatively, try the bold or luxurious combinations opposite.

◇◇◇ Guinevere's Necklace

Team glass centres with silver-lined seed beads and you get an altogether lighter, more delicate look that would suit Queen Guinevere, with rondelles linked together to make the front. Here, the rondelles are made from 10mm flat glass discs surrounded by two circles of seed beads – 28 size 10/0 silver-lined grey seed beads for the inner circle with 28 larger size 8/0 silver-lined crystal seed beads around that. Nine rondelles are linked together as for the Morgan le Fay Necklace (page 66) to make the front of the necklace, with a double strand of 10/0 seed beads along both edges and a simple bead-and-loop fastener.

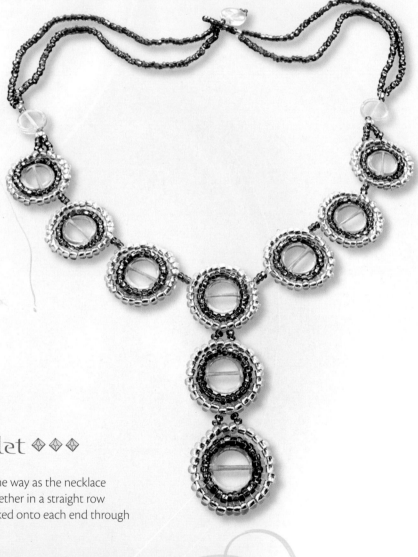

Guinevere's Bracelet ◇◇◇

This matching bracelet is made in the same way as the necklace above but the discs are double linked together in a straight row to make the design stable. The clasp is linked onto each end through a loop of size 10/0 seed beads.

◆◆◆ Symmetrical Necklace

Do you wonder how the Morgan le Fay necklace would look if all the rondelles were the same size? Here's your answer. This necklace uses 16mm (⅝in) cushion-shaped, silver-foil lined beads in three colours – pale blue, cobalt blue and teal. The blue beads are both encrusted with AB frost blue and AB transparent blue size 10/0 seed beads; the 16mm teal beads have been accented with AB frost teal and AB transparent teal size 10/0 seed beads. The arrangement of the finished rondelles emphasizes the symmetry.

Make it easy on yourself
Choose your colours wisely

You'll want to wear your rondelle jewellery at every opportunity, so take your time choosing the colours – either choose neutral colours, such as the grey and crystal of the Guinevere pieces, left, or use colours that you like to wear most often.

One to Watch ◆◆◆

With its classical shape and ornate design, this opulent bracelet can be worn for romantic evenings out and any number of special occasions. It centres around an 8mm crystal rondelle that has been encircled by six 6mm tanzanite rondelles. Further 6mm rondelles are placed in pairs along the straps.

Galadriel
Queen of the elves

Radiating light and sensitive to the moods of the earth and those who inhabit it, Galadriel is one of the most exquisite and mystical of all magical beings. Invented by J R R Tolkien for his *Lord of the Rings* trilogy, Galadriel is described as being a stunning beauty with dazzlingly long silver-gold hair and a powerful mind to match, capable of immense foresight and understanding.

We drew inspiration from Galadriel's femininity and mystical qualities to create jewellery in crystal and semi-precious stones, grey seed beads and pearls. Crystals are used as an aid to meditation, for massage and healing, and many precious stones carry meanings too, which adds to the mystic of the pieces.

At the end of this chapter you'll find projects inspired by these pieces, one with a different shape of focal bead. We hope that these will kindle the designer in you (see pages 82–83).

Focused around a 38mm (1½in) long crystal point, this necklace speaks of the mystical and magical. Use any crystal of a similar size and shape for the necklace, but don't choose it – let it choose you.

Galadriel Necklace

This unusual necklace is a gorgeous combination of crystals, pearls, seed beads and semi-precious chips. Tolkien's elves were blonde and beautiful and known for their fine silverwork, and this is expressed through the white/grey/mauve colour range and the use of semi-precious stones.

You will need

Bead Box
38 x 13mm faceted glass crystal point (or see page 82)

12g of size 10/0 AB crystal seed beads

8g of size 10/0 AB transparent grey seed beads

A pinch of size 6/0 silver-lined crystal seed beads

Up to 50 assorted toning small accent beads including 4mm crystal bicones or rounds in crystal AB and grey AB, 3–5mm freshwater pearls and semi-precious chips

Up to 20 larger accent beads including 6mm crystal rounds or bicones and 6–7mm freshwater pearls

Freshwater pearl or crystal for the clasp roughly 10mm

Fabulous Findings
10cm (4in) of 1.2mm (16-gauge) silver-plated half-hard wire

3m (3¼yd) of 0.010 diameter (7 strand) flexible beading wire

5m (5½yd) of 0.2mm (32-gauge) silver-plated soft wire

Four French crimps

Tools
Masking tape or sticky tape

Size 10 beading needle

Round-nosed pliers

Chain-nosed pliers or crimping pliers

Making the centre-front section

A faceted glass crystal point sits at the centre front of the necklace on a short piece of strong wire. The wire is woven over with lacings of beads on finer wire, covering the strong wire completely.

1 Turn a 3mm (⅛in) loop at one end of the 1.2mm wire (see Techniques, page 123). Thread on the large crystal point and make a loop at the other end of the wire (fig. 1).

fig. 1

Make it easy on yourself
Facing front
With a necklace like this it is important to decide which side is going to be the front before you get too far with the beading. Arrange your best beads on the front and aim to build up most of the texture here. Ideally you want the necklace to be fairly smooth on the back where it will lie against your skin.

2 Cut 50cm (20in) of 0.2mm (32-gauge) wire. Wrap the end of the wire around the base of the loop at one end of the 1.2mm (16-gauge) wire. Thread on 9 or 10 grey seed beads. Make a loose arch from the seed beads and twist the 0.2mm wire around the thicker wire, as shown in **fig. 2**. Leave 2–3mm (⅛in) play after the last bead because you will need to manoeuvre more wire through these beads as the design progresses.

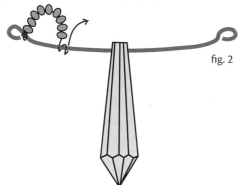

fig. 2

3 Thread on more beads and repeat the wrapping process. When you reach the crystal, secure it in the centre of the thicker wire with a few turns of the thinner wire. Now continue beading and wrapping to the end (**fig. 3**).

fig. 3

4 To make the remaining weaving easier, thread the needle onto the end of the 0.2mm wire. Thread on 7–10 size 10 crystal seed beads and pass the needle through 1 of the grey seed beads on the end arch (**fig. 4**), to make a loop or arch. Repeat the process to work your way back along the 1.2mm wire (**fig. 5**).

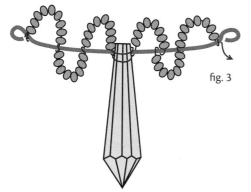

fig. 4

fig. 5

5 For the next pass, try wrapping the wire around the 1.2mm base wire and adding one or two of your larger accent beads (**fig. 6**), perhaps with a grey seed bead to either side. If you need to start a fresh length of wire, first tuck the old wire end into a nearby bead. Start the new wire by twisting it onto the 1.2mm base wire.

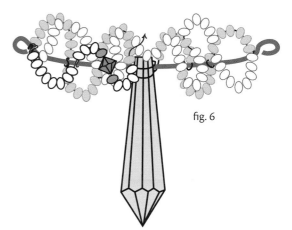

fig. 6

6 Repeat the weaving process to make a third, fourth and fifth pass of the 0.2mm wire, using mainly size 10 crystal seed beads but adding a sprinkle of smaller accent beads and grey seed beads. Pass the needle through beads on previous layers and occasionally wrap around the 1.2mm frame wire. Bring a few turns of wire around the crystal point and drop a few longer loops down the front of the point to amalgamate it into the design. As the weave builds up, it is easier to work with more potential places for the needle to pass through and thus secure the wire.

7 On the sixth pass, add one 4mm accent bead in the middle of a loop of seed beads to lie across and conceal the loop at the end of the 1.2mm wire (**fig. 7**). Make sure that this seed bead loop is securely held onto the 1.2mm wire loop as this will be the attachment point for the strap. Repeat at the other end of the centre front. Work another few passes, if necessary, just to fill in any gaps in the weave. Finish off the end of the wire neatly. Go back to any wire ends that may scratch the skin and tuck them into an adjacent bead.

fig. 7

Making the straps and clasp

The sides of the necklace are woven in a similar way to the front, but using flexible beading wire for comfort. The clasp is made from a 10mm freshwater pearl or crystal that fits into a simple loop of crystal beads on the other strap.

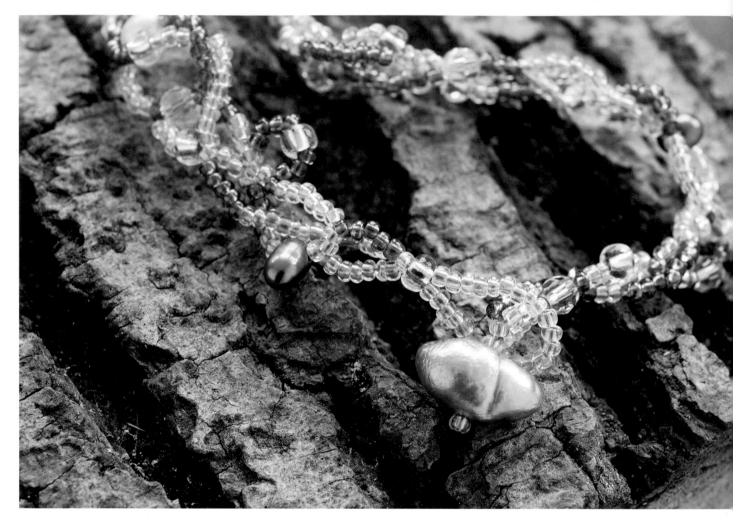

1 Divide the remaining accent beads into two piles – one for each side strap. Take 1.5m (60in) of flexible beading wire and thread the first 50cm (20in) through the 4mm accent bead wired at one end of the centre-front piece. Temporarily secure the flexible beading wire at the other side of the bead with a piece of masking tape or similar.

2 Thread 10–15 crystal seed beads onto the wire, an accent bead, 5–7 grey seed beads, 8 or 9 crystal seed beads and an accent bead. Continue up the length in a similar manner, adding blocks of seed beads spaced by accent beads every 2–3cm (1in or so) until the beading measures approximately 30cm (12in) from the loop end of the centre front. Secure the beads temporarily with a small piece of masking tape.

3 Return to the other end of the wire and remove the tape. This side of the wire is used to weave in and out of the beaded row just threaded to make a series of loops and twists. Thread on three or four crystal seed beads and pass through the third, fourth or fifth bead of the first length, as shown in **fig. 8**, to make the first loop. This first loop is quite small, just to get started. You can make subsequent loops up to eight or nine beads long to add variety to the design.

fig. 8

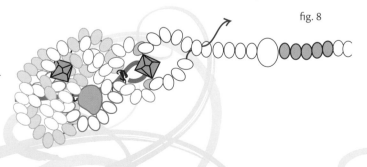

7 Weave the longer length of wire back down the side strap through all of the loops and spaces already created to add more texture. The wire can pass directly through the loops or through accent beads on the first two wire lengths but do not pull it too tightly – let it meander back down to the front of the work, adding seed beads and any further accent beads you may have remaining.

8 When the wire reaches the loop at the end of the centre-front wire, pass it into the beads of the centre front. Bring the end of the wire through the centre-front beads to emerge at the back of the work. Thread on a French crimp and push it right up to the last bead threaded through. Crush the crimp to secure the wire. Pass the end of the wire through a few more beads of the weave before trimming the wire to neaten it.

9 Start the second side strap and work to the end of step 5. Onto the longer wire only, thread two seed beads, the 10mm (⅜in) bead for the clasp and a final seed bead. Turn the end of the wire and pass it back through the clasp bead, the 2 seed beads, the crimp and the crystal accent bead (**fig. 11**). Pull the clasp bead up close to the end of the design. Crush the crimp to secure both wire ends. Trim the shorter wire as neatly as you can and use the longer wire to weave back down to the front of the necklace as before.

4 Thread on seven or eight seed beads and an accent bead and pass through a bead a short distance up the first strand to make a second loop. You can pass through the beads of the first row in either direction to make arch-shaped or more circular loops, as shown in **fig. 9**. Continue up the side strap until this woven part of the strap is 1.5cm (½in) shorter than you want this side of the necklace to be (you may be some way from the end of the first strand).

fig. 9

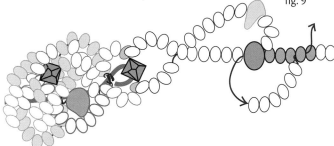

fig. 11

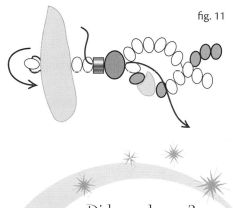

5 Remove the tape from the end of the first strand and take off all the excess beads so the last bead on the first strand corresponds in length with the weaving length. Pass both ends of the wire through a crystal accent bead and a French crimp.

6 Hold the two wires together and thread on sufficient crystal seed beads to make a loop that will just fit over the larger bead you have chosen for your clasp. Pass both ends of the wire back down through the crimp and the crystal accent bead, as shown in **fig. 10**. Pull the loop up neatly and crush the crimp to secure the wires (see Techniques, page 125). Trim the shorter wire away as closely as you can to the accent bead. Do not cut the longer wire.

fig. 10

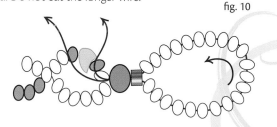

Did you know?
Stones carry meanings

*Precious and semi-precious stones are said
to bring certain qualities to the wearer,
so choose the stone chips for this necklace
accordingly. Amethyst is said to be the stone of
the spirit, offering calm, clarity and strength.
Clear quartz is said to stimulate psychic
perception and amplify prayers, while
labradorite is said to enhance
intuitions.*

Galadriel Bracelet

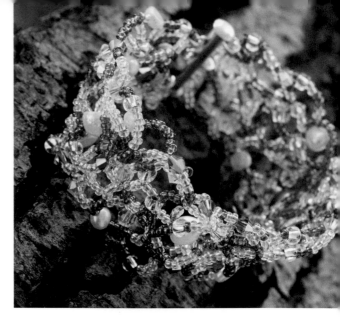

Combining semi-precious chips, freshwater pearls and both silver-lined and AB beads, this bracelet will add a touch of luxury to any outfit. It looks complicated but actually it is made in a similar way to the side straps on the necklace. The first layer of the bracelet weaves backwards and forwards across the width of the design to build up a lattice of beaded loops and bends. The second layer works back across the design to bring more texture and stability to the length.

1 Decide on the finished length of the bracelet by measuring your wrist. Start the beading in the middle of the flexible beading wire. Thread on a mixture of 16–20 seed beads and 1 or 2 larger feature beads. Pass one end of the wire up through the tenth bead from the end to form a loop, as shown in **fig. 12**.

fig. 12

2 Thread on a further assortment of 12–25 seed beads and feature beads and pass the end of the wire through one of the beads on the loop just formed, as shown in **fig. 13**, to make a longer loop.

fig. 13

3 Referring to **fig. 14** below, continue to work down the length of the bracelet, making loops of a variety of sizes and with a random selection of beads on each one. Each loop needs to link back onto the previous loop through one, two or three beads. Keep the loops quite tight but do not pull so hard that the work puckers. Work until the beading is 1cm (⅜in) short of the finished desired length.

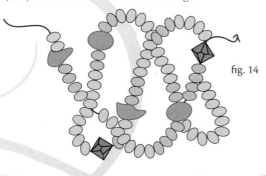

fig. 14

You will need

Bead Box
6g of size 10/0 AB crystal seed beads

6g of size 10/0 AB transparent grey seed beads

Up to 50 assorted toning small accent beads including 4mm crystal bicones or rounds in crystal AB and grey AB; 3–5mm freshwater pearls; semi-precious chips (rock crystal, labradorite etc)

Pinch of size 6/0 silver-lined crystal seed beads

Up to 8 larger accent beads including 6–7mm freshwater pearls

Fabulous Findings
Four-row sterling-silver sliding bracelet clasp (or see the alternative version on page 83)

8 jump rings, 5mm (¼in)

2m (80in) of 0.010 diameter (7-strand) flexible beading wire

4 French crimps

Tools
Size 10 beading needle

Snipe-nosed pliers or crimping pliers

Make it easy on yourself
Use a needle
Attach a needle to the end of the wire to help with the weaving. Pearls often have narrow holes, so when you reach a pearl, you'll need to remove the needle and thread the pearl directly onto the wire.

4 You can now work back down the length of the bracelet. Thread one end of the wire with 10–20 beads and gently bring it back across the beading just completed. To secure the wire, pass it through one of the beads of the lattice, bringing the new beads into a soft loop that links back into the weave, as shown in **fig. 15**, and continue. Weave through the loops and the beads of the first layer to amalgamate the two layers into one. Bring the other end of the wire into play and weave in from the other end of the design to build up the design from there. Check the overall length of the piece as you proceed and work so the two ends of the bracelet just touch around the wrist. As you complete the weave, ensure that the ends of the bracelet are firmly woven with small loops that will not pull out of shape.

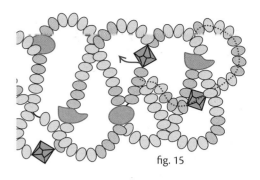

fig. 15

5 To finish off the wire ends, pass the wire through an adjacent bead on the weave. Thread on a French crimp and push it right up to the bead. Squash the crimp flat to secure the wire (see Techniques, page 125). Pass the end of the wire through two or three adjacent beads further down the weave and trim as closely as possible. Repeat with the other end of the wire. Use the jump rings to link the clasp through the loops of the weave.

Galadriel Earrings

The combination of crystals, pearls and AB seed beads make these earrings fit for a princess – an elvin princess. They are cleverly worked around a frame of 1.2mm (16-gauge) wire, which you shape yourself, so you can easily make them longer or shorter, wider or slimmer to suit you. Likewise you can adapt the colours to suit any outfit or occasion.

You will need

Bead Box

Selection of size 10/0 AB crystal and AB transparent grey seed beads

Pinch of size 6/0 silver-lined crystal seed beads

Small accent beads including 2 crystal AB bicones, 4mm

2 freshwater pearls, 7–8mm

Fabulous Findings

70mm (2¾in) of 1.2mm (16-gauge) silver-plated wire

1.5m (59in) of 0.2mm (32-gauge) wire

2 silver eyepins

2 silver ear wires

1 Take 35mm (1⅜in) of 1.2mm (16-gauge) silver-plated wire, make a 6mm (¼in) loop at one end and an 8mm (⁵⁄₁₆in) loop at the other end.

2 Cut 75cm (29½in) of 0.2mm (32-gauge) wire and attach the end to the thicker wire just below the small loop. Using size 10/0 seed beads and following **fig. 16**, make a series of beaded loops around the edge of the 1.2mm frame. These beaded loops will fill out the shape. Bring the wire back across the earring frame, adding a second layer of seed beads, a few crystal beads and a 7–8mm freshwater pearl across the centre of the large frame loop. Finish off the wire end with a twist and thread through a few beads before trimming.

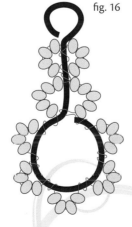

fig. 16

3 Link an eyepin onto the small loop of the frame and thread on a 4mm crystal AB bicone. Trim and loop the top of the pin. Add a frame of seed beads around the crystal bead with the 0.2mm wire. Attach an ear wire to the top of the earring.

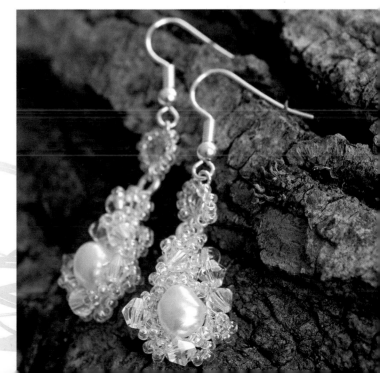

Inspirations

The Galadriel Necklace features a beautiful crystal point, but if you have a different shape of feature bead that you are keen to use or if you'd rather not have a large feature bead then find out here how you can adapt the design.

The simplified necklace and coordinating bracelet opposite are made in a subtle combination of copper tones, retaining the simplicity of the Galadriel colour scheme but in a warmer tone. These would also work well in different shades of blue, purple, pink or any colour you like to wear.

Amethyst Necklace ◆◆◆

Amethyst is a beautiful semi-precious stone that is said to guard against fearful feelings, protect against self-deception, aid healing and bring spiritual wisdom. It is indeed a stone that Galadriel would have been drawn to. Choose a bead with a central hole – the size is up to you.

Making the necklace

Cut a short length of 1.2mm (16-gauge) silver-plated half-hard wire and turn a 3mm (⅛in) loop at one end. Slip on the bead and turn a 3mm (⅛in) loop at the free end of the wire. Use a second length of 1.2mm wire to create a framework around the bead, as shown in the diagram above. Following the instructions for the Galadriel Necklace on page 76, use 0.2mm (32-gauge) silver-plated soft wire to bead around the amethyst, this time using black and opaque purple AB size 10/0 seed beads, amethyst chips and black Biwa pearls. Complete the necklace in the same way as the Galadriel Necklace.

Simplified Necklace ◈ ◈

This superb necklace in copper tones is made using the same technique as the main project but without the central crystal pendant for a subtler look. The front of the necklace is formed from a simple shape made from 1.2mm (16-gauge) half-hard wire, which can be shaped slightly as desired.

Making the necklace

To make the necklace use 10cm (4in) of 1.2mm (16-gauge) half-hard wire to make a plain necklace centre with a loop at each end. Bind a second length of 1.2mm wire onto the first piece to make a gentle curve, which hangs just below the first length, as shown in the diagram below. This second length of wire will give a deeper profile to the centre front of the necklace. Use 0.2mm (32-gauge) soft wire to bead the wire frame, following the instructions for the Galadriel Necklace but adding a few additional wires to bridge the gap and turn the centre front into a solidly encrusted piece. Complete the necklace following the instructions for the Galadriel Necklace on page 76.

Coppery Bracelet ◈ ◈

This variation of the Galadriel Bracelet (page 80) is made in the same warm gold, brown and copper tones as the necklace above. Follow the instructions for the Galadriel Bracelet but use a single-row toggle fastener attached with a pair of matching three-row end bars. These bars give stability and security to the ends of the bracelet.

Titania
Queen of the fairies

Shakespeare's queen of the fairies in *A Midsummer Night's Dream* is a captivating figure who delights in nature: her bed is a bank 'whereon the wild thyme blows... quite over-canopied with luscious woodbine, with sweet musk-roses, and with eglantine'. Hers is a world of moonlight dances, dew-drenched flowers, corn pipes, poetry and mermaids' song.

Picking up on the lovely wild flowers that surround Titania in her woodland bower, the necklace, earrings and tiara here incorporate pretty daisies made from dagger beads, as well as leaf-shaped beads and cupped flower beads. Silver chains capture the sparkle of the fairy world and suggest the dew-spattered flowers, while chains of linked fire-polished beads symbolize the woodbine (honeysuckle) above Titania's bed.

Later in the chapter (pages 92–93) there is a softer colour combination in keeping with the colours of wild honeysuckle, with ideas for making a charming bracelet and matching pendant plus a dramatic brooch.

You'll certainly feel like a fairy queen in this floral necklace, featuring clusters of pink and blue daisies and pretty flower dangles made from flower beads and silver chain.

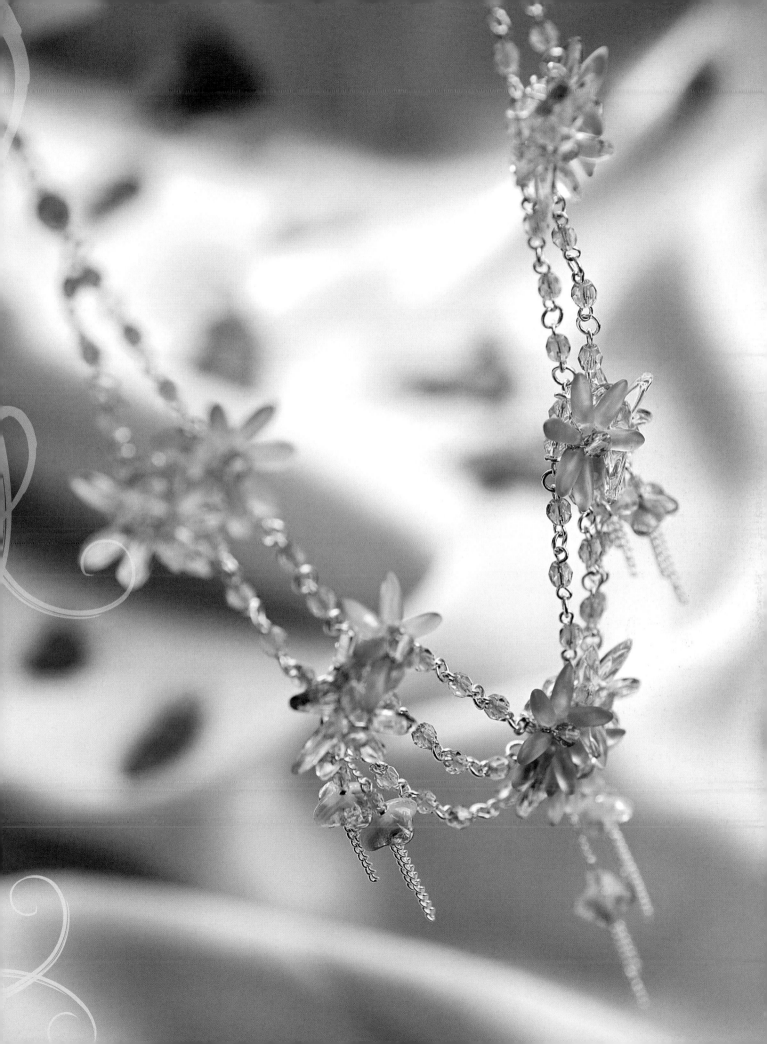

Titania Necklace

Suggestive of summer days and flowering hedgerows, this floral masterpiece is certain to brighten up your mood. It combines fire-polished beads with flowers and leaf shapes, silver wire and dangling chain for a fresh, bright and very feminine look. Start by making the daisies from the dagger beads and join them into clusters, then make the flower dangles before linking the whole lot together with the fire-polished beads and wire.

You will need

Bead Box

42 dagger beads, 11 x 3mm, in frosted pale blue **A**

35 dagger beads, 11 x 3mm, in transparent pale pink **B**

45 fire-polished faceted beads, 4mm, in topaz **C**

17 fire-polished faceted beads, 3mm, in topaz **D**

16 cross-holed leaf-shaped beads, 11 x 6mm, in fresh green **E**

6 cupped flower beads, 10mm, in pink marl **F**

28 fire-polished faceted beads, 4mm, in rose pink **G**

2 fire-polished beads, 6mm in topaz **H**

15 clear glass rounds or facets, 4mm **J**

6 silver-lined crystal size 10/0 seed beads **K**

Fabulous Findings

50cm (20in) of fine curb silver-plated chain

10 plain 3-hole silver-plated spacer bars

90 silver-plated jump rings, 4mm (³/₁₆ in)

70 silver-plated eyepins or see the tip, opposite

5m (5½yd) of 0.2mm (32-gauge) soft silver-plated wire

Vine-patterned silver-plated toggle clasp

Tools

Wire cutters

Round-nosed pliers

Second pair of pliers of any type to help to open the jump rings

Making the daisies

Daisy flowers are said to symbolize loyalty, friendship and love. On this pretty necklace they are each made from a ring of seven dagger beads with fire-polished faceted beads at the centre. Since these are made separately, you can also use them on other items of jewellery too, like the pretty earrings and tiara on pages 90 and 91.

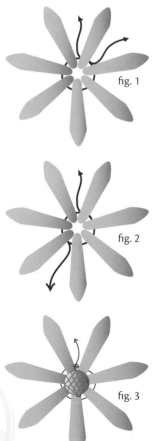

1 Cut 15cm (6in) of 0.2mm (32-gauge) wire and thread on 7A. Pass the end of the wire through the first bead threaded to bring the A beads into a tight ring in the middle of the wire, as shown in **fig. 1**.

fig. 1

2 Pass one end of the wire all the way around the ring of beads to strengthen it a little. Now pass the same end of the wire through the next three beads so that the wire ends emerge at opposite sides of the ring, as shown in **fig. 2**.

fig. 2

3 Thread 1C onto one end of the wire. Stretch this wire across the ring to sit the bead across the central hole. Passing the wire between the A beads at the far side of the hole, bind the wire end onto the wire of the ring that you can see between the A beads, as shown in **fig. 3**.

fig. 3

4 Bring the end of the wire through to the back of the flower and thread on 1D. Stretch the wire across the back of the flower to sit the D bead into the hole on this side of the flower. Wrap the wire in between the A beads to secure the D bead in place.

5 The petals of the flower will be quite loose and will flop backwards and forwards. Use the two ends of the wire to wrap in between each of the A beads to take up any slack in the original ring of wire – this will help to make the flower shape more stable (and when joined into the necklace it will be more stable still). Finish off the wire ends with a final wrap around the ring before passing through the C bead. Trim at the far side of the C bead. Repeat to make five more A-bead daisies and five daisies from the B beads.

Make it easy on yourself
Use wire instead of eyepins

Use 0.6mm (22-gauge) wire instead of the eyepins. This will be more economical because the links are very short and the wire will produce less wastage. You will need 2m (80in) of 0.6mm half-hard plated wire.

Making the daisy clusters

Most of the daisies are formed into two- and three-flower clusters over a framework of beads and spacer bars. When wiring on the flowers and leaf beads, make sure you don't obstruct the loops in the framework because you will need these when you assemble the necklace.

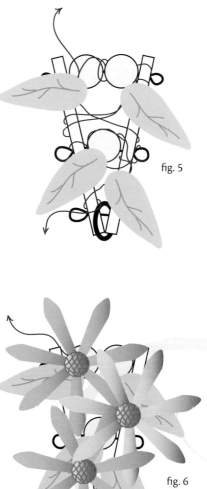

fig. 5

fig. 6

1 Thread an eyepin through the end hole of one of the spacer bars. Thread on 2J and the end hole of a second spacer bar. Trim the pin to 6mm (¼in) from the bar and make a loop. Pass a second eyepin through the middle hole of the first bar. Thread on 1J and pass the pin out through the middle hole of the second bar. Trim the pin to 6mm (¼in) and make a loop. Thread an eyepin through the bottom hole of the first bar and thread a jump ring onto the pin. Pass the pin out through the bottom hole of the second pin to trap the jump ring between the 2 bars. Trim to 6mm (¼in) and make a loop (**fig. 4**). Make two more identical units and two units without the jump rings.

2 Take one of the units with a jump ring attached. Cut 30cm (12in) of 0.2mm wire and wind the middle of the wire onto one of the bars to make a firm anchor. Onto one triangular face of the bar unit wire 4 leaf-shaped E beads. The E beads need to lay flat and point outwards from the centre of the triangle, overhanging the edge by at least 6mm (¼in) or they will not be seen behind the daisies. Wrap the wire over the bars, through the J beads, or hook it around the eyepin loops but do not snag the jump ring or block any of the eyepin loops (**fig. 5**).

3 Bring one end of the wire down towards the jump ring point of the triangle and then pass it through the D bead at the back of the first blue daisy. Draw the daisy down onto the triangle and wire it into place. Pass the end of the wire through the D bead at the back of the pink daisy and wire it into place just above and to the side of the first flower. Wire the last blue daisy into place close to the top of the triangle, as shown in **fig. 6**.

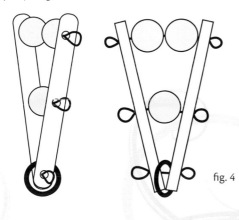

fig. 4

4 Use the two ends of the wire to make the flower petals firmer – pass the wire through the tiny gaps between the bottom of the petals on each flower and bind it onto the base triangle – a few wire stitches will stop the petals from waving around. Finish the wire ends, pass through an adjacent bead hole and trim.

5 Make two similar clusters for each side of the centre front on the two remaining triangles with a jump ring attached. These clusters require just three leaves, one pink and one blue daisy each. Make sure that the leaves and flowers cover the whole face of the triangle, as shown in **fig. 7**. Cover the remaining two triangles each with three leaves, one pink and one blue flower.

fig. 7

Making the flower dangles

Chain tassels, embellished with beads and flowers, hang down from the jump rings on three of the flower clusters to swing like trailing flower vines in the breeze as you move. These are like the country flowers in Shakespeare's play that hang over Titania as she sleeps in her bower.

Make it easy on yourself
Cut equal lengths of chain

To accurately prepare the chain lengths, cut the first length against a measure. Now thread a length of wire through the end link of this first cut length and hold it up in front of you. Slip the end link of the uncut chain onto the wire and push it up parallel to the cut chain. You can now easily see which link you need to cut through to make the two chains match.

1 Cut two pieces of chain 28mm (1⅛in) long and two pieces 18mm (¾in) long. Thread the end link of one long and one short chain onto the loop of an eyepin. Close the loop firmly. Thread 1F (petals pointing downwards), 1K and 1D onto the pin. Trim the wire and form a loop (see Techniques, page 123). Repeat with the second two chains. We'll call these the dangles.

2 Cut one 24mm (1in) chain and one 14mm (½in) chain. Attach one chain length to the loop at the top of each flower dangle. Thread both these chains at the other end onto a jump ring (**fig. 8**) and then attach this jump ring to the jump ring at the bottom of the three-flower cluster.

fig. 8

3 The tassels for the clusters on each side of the centre front are slightly shorter. Cut four chains 10mm (⅜in) long and four chains 18mm (¾in) long. Take one long and one short chain and add to the loop on an eyepin. Thread 1F, 1K and 1D onto the pin. Trim the wire and make a loop as before. Repeat to make the remaining cut chain lengths into three more flower dangles.

4 Cut two chains 4mm (³/₁₆ in) long and two chains 10mm (⅜in) long. Attach one to the top loop of each of the flower dangles just completed. Pair up one short and one long dangle onto a jump ring and link onto the jump ring at the bottom of one of the prepared flower clusters. Repeat with the other two dangles.

Linking the design

To create a glittering effect, the beads that join the flower clusters are individually wired and linked with jump rings. You'll need more of these beaded links to form the back of the necklace.

1 Thread 1C onto an eyepin. Trim the pin and loop the trimmed end in the same plane as the loop at the other end of the pin (**fig. 9**). Make sure that the loops are tight against the bead at both ends. Repeat for the remainder of the C, G and H beads.

fig. 9

2 Using jump rings between each pair of links, join together 1C link, 1G link and a C link (**fig. 10**).

fig. 10

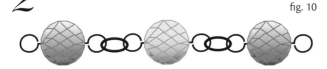

3 Referring to **fig. 11**, below, twist open a jump ring and thread on the end loop of the bead chain. Flip the central cluster onto its front and locate the three eyepin loops on each side of the triangle support. Link the open jump ring at the end of the chain to the loop on the back of the triangle on the top right-hand side. Flip over the cluster that will sit next to the centre front at this side of the design. Use a new jump ring to link the other end of the chain to the top loop on the left-hand side of this cluster. Make a 1G, 1C, 1G, 1C chain to link between the middle loops of the clusters and a 1C, 1G, 1C, 1G, 1C chain for the bottom two loops on either side of the centre front. Repeat out to the cluster at the other side of the centre front.

4 Refer to **fig. 12** – there are only two rows of chain in the next gap, one between the top loops and one between the middle loops on each side. Make the top chain for each side from 1C, 1G, 1C. Make the bottom chains 1G, 1C, 1G, 1C. Link to the two-flower clusters. The next gap links up to the H beads prepared in step 1. Make the chain for the top loop on each side of the design from 1C, 1G and 1C. Make the chain for the second loops from 1C, 1G, 1C and 1G. Link these into place on the edge of the triangles. Use a jump ring and the H bead links to bring the two chains together on each side of the length.

5 Decide how much longer you want the finished necklace to be. Starting with 1G link at each side of the design, add links equally on both sides until the necklace is the desired length. Attach the end links to the toggle clasp.

fig. 11

fig. 12

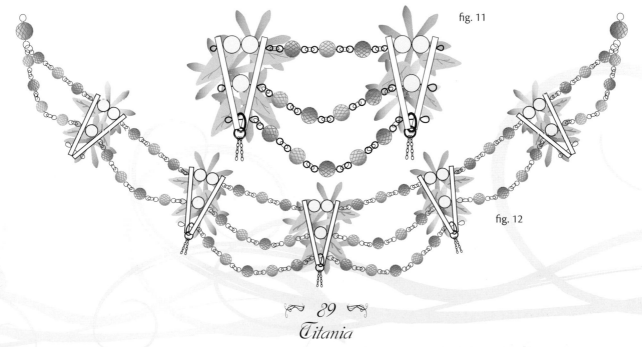

Titania Earrings

What could be prettier for a summer picnic or outdoor party than these enchanting earrings, which combine the daisies and floral chains from the necklace? Young girls will like these too and the earrings and tiara opposite would look wonderful on a flower girl – just use earring fittings for non-pierced ears, if necessary.

You will need

Bead Box

14 dagger beads, 11 x 3mm, in frosted pale blue **A**

4 fire-polished faceted beads, 4mm, in topaz **C**

4 fire-polished faceted beads, 3mm, in topaz **D**

4 cross-holed leaf-shaped beads, 11 x 6mm, in fresh green **E**

4 cupped flower beads, 10mm, in pink marl **F**

4 size 10/0 silver-lined crystal seed beads **K**

Fabulous Findings

30cm (12in) of fine curb chain

6 silver-plated eyepins (or 20cm / 8in of 0.6mm (22-gauge) half-hard silver-plated wire)

1m (40in) of 0.2mm (32-gauge) soft silver-plated wire

Pair of ear-fittings

2 jump rings, 4mm (⁵/₁₆in)

Tools

Wire cutters

Round-nosed pliers

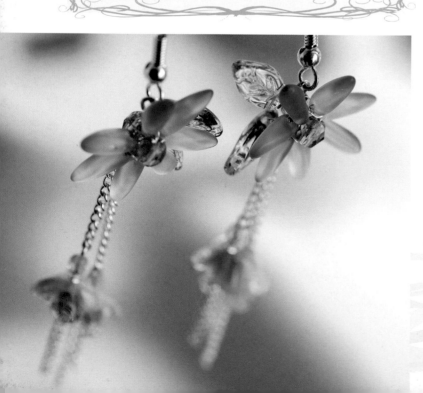

1 Using 40cm (16in) of 0.2mm (32-gauge) wire, follow the instructions for the Titania Necklace to make two daisies from the A beads, substituting the D bead in the necklace instructions with a second C bead so that these flowers have a C bead centre at both the front and the back; do not finish off the wire ends.

2 Bring the longest wire end to the back of the flower, pulling it tightly between the bases of the A beads. Thread on 1E. Make a loop in the wire to hold the leaf about 6mm (¼in) from the back of the flower. Bring the two sides of the loop together and twist to form a wire rope effect that will support the leaf, as shown in **fig. 13**. Wrap the end of the wire between the A beads of the petals to anchor the rope and bring the wire end through to the back of the flower once more. Thread on 1E and repeat to add a second leaf stamen to the back of the daisy. Secure the wire ends and trim. Arrange the leaves to lie flat against the back of the flower but just peeking out between the petals when viewed from the front.

fig. 13

3 Cut four lengths of chain 16mm (⅝in) long and four lengths 10mm (⅜in) long. Thread the end link of one long and one short chain onto the loop of an eyepin. Close the loop firmly. Thread 1F (petals pointing downwards), 1K and 1D onto the pin; trim the wire and form a loop. Repeat with the remaining chains to complete four flower dangles.

4 Cut two lengths of chain 26mm (1in) and two lengths of chain 18mm (¾in). Attach one chain length onto the top of each prepared flower.

5 Use a jump ring to link one long and one short flower dangle onto an eyepin. Pass the pin up through the hole in the D bead at the back of the daisy. Trim the pin and carefully loop it in the same plane as the loop at the other end of the pin, as shown in **fig. 14**. Attach an ear fitting to the loop. Repeat step 5 to complete the other earring.

fig. 14

Titania Tiara

Every fairy should have her own tiara, and this is a twinkling delight. The daisy flowers, cupped flowers and leaves are bound onto a plain headband that you can buy ready-made. If you cannot find one, make your own as explained on pages 96–97.

1 Make four pink daisies and three blue daisies following the instructions on pages 86–87 but don't trim off the excess wire. Cut 1.1m (43in) of 0.2mm (32-gauge) wire and bind the middle onto the middle of the tiara band. (One end will work to the left and the other to the right along the band.)

2 Offer up a pink daisy to the middle of the tiara and secure it by wrapping the tails of the daisy wire over the band. Use the working wire to wrap twice over the daisy wire wraps to the left and right.

3 Thread 1E onto the left-hand wire and bind into place 5mm (¼in) from the daisy. Thread on 1F and 1G. Pass the end of the wire back through the hole in the F bead to pull the G bead into the centre. Wrap the wire over the band to secure the flower 5mm (¼in) along from the leaf. Add 1F to the band. Add one blue daisy to the band, reinforcing the binding with the working wire. Repeat with the right-hand working wire.

You will need

Bead Box

21 dagger beads, 11 x 3mm, in frosted pale blue **A**

28 dagger beads, 11 x 3mm, in transparent pale pink **B**

7 fire-polished faceted beads, 4mm, in topaz **C**

7 fire-polished faceted beads, 3mm, in topaz **D**

16 cross-holed leaf-shaped beads, 11 x 6mm, in fresh green **E**

8 cupped flower beads, 10mm, in pink marl **F**

8 size 10/0 silver-lined crystal seed beads **G**

Fabulous Findings

10m (11yd) of 0.2mm (32-gauge) soft silver-plated wire

Tiara headband

Tools

Wire cutters

4 Work one repeat to the left and one to the right until all the beads are used. Bind the ends of the wire tightly around the last bead and push the end into an adjacent bead to conceal it.

Inspirations

The Titania Necklace (page 86) has a youthful look with its pretty pastel blue, pink and yellow colour scheme, but it would work equally well in a subtler colour range, such as the soft yellow and topaz tones of the jewellery here, which capture the true colours of wild honeysuckle.

To increase your choice of designs, we've used this soft colour scheme to make a lovely bracelet and simple pendant. Both are comparatively easy to make, especially if you've already made the necklace.

Tree-fairy Pendant ◈

This lovely pendant, made to match the bracelet opposite, is quick and easy to make. Make the daisy in the same way as on the earrings (see page 90). Make two flower dangles as on the bracelet opposite and attach each one to a jump ring. Next attach two dangling leaves to separate jump rings. Join the rings to make a chain and attach the chain to the bottom of the flower. Attach the daisy to a final jump ring at the top so that you can thread it onto a neck chain.

Did you know?
All about yellow

Yellow is said to symbolize wisdom, and it is supposed to be a favourite with clever people. It's also the colour of spring, of renewal and therefore of joy and growth. Clear, light yellow is also said to bring clarity and make the mind alert, so the yellow bracelet and necklace shown here might be useful presents for someone who is about to take an exam.

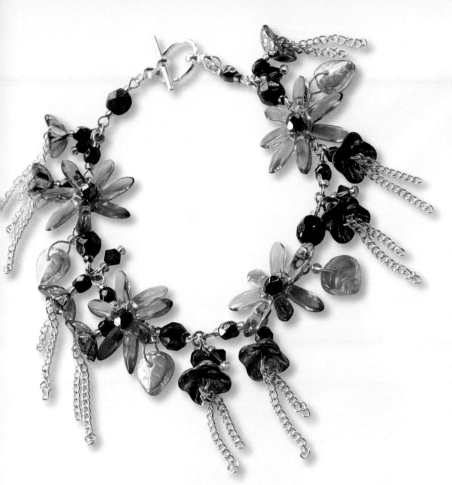

Tree-fairy Bracelet ◆◆

This captivating bracelet would suit any woodland fairy. It is really an adaptation of the Titania Earrings, combining linked beads, daisies and flower dangles. The daisies are made with a 4mm fire-polished bead centre on both the front and the back. Each one is made into a link with a silver-plated eyepin passing through the hole in one of the 4mm beads and the chain flower dangles are exactly the same as on the earrings. The bracelet length is made from 6mm and 4mm fire-polished gunmetal colour beads linked together with gilt jump rings. This combination of silver and gold coloured metals can look really effective as each has a softening effect on the other. The leaves on this design need a large loop so they can dangle freely; this is made using the widest part of the round-nosed pliers and 0.6mm (22-gauge) wire.

Brooch ◆◆◆◆

Using the striking colours of oriental lacquer-work, this chrysanthemum brooch makes a bold statement on a lapel or will pin through a French pleat to create a stunning hair accessory.

Making the brooch

The flower is made from two rings of 16 x 5mm dagger beads – one in black and one in red. The third ring is made from dark red 11 x 3mm dagger beads. A headpin threaded with a 4mm fire-polished bead passes through the centre of the rings to bring the flower together. The end of the headpin is wrapped tightly onto the centre of a 1.2mm (16-gauge) half-hard wire scroll and then a 3m (3¼yd) length of 0.5mm (24-gauge) black wire wraps neatly over the scroll. As the wire wraps along it branches out into sprays of 4mm fire-polished faceted beads and 9 x 8mm heart-shaped leaves. To finish, the ends of the 1.2mm wire are looped to take the simply decorated hat pin that will hold the brooch in place.

Snow Queen
Cruel ice queen

The Snow Queen is tall, elegant and as cold as the ice and snow from which she is made: 'she was fair and beautiful but made of ice – shining and glittering ice'. She is a type of Jack Frost, who is made of ice and snow and who brings the cold. Created by Hans Christian Anderson, she is a sinister figure whose kisses make people forget and who has 'neither peace nor rest' in her eyes.

Inspired by the Snow Queen and her palace, 'so icy, cold and glittering', the jewellery here reflects the forms and colours of icicles and snowflakes. The main project is a spiky icicle tiara that is decorated freehand with a variety of small beads to build up an encrusted texture. This is accompanied by a snowflake pendant necklace and matching earrings.

Frost is also associated with tones of blue and lilac – the colours of the shadows on a sunny winter's day – so we have also made a version of the tiara and pendant in these colours. And for those of you who are attracted to the Snow Queen's sinister side, there are also some designs in grey and red.

What could be more fitting for a snow queen than a tiara that looks as if it is made of icicles? Glittering with crystals, it sparkles and shimmers in the light.

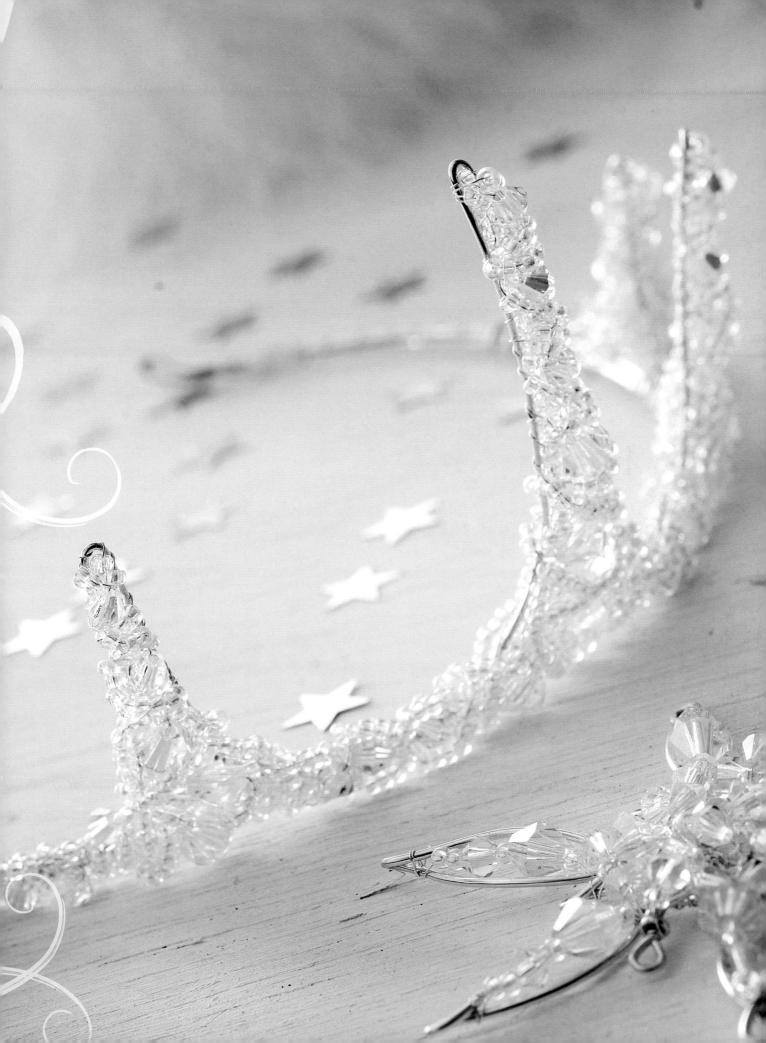

Snow Queen Tiara

She shall go to the ball in this tiara with its striking icicle spires and shimmering crystal beads. It would work beautifully for a bride or maid of honour, for a prom or a party. Because it is made to measure, you can make it for children or adults.

Making the frame

The tiara is created over a wire frame made from 1.2mm (16-gauge) half-hard wire for the base, 0.8mm (20-gauge) half-hard wire for the icicle points and 0.2mm (32-gauge) soft wire for binding the two other wires together. Once you understand how it is done, you'll find this process easily adaptable for other designs too, so you could incorporate, say, the leaves or flowers from the Dryad projects (see pages 52–63).

1 Cut the 1.2mm (16-gauge) wire in half. Cut a 1m (40in) length of 0.2mm (32-gauge) wire. Bend the two pieces of 1.2mm wire into matching gentle curves and bind together with the 0.2mm wire, as shown in **fig. 1**. Make sure that the two thicker wires sit one on top of the other and do not twist around each other. This is the headband.

2 To make the points of the frame symmetrical, fold the 0.8mm (20-gauge) wire in half so that the curves can be made to both sides of the centre front at the same time. Make sure the two sides of the wire lie parallel to one another. Measure 2cm (¾in) from the fold in the wire and hold this point against the mould; wrap the two long ends of the wire two thirds of the way around the mould, as shown in **fig. 2**.

You will need

Bead Box
18g of size 10/0 lustre crystal seed beads
50 crystal AB bicones, 4mm
15 crystal AB bicones, 6mm

Fabulous Findings
80cm (31½in) of 1.2mm (16-gauge) half-hard silver-plated wire or a tiara band
1m (40in) of 0.8mm (20-gauge) half-hard silver-plated wire
20m (22yd) of 0.2mm (32-gauge) soft silver-plated wire
10cm (4in) of narrow silver ribbon
White florist's tape

Tools
Wire cutters
Round-nosed pliers
Cylindrical mould about 3cm (1¼in) in diameter

fig. 1

fig. 2

3 Using the round-nose pliers, grip across the two thicknesses of wire 1cm (⅜in) past the end of the curve you have just made. Bend the wire over the pliers until it touches back on the outside of the curve just made (**fig. 3**).

fig. 3

5 Very gently open the fold out in the centre of the wire to make two symmetrical sets of points to each side of the taller central point (**fig. 5**).

fig. 5

4 About 1cm (⅜in) from the bend wrap the next section of parallel wires halfway around the mould. Hold the two thicknesses of wire in the pliers 1cm (⅜in) past the end of the curve and bend back as before (**fig. 4**). About 1cm (⅜in) from the bend wrap the next section of wire one third of the way around the mould.

fig. 4

6 Cut 1m (40in) of 0.2mm wire; attach the centre to the centre of the headband. Offer the prepared points up to the band so that the bottom curves touch the top of the headband. Wind the ends of the 0.2mm wire out to each side of the band, binding the curves into place. Bind the 0.8mm tails of the curves directly over the band to make the frame stable (**fig. 6**). Trim all the excess wire ends.

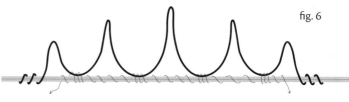

fig. 6

Decorating the frame

Using soft wire and a selection of small beads, you can now decorate the frame. String on a few beads each time, attaching the soft wire to the frame with a twist or two. We used mainly seed beads with a few 4mm and 6mm bicone crystal beads, but you can use a variety of beads – whatever you have in your bead box that you think will look good.

1 Cut 1.5m (60in) of 0.2mm wire. Bind the centre of the wire onto the headband at the bottom of one of the points – this gives you 2 ends of wire to weave beads onto the frame. Thread on 10–20 seed beads. Stretch the wire across the frame to the edge of the point and bind around the frame to secure it. Repeat with 6–15 seed beads, this time binding across the point, as shown in **fig. 7** below. Repeat at random over the point to build up a thin covering of seed beads.

2 When the point is thinly covered, start to add the crystals – thread on a few seed beads then a crystal and a seed bead or two before securing the strand. Secure the beading wire by wrapping over the 0.8mm wire frame or by passing through one of the seed beads already threaded.

3 Repeat steps 1 and 2, working across all points to cover the tiara with seed beads and a sprinkling of crystal beads. Cover the band in between the points as well to join up the whole design across the tiara. Finish off all of the loose ends.

4 Carefully try the tiara on and trim the back of the headband to size using wire cutters. At each end cut back one thickness of the 1.2mm wire by 1cm (⅜in). Fold the other end of the thick wire in half to meet the cut end of the shorter wire.

5 Fold the ribbons in half and bind into place at the end of the bands to make a loop that overhangs each end of the band. Bind the loops into place with a piece of 0.2mm wire, as shown in **fig. 8**. Cover the join with the florist's tape – the tape will only stick when stretched, so stretch and bind over the join. Tear away the excess tape.

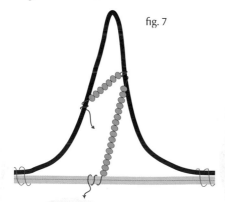

fig. 7

fig. 8

Snow Queen Pendant

Based on the form of a snowflake, this versatile necklace is elegant yet eye-catching with its dramatic shape and shimmering crystal beads. The pendant has two layers – a large star made from 1mm (18-gauge) wire and a smaller star on top made from 0.8mm (20-gauge) wire. These are then bound together with finer wire and embellished with crystals. The snowflake is hung from a triple row of seed beads, though you could add some crystal beads here too, if desired.

You will need

Bead Box

31 crystal AB bicones, 4mm **A**

8 crystal AB bicones, 6mm **B**

12g of size 10/0 lustre crystal seed beads **C**

Fabulous Findings

1.5m (60in) of 1mm (18-gauge) half-hard silver-plated wire

60cm (24in) of 0.8mm (20-gauge) half-hard silver-plated wire

5m (5½yd) of 0.2mm (32-gauge) soft silver-plated wire

One 8mm (⁵⁄₁₆in) silver-plated jump ring

Reel of White Nymo D beading thread

Tools

Round-nosed pliers

Wire cutters

Size 10 beading needle

2cm (¾in) and 1cm (⅜in) cylindrical moulds

Making the wire stars

The double form of the snowflake is made by twisting wire around cylindrical forms to create stars, one large and one small. If you have a wire jig you can use this with appropriate super pegs. Otherwise use a ring mandrel or whatever you have in the home of a suitable size.

1 Measure 10cm (4in) from the end of the 1mm (18-gauge) wire and wrap the wire three quarters of the way around the 2cm (¾in) mould. At the end of the curve, grip the wire with the round-nosed pliers and fold back to touch the wire back on the outside of the curve (**fig. 9**).

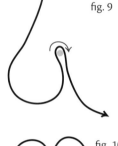

fig. 9

2 Make another 4 curves and folds following on from the first to make a rough flower shape (**fig. 10**). Finish with a final curve but no fold.

fig. 10

3 Gently fold back each adjacent pair of curves to cross over the tips of each curve into a small loop, as shown in **fig. 11**.

fig. 11

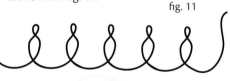

Make it easy on yourself
Practice wire

If you haven't got much experience working with wire, buy some extra wire and practice making the shapes – it doesn't have to be silver-plated, but it should be the same thickness as the wire you are going to be using for the snowflakes.

4 Gently open up each curve to bend the wire into a six-pointed star – the sixth point is only half formed at present (see **fig. 12**).

fig. 12

5 Complete the last point by wrapping one side of the wire over the other to close up the star shape. Trim the other wire end to 8mm (⅜in) and roll a loop to match the other points of the star. Trim the wire ends (**fig. 13**). Make a similar star from the 0.8mm (20-gauge) wire using the 1cm (⅜in) cylindrical mould.

fig. 13

Assembling the snowflake

Decorate the points of both stars and the centre of the smaller star before wiring the two stars together and adding further beads to cover the gaps.

1 Start by beading the points of the large star. Cut 1m (40in) of 0.2mm wire and bind it onto the bottom of a point. Thread on 1C, 1B, 1C, 1A and 1C. Wrap the wire around the twist at the point of the star. Pass the wire back down the beads, as shown in **fig. 14**, and on to the next point. Repeat around the remaining five points and set aside. Repeat on the smaller star using just 1C, 1A and 1C on each point (as in the illustration on page 101).

2 Using the beading technique from the Snow Queen Tiara (see page 97), cover the centre of the small star with C beads and 5A beads.

3 Place the small star on top of the large star so the small points fall in between the long points. Wire the small star into place, binding 2A beads to the large star frame between all the points of the small star as you work around (**fig. 15**). Finish off all the wire ends. Fix the jump ring to the bound point of the large star.

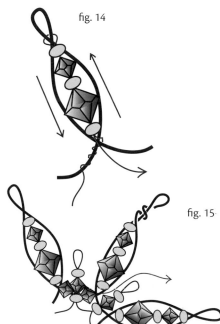

fig. 14

fig. 15

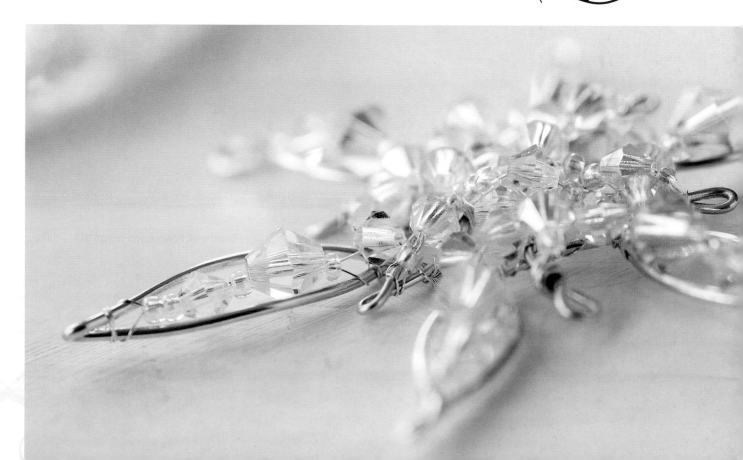

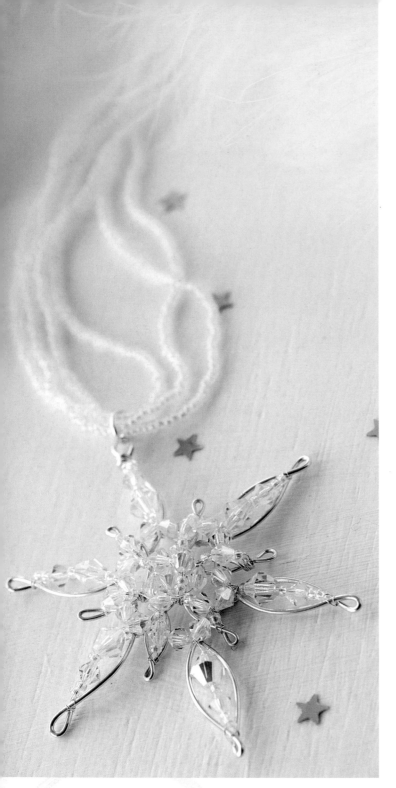

Making the necklace

The snowflake pendant is threaded onto a simple three-strand necklace made from seed beads with a bead-loop fastener. This necklace is very simple so as not to draw attention away from the pendant, but if desired you could add a few crystal beads and any other beads in your bead box that you think would enhance the necklace.

1 Decide how long you want the necklace cord to be. Prepare the needle with 1.5m (60in) of double thread and tie a slipknot at the end. Thread on 1A and sufficient C beads to make the first row of the necklace cord. Thread on 1B, 3C, 1B and 4C. Turn the needle and pass it back through the first C of the last 4C threaded to bring the last 3C into an anchor. Pass the needle back down the following 5 beads just added to emerge at the end of the strung length, as shown in **fig. 16**, to complete the bead end of the clasp.

fig. 16

2 Make the second row of the necklace by threading on sufficient C beads to reach the single A bead at the slipknot end. Pass the needle through the A bead to bring the two rows parallel to one another. Thread on 1C and sufficient C beads to make a loop that will just fit over the B beads at the far end (approximately 16C). Pass the needle back down the single C bead and the A bead to draw up the loop.

3 Thread up another length of C beads to match the other lengths. Pass the needle into the B beads at the end and fasten off the thread. Finish off the other end of the thread securely. Open the jump ring at the top of the pendant and link it onto the centre of the three C-bead strings.

Make it easy on yourself
Use an existing necklace
If you're in a hurry, you can skip this section and slip the snowflake pendant on any necklace in your jewellery box that is suitable, from a simple beaded strand to a silver chain. You can even wear it on a length of silver ribbon or length of plaited cord (see the pendant on page 103).

Snow Queen Earrings

These pretty earrings would be brilliant fun at a Christmas party or formal dinner and will go with just about any outfit. You can have endless fun experimenting with different bead combinations – a few pearls would work well or you could introduce some semi-precious chips on the dangles.

1 Make two of the smaller stars from the pendant (see pages 98—99) and fill each point with a seed bead, a 4mm crystal AB bicone and then another seed bead.

2 For each earring thread five headpins with 1C, 1A and 1C; trim the wire and make a loop at the end (see Techniques, page 123). Add an eyepin to three of the looped pins then add 1C, 1B, 1C to 1 pin and 1C, 1A, 1C to the other two pins. Trim the wire to 6mm (¼in) and make a loop at the end. Link the prepared dangles onto the earring stars as shown in **fig. 17**.

fig. 17

3 Add an eyepin to the top loop and thread on 1B. Trim the wire and make a loop as before and then add an ear wire.

You will need

Bead Box
22 crystal AB bicones, 4mm **A**
4 crystal AB bicones, 6mm **B**
5g of size 10/0 lustre crystal seed beads **C**

Fabulous Findings
120cm (47in) of 0.8mm (20-gauge) half-hard silver-plated wire
10 silver-plated headpins
6 silver-plated eyepins
Two silver-plated ear wires

Tools
Round-nosed pliers
Wire cutters
Size 10 beading needle
1cm (⅜in) cylindrical mould

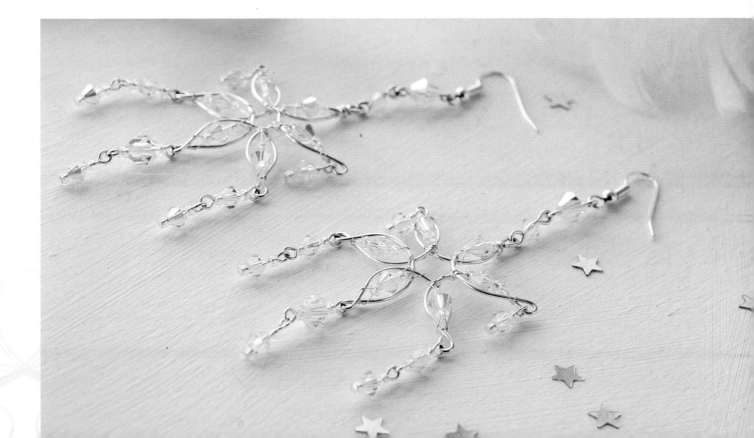

Inspirations

The snowflake motif from the Snow Queen designs is infinitely adaptable for a host of other jewellery items. Why not create a brooch or hair slide, for example? We've also used the snowflake to create an elegant choker, by simply joining snowflakes together.
If the white of the Snow Queen isn't for you, it is a simple matter to change the colour scheme, as shown here, for example.

Circlet Tiara ◇ ◇ ◇

This dazzling variation of the Snow Queen tiara is extended to make 11 points. It's so lovely that if you can't think of an occasion to wear it you will just have to arrange one yourself. Use 0.9mm (19-gauge) Lilac wire for the points, binding it with matching 0.2mm (32-gauge) wire. Encrust the points with a mix of pale Ceylon lilac and AB silver-lined pale blue seed beads, adding tanzanite crystal bicones to sparkle and catch the eye. If you wish, you could even take this design one stage further, turning it into a crown by binding the ends together.

◇ ◇ Snowflake Hairpins

The single snowflake stars used on the choker and earrings are highly versatile and can be used for brooches, hatpins and more. You could even make one to decorate a gift. Here, we've used the design to decorate a hairpin. It requires 60cm (24in) of 0.9mm (19-gauge) soft wire in Gunmetal, 1.5m (60in) of soft 0.2mm (32-gauge) gold-plated wire plus 11 garnet 4mm AB crystal bicones and 1g of 10/0 black seed beads. Make the star in the same way as for the choker, opposite, but add an extra crystal to the centre. Now attach the snowflake star to a hairpin using the ends of the 0.2mm wire.

Lilac Snowflake Pendant ◆ ◆ ◆

Made in Supa Lilac 0.9mm (19-gauge) wire, this snowflake pendant uses the same vibrant bead combination as the tiara opposite. The plaited cord is finished with box lace ends. Follow the instructions on pages 98–99 to make the pendant but use the beads listed for the tiara opposite. Instead of a three-strand necklace, this pendant is hung from plaited cords.

Snowflake Choker ◆ ◆

This elegant choker is made by simply linking seven small snowflake stars together. It could easily be adapted to make a matching bracelet – just adjust the number of stars used. You'll need 5m (5½yd) of 0.9mm soft wire in Gunmetal plus about 10m (10¼yd) of 0.2mm (32-gauge) soft gold-plated wire for the snowflakes. We also used 102 garnet AB crystal 4mm beads and 2g of size 10/0 black seed beads.

Making the choker

Start by making seven beaded stars following the instructions on pages 98–99. Wire one crystal around each side of the centre of each star then wire each star to its neighbour with two Gunmetal wire and crystal bead links. Attach two bolt-ring clasps with 4mm (³⁄₁₆in) jump rings to one end of the clasp and corresponding 6mm (¼in) jump rings on the other end.

Persephone
Queen of the underworld

Persephone was the daughter of Demeter, goddess of fruits and harvest. When she was abducted by Hades, King of the Underworld, her mother was so grief stricken that she neglected the world and it turned to winter. Demeter got her daughter back, but because Persephone had eaten a few pomegranate seeds while in the Underworld she was bound to it. Now she goes back to Hades in the autumn and the world turns cold, but when she returns in the spring Demeter rejoices and the world is fruitful once more.

Using the colours of pomegranate flesh, these ornate designs are surely made for the queen of the underworld. As well as a dramatic choker, there is a pair of matching earrings and a beautiful pendant.

To give you further inspiration, we've recombined elements of the designs to create two stunning new pieces (see pages 116–117).

Glistening reds, oranges and purples are the colours of the pomegranate seeds that were Persephone's downfall and the colours of hell — where she must live.

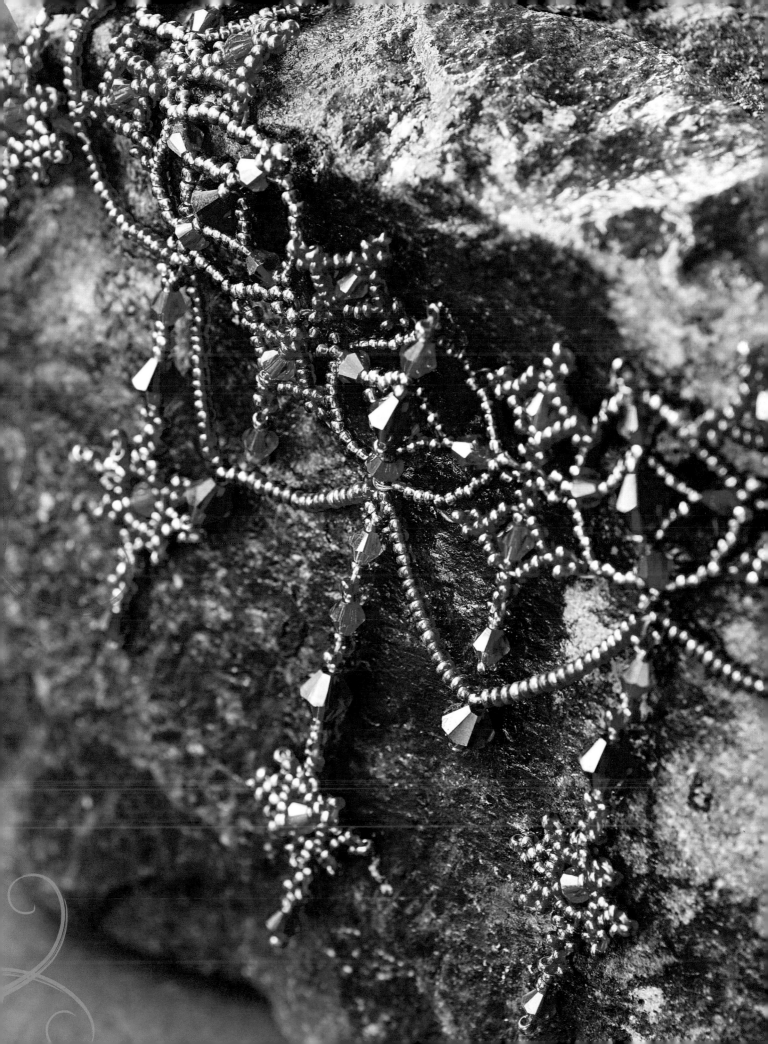

Persephone Choker

This sumptuous choker in rich reds, orange and purple captures the luscious colouring of the pomegranate in an ornate design that is truly fit for the queen of the underworld. Forced to live in Hades' palace deep in the underworld for part of each year, Persephone would have yearned for a sight of sky, so this choker features stars, both on the hanging pendants and on the choker band itself. The finished choker is 33cm (13in) long.

You will need

Bead Box

15g of dark red AB size 10/0 seed beads **A**

12g of purple AB size 10/0 seed beads **B**

22 dark red crystal bicones, 6mm **C**

26 orange crystal bicones, 4mm **D**

45 red AB crystal bicones, 4mm **E**

5 dark red crystal bicones, 4mm **F**

Fabulous Findings

Reel of orange Superlon 'AA'

Tools

Scissors

Size 13 beading needle

Making the small stars

The small stars are created by stringing 28 dark red AB seed beads around a 4mm orange crystal bicone to create the pretty star shape. You'll need 20 of these stars to complete the top band of the choker.

1 Prepare the needle with 60cm (24in) of single thread and tie a slipknot 10cm (4in) from the end. Thread on 1D and 5A. Turn the needle and pass it back through the 2A nearest the D bead and through the D bead, as shown in **fig. 1**, to pull the last 3A beads into a decorative picot.

fig. 1

2 Thread on 5A. Turn the needle and pass it back through the 2A nearest the D bead, through the D bead and the following 1A, as shown in **fig. 2**, to make a second picot.

fig. 2

3 Thread on 7A. Turn the needle and pass it back through the fourth A bead just added to bring the last 3A into a picot, as shown in **fig. 3**.

fig. 3

4 Thread on 3A. Pass the needle through the A bead on the far side of the D bead, the D bead and the following 1A, as shown in **fig. 4**.

fig. 4

5 Repeat steps 3 and 4 to complete the beading around the D bead. Run the needle through the outer beads of the motif to reinforce the shape (**fig. 5**). Finish the thread ends either side of the D bead so as not to block the holes in the beads around the edge of the motif. Repeat to make a total of 20 of these stars.

fig. 5

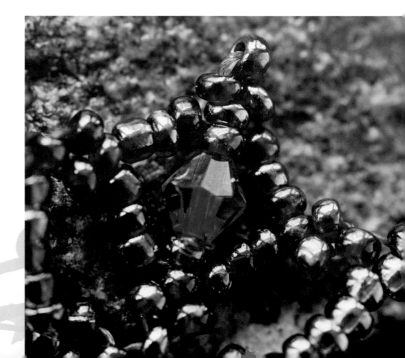

Making the large stars

The large stars combine the 6mm dark red crystal bicones with the red 4mm AB bicones and the purple seed beads to dramatic effect. You'll need nine large stars to complete the top band of the choker.

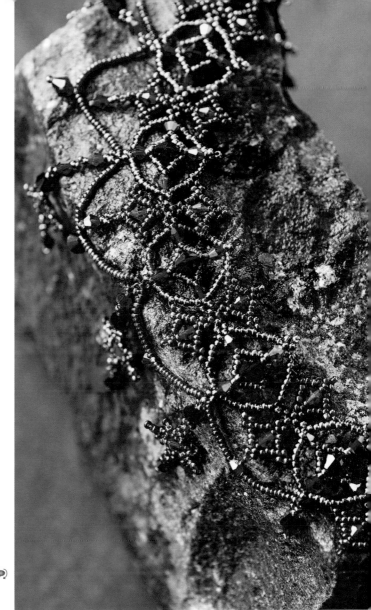

1 Prepare the needle with 80cm (31½in) of single thread and tie a slipknot 10cm (4in) from the end. Thread on 1C, 2B, 1E and 4B. Turn the needle and pass it back through the B bead adjacent to the E bead and the following 1E, 2B, 1C beads to draw the last 3B beads up into a picot, as shown in **fig. 6**.

fig. 6

2 Thread on 2B, 1E and 4B. Turn the needle and pass it back through the B bead adjacent to the E bead and the following 1E, 2B, 1C, 1B (**fig. 7**).

fig. 7

3 Thread on 5B, 1E and 4B. Turn the needle to make a picot, passing back through the B bead adjacent to the E bead, the E bead and the following 1B (**fig. 8**).

4 Thread on 4B. Pass the needle through the B bead to the far side of the C bead, the C bead and the following B bead as shown in **fig. 9**, below.

fig. 8

5 Repeat steps 3 and 4 to complete the first round of beading around the C bead, as shown in **fig. 10**.

6 Pass the needle through the following 1B and 1E bead to emerge close to the edge of the motif. Thread on 10B. Pass the needle down through the next E bead, through the single B bead beneath it and the following 4B beads going clockwise around the central C bead. Pass the needle through the B bead below the next E bead and out through the E bead to emerge close to the edge of the motif (**fig. 11**).

7 Thread on 10B. Pass the needle down through the next E bead. Pass the needle through the B bead below and the next 5B beads clockwise, and then pass it up through the next E bead to emerge close to the edge once more. The needle now works back anticlockwise to add 10B bead straps in the two gaps. As with the smaller star, run the needle through the beads of the outer edge of the motif to reinforce the shape. Finish the thread ends next to the C bead to avoid blocking the holes in the outer ring of B beads. Make nine large stars (**fig. 12**).

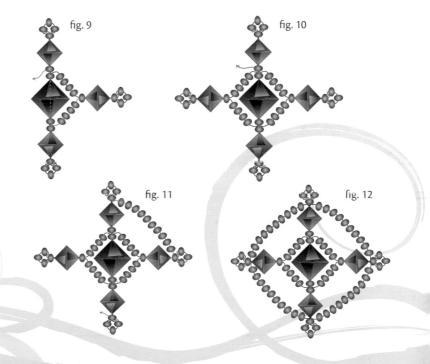

fig. 9

fig. 10

fig. 11

fig. 12

Assembling the choker band

The band at the top of the choker is created by joining two small stars, one on top of the other, to one large star, two small stars and so on. The stars must be positioned so that the holes in the central beads run vertically.

1 Starting with two small stars, lay out the stars so that they alternate. You will also end with two small stars. Make sure that the holes in the centre beads run vertically.

2 Attach a 1m (40in) of thread to the first large star so that the needle emerges through the E bead to the right of the central C bead. Pass the needle up through the first 6B beads of the 10B bead strap towards the top of the star. Offer up the end A bead of the picot on a small star. Pass the needle through this A bead and back down through the 5B beads of the strap above the E bead (**fig. 13**).

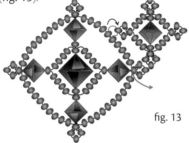

fig. 13

3 Pass the needle up through the B bead at the bottom of the picot, through the 3B beads of the picot and back down the B bead adjacent to the E bead (this crosses the thread over the gap between the top right-hand strap of 10B and the lower right-hand strap of 10B).

4 Pass the needle through the following 6B beads of the lower strap. As in step two, offer up the end A bead of a picot of a small star. Pass the needle through this A bead and up through the 5B beads of the strap to emerge at the base of the B bead picot (in the same position as at the end of step 2).

5 Pass the needle through the B bead at the base of the picot and the following 2B beads of the picot itself. Bring the two small stars into line so that the bottom picot of the top star and the top picot of the bottom star touch the B bead where the needle is emerging. Position another large star so that the B bead at the end of the left-hand picot just meets those from the small stars. Run the needle through the four end picot beads twice to bring the four motifs together as shown in **fig. 14**. Pass the needle through to the end of the closest E bead on the second large star. You can now link the right-hand side of the small stars to this large star as before.

fig. 14

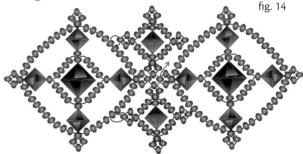

6 Pass the needle through the B beads of the outer ring of the second large star, bridging the gap where the E bead at the top or bottom of the motif meets the ring by running the needle through the picot as before. When the needle reaches the far side of the second large star make the links to the next two stars as before. Continue along the choker until you have linked all of the large stars together and you have four small stars remaining.

7 As before, make a link between the straps of B beads around the end large star and the picots to the side of the last two small stars clockwise. Bring the needle through to the end of the picot on the large star as before. This time there is not a large star to make up the fourth bead of the final link; instead use a single B bead straight from the packet so this last link contains four beads as well. Leave the thread end attached. Repeat at the other end of the choker to add the final two stars.

Adding the clasps

As this design is quite deep it will need two fasteners, one extending from each small motif. We've chosen simple bead-and-loop fasteners because these are easy to make, inexpensive, very discreet and give you the opportunity for slight adjustment.

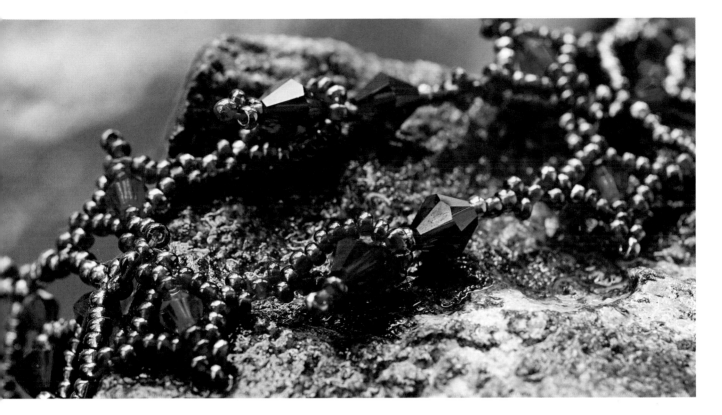

1 If necessary, join on a new thread and bring the needle through to the end bead of the picot on the top end star. Thread on 1A, 1B, 1A, 1B, 1C, 1B, 1A, 1B, 1C, 1B and 3A. Turn the needle and pass the needle down through the last B bead and the following eight beads to emerge just before the first bead of the sequence. Thread on 1A. Pass the needle through the end bead of the small star in the same direction as before to centre the bead tag on the end of the picot, as shown in **fig. 15**. Run the needle through the beads of the star and onto the end bead of the star below. Make a second bead tag as before and finish off the thread securely.

2 At the other end of the choker attach a new thread, if necessary, and bring the needle through to the end bead of the top star. Thread on 1A, 1E and sufficient A beads to make a loop that will just fit over the C beads of the tags (approximately 17A). Pass the needle back through the E bead to pull up the loop and thread on 1A. Pass the needle through the A bead at the end of the picot to centre the bead loop on the end of the motif, as shown in **fig. 16**. Work the needle through to the end of the second motif at this end of the design and make a second bead loop. Finish off the thread end securely.

fig. 15

fig 16

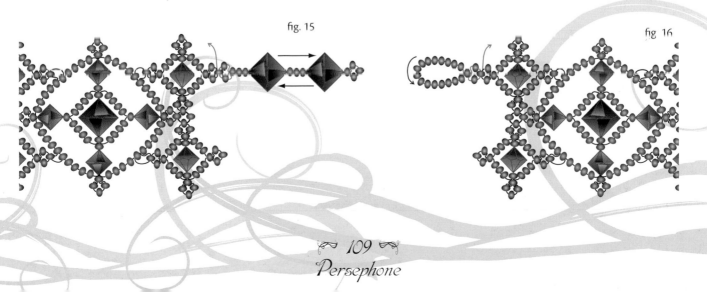

Making the pendants

Five pendant stars hang from the choker, each one representing an orange pomegranate seed surrounded by the flesh of the fruit. These eight-pointed stars are based on the small star pattern of the choker band. The centre pendant is the longest, with a medium-sized pendant on each side and then a smaller pendant at each end.

1 Prepare the needle with 1m (40in) of thread and make a small star as explained on page 106, using A beads with a D bead at the centre; leave the needle emerging from the first A bead past the D bead at the centre. Do not finish off the thread yet.

2 Pass the needle through the first 2A beads of the strap around the D bead and thread on 2B and 3A. Turn the needle and pass it back down the last B bead threaded. Thread on 1B. Pass the needle through the middle bead of the strap once more and the last B bead of the strap (**fig. 17**).

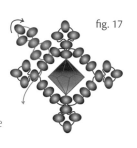

fig. 17

3 Work the needle around the other three sides of the D bead to add three more spikes in the same way. Work the needle around to the outermost A bead on one of the new spikes and leave the thread attached. Make a total of five pendant stars in the same way.

4 For the centre pendant thread on 1A, 1B, 1C, 1B, 1A, 1B, 1E, 1B, 1A, 1B, 1D and 2B. Pass the needle through the bottom B bead of the central large star on the choker. Thread on 1B. Pass the needle through the B bead adjacent to the D bead just added and the following B bead. Thread on 1A and pass the needle through the B bead adjacent to the E bead, bringing the new A bead to sit alongside the A bead just skipped past. Pass the needle through the E bead and the following B bead. Thread on 1A and pass the needle through the B bead before the C bead, the C bead and the next B bead. Thread on 1A and pass the needle through the A bead at the top of the star, as shown in **fig. 18**.

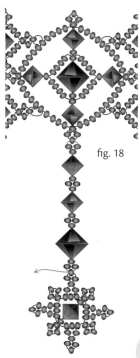

fig. 18

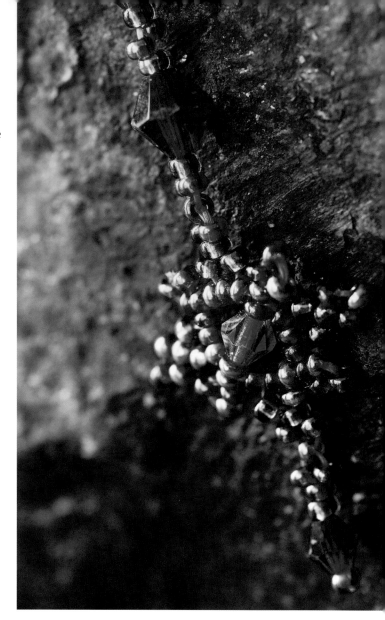

5 Work the needle through the outer edge of the pendant to emerge through the A bead at the end of the bottom spike on the star. Thread on 2A, 1B, 1F and 1A. Turn the needle and pass it back up through the F bead and the following 1B and 1A. Thread on 1A and pass the needle through the A bead at the bottom of the pendant to centre the crystal bead below the star, as shown in **fig. 19**. Finish off both of the thread ends.

fig. 19

6 For the medium-sized pendants add 1A, 1B, 1C, 1B, 1A, 1B, 1E and 2B to the top of a star. Pass the needle through the bottom B bead on the first large motif to the right of the centre front. Thread on 1B. Pass the needle back through the B bead above the E bead and the next two beads. Thread on 1A and pass the needle back through the next B/C/B beads. Thread on 1A and pass the needle through the A bead at the top of the star.

7 Work the needle around to the bottom of the star and add an F bead dangle as on the centre pendant. Repeat to the left of the centre front.

8 For the short pendants add 1A, 1B, 1C, 1B and 1A to the top of a star. Pass the needle through the A bead at the bottom of the next large motif along the choker band and thread on 1A. Pass the needle back through the B/C/B beads and thread on 1A. Pass the needle through the A bead at the top of the pendant. Add an F bead dangle to the bottom of the star as before. Repeat at the other side of the design.

Adding the swags

The finishing touch to the choker is to add the curving swags that link the pendants to the choker band and symbolize the ties that bind Persephone to the Underworld.

1 Prepare the needle with 1m (40in) of single thread and attach it to the second large star from the clasp end of the design so that the needle emerges through the bottom A bead of the motif and points towards the centre of the necklace. Thread on 1A, 1B, 1C and 1B. Turn the needle and pass it back up through the C bead and B bead above it. Thread on 1A and pass through the A bead at the bottom of the motif to point towards the centre of the necklace.

2 Thread on 13A, 1E and 13A. Pass the needle through the B bead at the bottom of the next large star along – make sure that you do not snag the pendant hanging from this bead. Thread on 15A, 1B, 1E and 1B. Turn the needle and pass it back up through the E bead and the B bead above it in the same direction you were working before to bring the E bead to sit below it (fig. 20).

fig. 20

3 Thread on 15A and pass the needle through the bottom E bead on the next large star. Thread on 18A, 1B, 1C and 1B. Turn the needle and pass it back up through the C bead and through the B bead above it in the same direction as in step 2. Thread on 18A and pass the needle through the B bead at the bottom of the central large star. This completes half of the swag design. Work out to the other end of the choker band, making a mirror image of these swags. Finish off the thread ends.

4 To complete the design, add two small droppers to the bottom of the two small stars closest to the centre front. Add a new thread and bring the needle through the bottom A bead of the first star. Thread on 2B, 1E and 1B. Turn the needle and pass it back up the E bead and the B bead above it. Thread on 1B and pass through the A bead at the bottom of the motif. Finish off the thread end and repeat on the other side of the design.

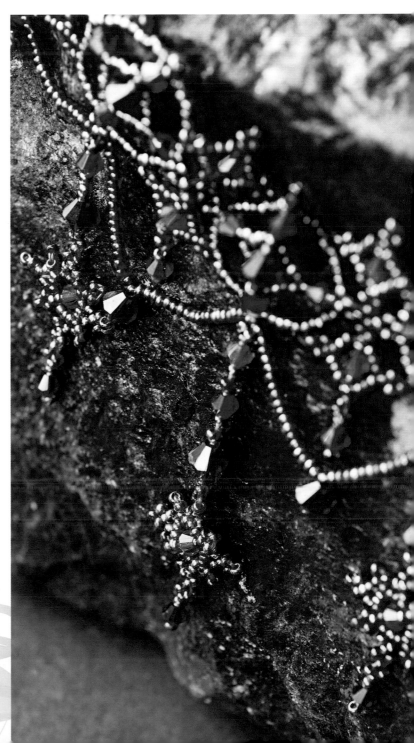

Persephone Pendant

This ornate pendant expresses some of the glamour of the choker, but it's much quicker to make. Instead of the red, orange and purple of the other pieces, this pendant uses a dramatic combination of topaz, purple and black for a more gothic look.

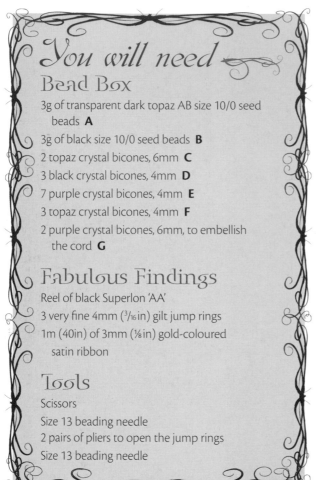

You will need

Bead Box

3g of transparent dark topaz AB size 10/0 seed beads **A**

3g of black size 10/0 seed beads **B**

2 topaz crystal bicones, 6mm **C**

3 black crystal bicones, 4mm **D**

7 purple crystal bicones, 4mm **E**

3 topaz crystal bicones, 4mm **F**

2 purple crystal bicones, 6mm, to embellish the cord **G**

Fabulous Findings

Reel of black Superlon 'AA'

3 very fine 4mm (³/₁₆in) gilt jump rings

1m (40in) of 3mm (⅛in) gold-coloured satin ribbon

Tools

Scissors

Size 13 beading needle

2 pairs of pliers to open the jump rings

Size 13 beading needle

Making the beaded circle

The main focus of the pendant is a beaded circle, which is based on the large star from the choker band with a topaz crystal bicone in the centre. Refer to the illustrations for Making the Large Stars, page 107 for the beading procedure.

1 Tip your A beads out and put aside the four beads that have the largest holes in the selection – call these four beads X. Prepare the needle with 80cm (31½in) of single thread and tie a slipknot 10cm (4in) from the end. Thread on 1C, 2B, 1E, 2B, 1X and 1B. Turn the needle and pass it back through the B bead adjacent to the E bead and the following 1E, 2B and C beads to draw the last three beads up into a picot.

2 Thread on 2B, 1E, 2B, 1X, 1B. Turn the needle and pass it back through the B bead adjacent to the E bead and the following 1E, 2B, 1C and 1B, making a picot at the opposite end.

3 Thread on 5B, 1E, 2B, 1X, 1B. Turn the needle to make a three-bead picot, passing back through the B bead adjacent to the E bead, the E bead and the following 1B. Thread on 4B. Pass the needle through the B bead to the far side of the C bead, the C bead and the following B bead. Repeat this step to make a second strap to the other side of the C bead.

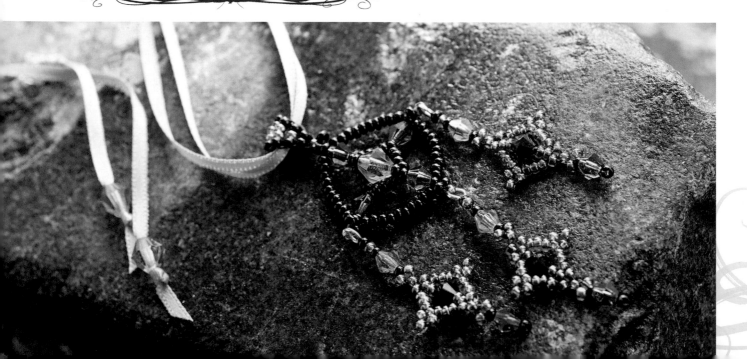

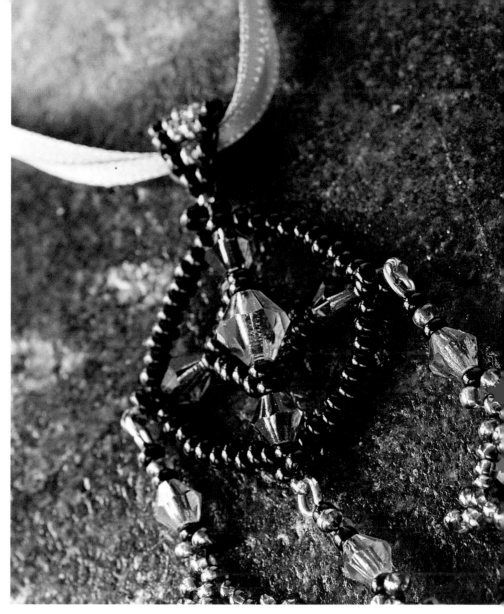

4 Pass the needle through the following 1B and 1F beads to emerge close to the edge of the motif. Thread on 10B. Pass the needle down through the next E bead clockwise around the motif, through the single B bead beneath it and the following 4B beads going clockwise around the central C bead. Pass the needle through the B bead below the next E bead and out through the E bead to emerge close to the edge of the motif.

5 Thread on 10B. Pass the needle down through the next E bead clockwise around the motif. Work the needle through the B bead below it and the next 5B beads clockwise and pass up through the next E bead around the motif to emerge close to the edge once more. The needle now works back anticlockwise to add 10B bead straps in the two gaps (see **fig. 21**).

6 To make the bail that attaches the pendant to the ribbon, first bring the needle through to emerge through one of the X beads at the edge of the circle. Thread on 2B. Pass the needle through the X bead and the two new B beads once more to bring the 2B alongside the X bead, as shown in **fig. 22**.

7 Thread on 1B, 1A and 1B. Pass the needle through the 2B beads of the previous stitch and the three new beads once more, as shown in **fig. 23**, to bring the two stitches parallel to one another. Work the next stitch with 1B, 2A and 1B, the next two stitches with 1B, 3A and 1B and the fourth stitch with 1B, 2A and 1B. Work the following stitch with 1B, 1A and 1B and the last stitch with 2B to make a diamond-shaped strap. Fold the strap in half and attach the last row to the X bead at the top of the pendant to complete the pendant bail.

8 Attach a jump ring through each of the remaining 3X beads.

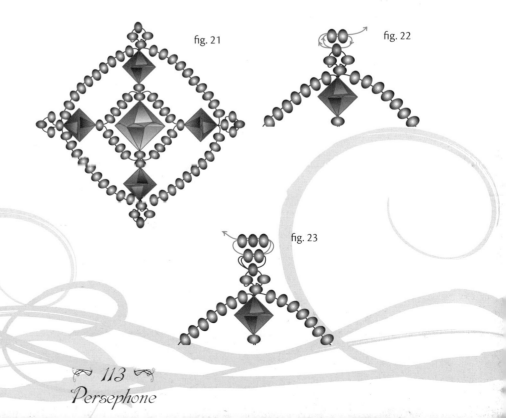

fig. 21

fig. 22

fig. 23

Adding the dangles

Three small stars and a selection of beads hang from the jump rings on the beaded circle. These will swing as you move, catching the light and drawing the eye. The stars are made in the same way as the small stars on the choker band.

1 Prepare the needle with 80cm (31½in) of single thread and a slipknot. Make a small star using the A and D beads, following the instructions on page 106; do not finish off the thread ends.

2 Bring the needle through the end A bead of the first picot and thread on 1A, 1B, 1F, 1B, 1A and 1B. Pass the needle through the first jump ring on the beaded circle. Making sure that the thread does not slip through the split in the jump ring, pass the needle back down through the last B bead; add 1A then pass the needle through the next 1B, 1F and 1B already added. Add 1A then thread through the top A bead of the small star, as shown in **fig. 24**.

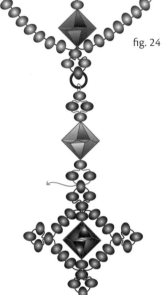

fig. 24

3 Work the needle through the edge beads of the small star to emerge through the A bead at the bottom. Thread on 1A, 1B, 1E and 1B. Turn the needle and pass it back up through the E bead and the following B bead. Thread on 1A and pass the needle through the A bead at the bottom of the star to centre the crystal bead below it, as shown in **fig. 25**. Finish off the thread ends. Repeat steps 1–3 to make and attach a dangle to each of the remaining two jump rings.

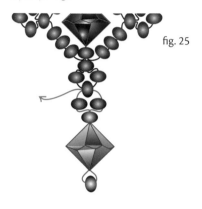

fig. 25

Finishing the ribbon neck cord

You could wear this dramatic pendant on a single, double or treble beaded string, like the one used for the Snow Queen Pendant (page 98) or from plaited cord, like the Dryad Pendant (page 60), but an even quicker option is to use a loop of ribbon. This one is cleverly beaded to create a simple fastening.

1 Fold the ribbon in half and thread 10cm (4in) of spare beading thread through the loop. Pass both ends of the thread through the hole in a C bead and pull hard to draw the ribbon through the crystal, making a loop of ribbon 8mm (5/16 in) long on one side of the bead (**fig. 26**).

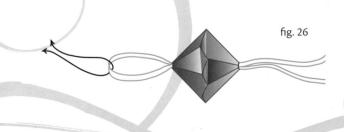

fig. 26

> ## Make it easy on yourself
> ## Changing the ribbon
> Make sure you decide which cord, ribbon or necklace you are going to use before you make the pendant. That way, if you use a different colour you can alter the colour of one of the beads to coordinate.

2 Pass both cut ends of the ribbon through the bail at the top of the pendant. Tie the two ends of ribbon together 10cm (4in) from the cut ends with a simple overhand knot.

3 Using the thread technique, pull one end of the ribbon through 1G and push the bead up to the knot. Make another knot in this ribbon to keep the G bead in place – this bead will fasten the cord in place.

4 Thread the remaining C bead onto one end and the G bead onto the other end of the ribbon. Make a simple knot to keep each bead on the ribbon – stagger the beads slightly but try to place them quite close to the ends of the ribbon. Fasten the necklace by passing the two crystals at the tail ends and the single G bead through the ribbon loop at the other end of the design.

Featuring the same eight-pointed stars as on the choker, these sumptuous earrings remind us of the pomegranate seeds that Persephone ate, which bind her to the underworld. Stars and beads are linked together with looped eyepins and jump rings so that the earrings flex easily as you move.

1 Tip your A beads out and put aside the 4 beads that have the largest holes in the selection – call these 4 beads X. Prepare the needle with 1m (40in) of thread and make a small star following the instructions on page 106; do not finish off the thread ends.

2 Pass the needle through the first 2A beads of the strap around the D bead and thread on 2B, 1A, 1X and 1A. Turn the needle and pass it back down the last B bead threaded. Thread on 1B. Pass the needle through the middle bead of the strap once more and the last B bead of the strap (see step 2, page 110).

3 Work the needle through to the second A bead of the next strap around the D bead and thread on 2B and 3A. Turn the needle and pass it back down the last B bead threaded. Thread on 1B. Pass the needle through the middle bead of the strap once more and the last B bead of the strap. Work the needle around the D bead to the next strap and repeat to make one more spike with an X bead at the end and a final spike in the remaining gap with an A bead at the end.

4 Attach a jump ring through each of the X beads at each end of the motif. For the bottom of the earring thread a headpin with 1B, 1F and 1B. Trim the wire to 6mm (¼in), make a loop and link onto the bottom jump ring of the star motif.

5 Attach an eyepin to the top jump ring and thread on 1B, 1C and 1B. Trim the wire to 6mm (¼in) and make a loop. Attach a second eyepin to the loop just made and thread on 1B, 1E and 1B. Trim the wire to 6mm (¼in) and make a loop, attaching an ear fitting to the loop just completed. Repeat to make the second earring.

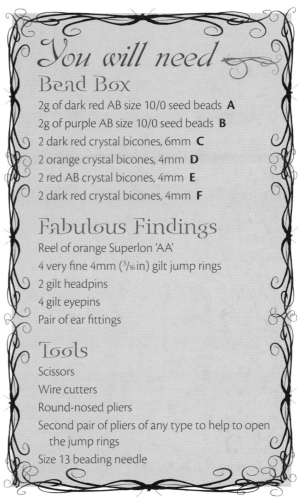

You will need

Bead Box
2g of dark red AB size 10/0 seed beads **A**
2g of purple AB size 10/0 seed beads **B**
2 dark red crystal bicones, 6mm **C**
2 orange crystal bicones, 4mm **D**
2 red AB crystal bicones, 4mm **E**
2 dark red crystal bicones, 4mm **F**

Fabulous Findings
Reel of orange Superlon 'AA'
4 very fine 4mm (³/₁₆in) gilt jump rings
2 gilt headpins
4 gilt eyepins
Pair of ear fittings

Tools
Scissors
Wire cutters
Round-nosed pliers
Second pair of pliers of any type to help to open the jump rings
Size 13 beading needle

Make it easy on yourself
Jump rings too big?
If the jump rings that you have are too thick to link into the size 10/0 beads, swap just these beads for size 8/0 beads in a matching colour – size 8/0 beads have a much bigger hole.

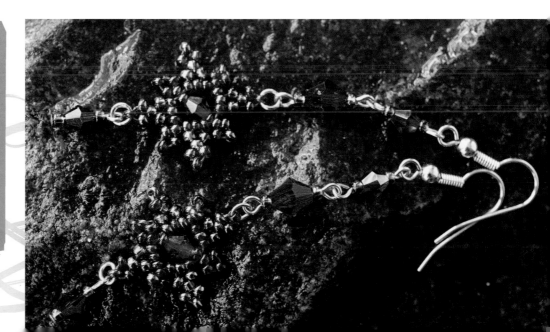

Inspirations

If you'd like to make a bracelet to go with the Persephone Choker, the easiest option is to make the choker band (see page 106) to fit your wrist. However, we think that the band is quite wide, so we've created a narrower bracelet, shown here. It's made in the same black, purple and topaz combination as the pendant on page 112, but you could make it to match the choker instead, if desired.

If the deep reds, purple and black of the Persephone Choker don't suit your mood or outfit, you can easily change the colours to reds and pinks or blues and greens, for example. To give you an idea of the alternatives, we've come up with a dramatic combination of blues and black for the necklace opposite, and we've also changed the design into a necklace rather than a choker.

Star Bracelet ◆◆◆

With the startling combination of topaz and purple crystal beads surrounded by black and topaz seed beads, this lovely bracelet is bound to be one of your favourites. Work the eight-pointed star of the Persephone Choker pendant (see page 110) using the black, topaz and purple colour combination of the Persephone Pendant, swapping the A and B beads around and using alternating black and topaz 4mm crystal bicones for the centres. Link the stars from long spike to short spike to vary the profile along the length, and bridge the gaps with two 3mm purple crystal bicones, which keep the bracelet lying flat. Add a bead-and-loop clasp to the ends.

❖ ❖ Art Deco Necklace

Here's a lovely version of the Persephone Choker worked in a dramatic combination of blues and black. Notice how the blues appear to glow when set beside the black seed beads. This swagged style of necklace is often seen in Georgian illustrations of high fashion as well as suiting the 1920s Art Deco look.

Making the necklace

First work three large stars following the instructions on pages 107–108 but using blue and black beads and working the picots in a contrasting colour. Next make three of the small stars (page 106) and link them to the large stars in the same way as the pendants on the choker. Make an additional two small stars to add to the necklace. Now you can string the stars together using simple beaded strands. We used three strands to link the large stars with two strands linking back to the remaining small stars and onto the bead-and-loop clasp.

Tools and Techniques

This section provides examples of the beads, threading materials, wires, findings and so on used to create the jewellery in this book and explains which tools you will need and how to use them. It is worth looking through this section even if you have done quite a bit of beading before because it contains some useful and interesting information.

Beads

We have used mainly glass and crystal beads in this book, with some freshwater pearls and semi-precious beads. The overall cost of the beads required for any one project is not high, and we hope you will be pleasantly surprised by just what you can achieve for so little outlay. The beads we used are described here:

Seed beads and rocailles are small glass beads made in a variety of sizes and finishes. They come from two main sources: the Czech Republic and Japan. Czech beads tend to be rounder than the Japanese beads and this shape difference means that it is unwise to mix the two different sources within the same project. Seed bead sizes are denoted as 6/0, 7/0, 8/0 etc. As the number increases the size of the bead decreases. A size 6/0 is approximately 3mm (⅛in) in diameter whereas size 15/0 is barely half that.

Glass bead finishes

Beads come in many different finishes. Here are some of the most common:

AB: treated with a thin transparent rainbow coating that gives extra sparkle
Ceylon: pearlescent bead
Chalk: plain opaque colour
Crystal: a bead made from crystal glass or any transparent bead
Lustre: with a high-gloss finish
Matt: with an acid-etched frosty finish
Silver-lined: when a silver deposit has been drawn through the bead hole to shine through

Bugles are tubular beads, available in a range of lengths. They are all used for bead weaving, bead embroidery or embellishment and straight stringing. Bugle bead sizes start at size 1, which is approximately 3mm (⅛in) long; size 2 are 6mm (¼in) and size 3 are 9mm (⅜in) long etc.

Delicas are small, precision-made beads from Japan, most often used for bead weaving. They are available in many hundreds of colours and finishes. The code numbers used for the range are universal. This book uses only size 11/0 Delicas.

Faceted crystal beads are made in the Czech Republic and Austria from a high-quality crystal glass, these beads have ground and polished facets. All of the facets have crisp edges to produce maximum reflection and sparkle. This book uses crystal rounds, bicones and drops.

Fire-polished beads are faceted in a very similar way to crystal beads but the final shine is produced by heating in a kiln until the glass just starts to melt. This process makes a bead with a very shiny surface but the edges of the facets are not as crisp as on a crystal bead. Fire-polished beads are consequently not quite as sparkly as crystal beads, but they are much more economical to buy, and make a very good substitute for crystal beads.

Pressed-glass beads are pressed out from the end of a molten-glass cane. Flowers, drops, daggers, leaves and plain rounds are all produced in this way. A pressed-glass bead will have a small, clean hole and can be made in a plain or fancy glass with a glossy, matt or lustred finish or treated with any number of special coatings.

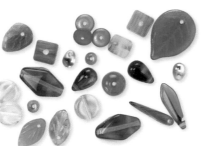

Hand-made beads often have remnants of a chalky release agent coating the inside of the hole – this can be removed with the end of a pin if you need to make the hole larger. These beads can be plain but more often they have layers of applied coloured glass, foils and motifs to lift them out of the ordinary. High-end beads of this type are sometimes called 'Lamp Beads' and these do not usually have the coating left blocking the hole.

Cross-hole and through-hole beads Beads that are not round, such as drop-shaped or leaf-shaped beads, for example, can have the hole running across the shape (cross hole) or vertically from top to bottom (through hole). The direction of the hole will determine how you attach the bead to the work and how it will hang once attached.

Semi-precious beads can be made in a variety of shapes. Often the hole is very small so if you need to pass a wire through the beads, check the hole size before you buy.

Freshwater pearls come in many colours shapes and sizes. Like semi-precious beads they often have a small hole, and you should check this before you buy. Unusually shaped pearls include stick-shaped Biwa pearls as used for the amethyst necklace in the Galadriel chapter (see page 82).

Bead shapes

Beads are available in an ever-increasing range of shapes and sizes. We have used mainly seed beads, bicones and round beads in this book plus a few unusual beads for accents such as the flower and leaf beads in the Titania Necklace (see page 86).

Findings

All the little bits and pieces you need to make your jewellery – the rings, clasps, ear wires and so on – are collectively called findings. Most are available in several materials including gilt, silver-plate, silver, gold-fill and gold.

Clasps can be any type of fastener used on bracelets and necklaces. Simple clasps for single-row necklaces include circular bolt rings, oval lobster clasps and oblong box clasps, all of which are easily available and inexpensive to buy. Fancier single-row clasps include toggle-style designs where a bar on one side of the design links into a fancy ring on the other end. Multi-row clasps are useful on wider designs.

Ear fittings come in several styles for pierced and non-pierced ears. Choose a style that suits your purpose and make sure that they comply with the EC directive on low-nickel content.

Hatpins are long pointed pins with a flattened head. They are made from 0.8mm (20-gauge) hard wire but are soft enough to be bent with a pair of pliers. Use a pin guard to cover the point when worn.

Headpins are the straight wires that support the beads on dangling earrings, wired fringes and straight-linked designs. Made from 0.6mm (22-gauge) wire, a headpin has a flat end to stop the first bead sliding off.

Eyepins are like headpins but have a looped end to link to a dangling element or to another loop.

French crimps are tiny tubes of metal tape that are used to finish off stranded wire threads. They are crushed onto the thread with flat-nosed pliers or crimping pliers. See page 125.

Jump rings are small round or oval links used for joining together two or more components. See page 124.

Lace ends (cord ends) fold over the end of a cord or group of cords to make a neat connection to the clasp. They are available in two main shapes – spiral and box. See page 124.

Spacer bars are used to space the rows of a multi-strand necklace or bracelet evenly. A simple spacer bar is just a thin strip of metal with a number of evenly spaced holes. End spacer bars bring the multi rows down into one – at one side you attach the rows to a series of evenly spaced loops; at the other side of the bar is a single loop to connect to the clasp.

Threads and threading materials

What type of stringing thread should you choose? If you are using only seed beads, rocailles and bugles try thread, otherwise stranded wire thread is the right choice.

Beading threads for use with a needle are fine and very strong. They are available in several thicknesses: size D is the most useful general thread, while A and AA are finer and good for beads with small holes or when many passes of thread are required. Nymo D is suitable for most projects in this book although Superlon AA or C-Lon AA is recommended where a finer thread is required. Choose a thread colour to match the darker end of your colours.

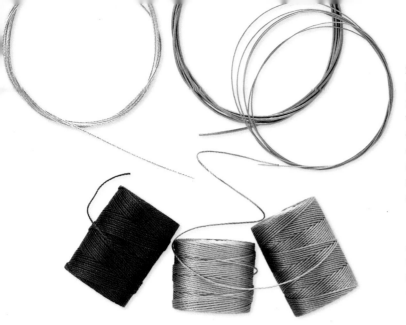

Stranded wire threads are available in a range of thicknesses, strengths and flexibilities under two main trade names: Soft Flex/Soft Touch and Beadalon. Each reel of wire will tell you the number of wire strands, the diameter of each strand and the breaking strength of the thread. The designs in this book call for maximum flexibility through some very small holes and where required the project will state the most suitable type. Wire threads are finished with a French crimp (see page 125).

Macramé cord Both Superlon and C-Lon produce a superb range of beader's macramé cord. Fine enough to thread a crystal bead or a large seed bead, this cord can be used for knotting, stringing, plaiting, or flowing tassels (see the Gaia Necklace on page 44).

Thread conditioners

Beading threads have a slightly waxed finish but thread handling is improved if you apply a thread conditioner such as Thread Heaven or beeswax. These conditioners help to prevent the thread twisting and knotting and help the thread run through the tiniest of bead holes.

Wire

Wire is available in many different diameters, sold in the UK in millimetres and in the US by gauge. The hardness of the wire will also affect its usefulness. In general, wire for binding and knitting should be soft and wire for structural components should be half hard.

Colours

Most jewellery wire for beaders is made from copper. The wire can be plated for a gold or silver finish or dipped in dyed shellac to give a whole rainbow of colours. If the shellac is damaged the copper will show through so do not scratch or abrade it unduly.

Pre-knitted tubular wire

This is used extensively in the Gaia chapter (page 42). This is available in close knit or coarse knit; in 15mm (⁵/₁₆in) tubes or 85mm (3⅜in) tubes and made from 0.1mm (38-gauge) or 0.2mm (32-gauge) wire. The projects in the book that utilize this wire use 0.1mm close knit 85mm (3⅜in) tubular wire. It can be cut with strong scissors. Tubular wire sheds when you cut it, so to save bits going everywhere, always cut it over scrap paper.

Wire care

Wire, especially silver-plated wire, can tarnish over time. Always work with clean hands – a little plain talc can help if your hands are hot. Store the finished jewellery in an acid-free tissue wrap inside an airtight container and add a few grains of uncooked rice or a silica-gel sachet to keep the moisture away. Plated wire will clean with a little clear alcohol or methylated spirits. Shellac-coated wire can be washed in mild soapy water and left to dry thoroughly in a warm place.

Wire conversions

The wire used in this book is sold in millimetre thicknesses. For those of you using the B and S gauge in America, here are conversions:

mm	B&S gauge
0.2mm	32
0.314mm	28
0.4mm	26
0.6mm	22
0.8mm	20
0.9mm	19
1mm	18
1.2mm	16

Tools

In addition to a pair of scissors there are just a few tools that you will need to complete the projects in this book – pliers, needles, glue and cutters, for example. These are described here:

Pliers and cutters

These are the mainstay of your toolbox.

Round-nose pliers have tapering round prongs and are used to make loops and bends in wire. You will need them for most projects involving wirework.

Flat-faced pliers can either be flat nosed (with a blunt nose) or chain nosed (with a tapering nose) but both have flat ends and are used for gripping and squashing and for opening and closing jump rings in conjunction with a second pair of pliers (round-nose ones will do). You can also use them to secure French crimps.

Wire cutters are needed to cut the wire. Don't try to use scissors instead because you will damage them. Also jewellery-making wire cutters are designed to reach easily into small spaces for a neat job.

Crimping pliers are not essential because you can use flat-nosed pliers instead, but they do make a neat job of securing French crimps.

Beading needles

Size 10 needles are suitable for most projects but a finer beading size 13 is used for the size 15/0 beads and where the needle needs to pass many times through the same bead. Size 13 needles are also advisable when using freshwater pearls because of the small holes. The needles are also available in different lengths but this is a matter of personal preference not of function.

Knitting needles

Use metal knitting needles of the size specified in the project.

Other items

There are just a handful of other things that you need to complete your jewellery-making tool box:

Clear-drying nail varnish is useful to seal any knots at the end of the work.

Beading glue makes a great alternative to clear nail polish to seal the knots in your beading thread.

Macramé T-pins are useful for the Calypso project but long glass-headed pins will substitute well.

A craft knife is used for trimming cord(s) after you have attached a box lace end (see page 124).

A fleecy beading mat is not essential but it is very useful and will be invaluable if you intend to do a lot of beadwork. These stop beads rolling about so you are less likely to lose them.

Working with needle and thread

Here are the techniques we use when working with beading thread. We explain how to secure the beads when starting off and how to finish an old thread and start a new one.

Starting a beading thread

To prevent the first beads from falling off the thread you will need a temporary stopper. This can be a slipknot or a keeper bead. A slipknot is simple but if the first bead of the design has a large hole that might pass over the slipknot use a keeper bead.

To start with a temporary knot make a 2cm (¾in) loop in the thread. Reach through the loop to pick up the middle of the thread just beyond the loop. Pull the thread through to form a loop and tighten the first loop around its base (**fig. 1**). This knot will easily pull out when no longer required.

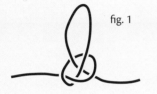

fig. 1

To start with a keeper bead first thread a spare bead onto the end of the thread. Tie a simple knot around the bead (**fig. 2**). Push the first bead of the sequence up tightly against the keeper bead to tension the thread through the knot – this will keep it in place. Remove the keeper bead when no longer required and finish the thread as explained right.

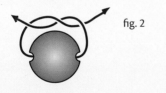

fig. 2

Starting and finishing threads

When starting or finishing a thread one of the most important things to remember is not to block the holes in the beads with knots that may hinder the progress of the needle later on. At the end of the project always seal the knots for added security, as explained here.

1 Leave the old thread end loose and prepare a new length. Tie a slipknot 10cm (4in) from the end of the new thread. About ten beads back from the old thread end, pass the needle through two or three beads and pull through to the slipknot. Pick up the threads between the beads and tie a double knot with the new thread around those threads (**fig. 3**).

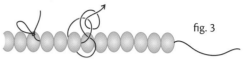

fig. 3

2 Pass the needle through another three beads and repeat. Pass the needle through the last few beads to emerge alongside the old thread end (**fig. 4**). Pull out the slipknot. Trim the thread as closely as possible to the work. Continue with the beading.

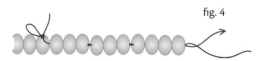

fig. 4

3 When you have worked a little further with the new thread return to the old thread and attach the needle to this end. Fasten off this end with a series of two knots as in steps 1 and 2. Pass the needle through a few extra beads before trimming the thread to conceal the end.

4 At the end of a project fasten off all of the remaining thread ends as explained above and dab any knots with a tiny amount of clear-drying nail polish or beading glue to ensure that they cannot come undone.

Working with pliers

You will need pliers to work with wire, headpins and eyepins. Buy a pair of round-nose pliers and a pair of flat-nosed (chain-nosed) pliers to start with. Later you can invest in some crimping pliers too. Use your pliers to make loops, open and close them neatly, and to attach jump rings, lace (cord) ends and French crimps as explained here.

Making a loop

You often need to make loops on plain wire, headpins or eyepins so that you can attach one element to another. Whether you are using wire, a headpin or eyepin, the technique is the same and is carried out using a pair of round-nosed pliers. If you have not made a loop before practice on a spare headpin or a length of wire.

fig. 5

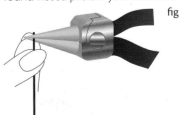

1 Grip the very end of the wire approximately 3mm (⅛in) from the tips of the round-nosed pliers. Bring the index finger and thumb of your other hand to grip the wire 6mm (¼in) below the pliers, as shown in **fig. 5**.

2 Hold the wire still and rotate your wrist away from yourself to start the bend – it will make a hook shape (**fig. 6**).

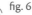
fig. 6

3 Move the pliers back from the end of the wire to the apex of the bend and roll again until the wire makes a P shape, as in **fig. 7**.

fig. 7

4 The loop now needs to be centred on the top of the pin. Using the very tips of the pliers, place one point in the bottom of the loop and the other point as far down the straight stem of the P as you can grip. Bring your other hand up as closely as possible to the points of the pliers and tip the loop back to make a symmetrical shape (**fig. 8**). If the loop has opened a little, re-roll it to close up the gap. This completes a loop on a blank wire.

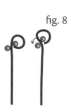
fig. 8

On a beaded wire trim the wire to 6mm (¼in) above the last bead of the sequence. Work the loop as above, bringing the completed loop to sit right up against the end bead.

Opening and closing a loop

When you make the link between two loops it is important that the loops are opened and closed properly so as not to distort the original shape. Use round or flat-nosed (chain-nosed) pliers.

1 Using the tips of the pliers, grip the loop at 90° to the main stem (**fig. 9**).

2 Hold the wire as close to the loop as you can with your other hand. Gently twist the pliers away from yourself to open the loop with a twist, as shown in **fig. 10**. Add on the loop to be joined and return the pliers to the 90° position. Twist the pliers back to close the loop tightly.

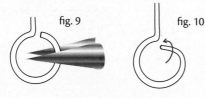
fig. 9 fig. 10

Opening and closing a jump ring

A jump ring should always be opened sideways in the same way as a loop in order to maintain the circular shape. You will need two pairs of pliers to hold the ring steady as you twist it open, such as round-nosed and flat-nosed (chain-nosed) pliers.

1 With the gap in the ring at 12 o'clock, hold the jump ring at 3 o'clock with the first pair of pliers. Bring the second pair of pliers up from the 6 o'clock position to hold as much of the second half of the ring as possible (**fig 11**).

2 Holding the second pair of pliers completely still, roll the other wrist over to twist the ring open, as shown in **fig. 12**. Insert the links as required and return the pliers to the same position, rolling the ring shut.

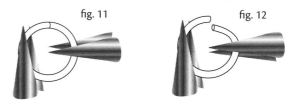
fig. 11 fig. 12

Attaching a box lace end

Box lace ends (cord ends) are used to neaten cords before they attach to a clasp. You will need a pair of flat-nosed pliers and a sharp craft knife. Do not trim the cord to length – use the excess length to help you to position the cord in the lace end.

1 Fold one side of the box down onto the cord(s), as in **fig. 13**. Fold the other half of the box down (**fig. 14**), and squeeze the whole box in the pliers to secure the cord(s); do not use too much pressure or you will cut the cord(s).

2 Use a sharp craft knife to trim the excess length away from the loop end of the box end and attach a clasp with a jump ring (see above).

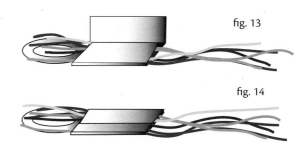
fig. 13

fig. 14

Using a French crimp with stranded wire thread

A French crimp is used to secure the end of stranded wire thread at a clasp, for example. You will need a pair of flat-nosed pliers or crimping pliers. Crimping pliers fold and crush the crimp into a smaller shape and require a little practice.

1 Thread the crimp onto the end of the wire thread. Fold the end of the wire back through the crimp to make a loop, as shown in **fig. 15**, having first attached the clasp or other item you are joining, if needed.

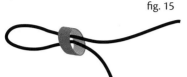

fig. 15

3 Trim the tail of the wire to 10mm (⅜in) and hide it inside the first few beads of the design, as in **fig. 17**.

fig. 17

2 Adjust the position of the crimp to bring the loop down to 3mm (⅛in) diameter or so to snuggle against the beads and/or clasp. Use flat pliers to crush the crimp flat or use crimping pliers to fold and crush the crimp. The crimp will bite through the plastic coating onto the wire and make a very strong join (**fig. 16**).

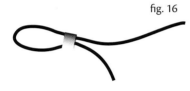

fig. 16

Make it easy on yourself
Use crimp covers
If you don't like the look of crimp beads, you can now buy covers that disguise the crimp as a small gold or silver bead. Simply slip the cover over the crimp once it has been attached to the wire and close it neatly over the crimp with your pliers.

Macramé knots

These are the simple knots you'll need to be able to tie in order to complete the spectacular Calypso pieces (page 30).

Lark's head knot Fold the cord in half and bring the resulting loop up behind the wire. Fold the end of the loop over the top of the wire and thread both ends of the cord through the loop. Pull tightly to secure the knot (**fig. 18**).

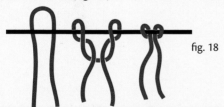

fig. 18

Square knot Make a half knot as explained below left. Now reverse the knot, taking the cord now on the right over the top of the two central cords and the cord now on the left to the underneath (**fig. 20**). You will notice that the cord that started on the left always passes to the front and the cord from the right goes underneath the central cords.

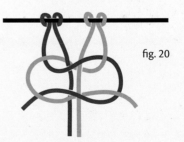

fig. 20

Half knot Take four cords. Cross the left-hand cord over the top of the two central cords. Cross the right-hand cord over the tail of the left-hand cord, under the two central cords and up through the loop formed by the left-hand cord, as shown in **fig. 19**.

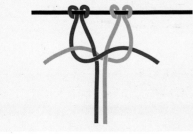

fig. 19

Make it easy on yourself
T-pins
These help you create an evenly spaced macramé net. Push the pin into the cork board and form the knot about it – the knots can be pulled tightly onto the pin without distorting the net. Leave the pins in place until the net is complete.

Suppliers

USA

Fire Mountain Gems
One Fire Mountain Way
Grants Pass
OR 97526 2373
Tel: 800 355 2137
www.firemountaingems.com
For a stunning range of beads and findings of every kind

Foxden Designs
10127 Northwestern Ave Franksville,
WI 53126 9206
Tel: 262 886 2323
www.foxdendesigns.com
foxdenbeads@sbcglobal.net
For a wide range of beads, C-Lon cord and friendly service

Fusion Beads
3830 Stone Way
North Seattle
WA 98103
Tel: 206 782 4595
www.fusionbeads.com
For a staggering selection of seed beads, Swarovski crystal beads, Delicas, Nymo threads, Superlon and much more

Shipwreck Beads
8560 Commerce Place
Dr. NE
Lacey
WA 98516
Tel: 800 950 4232
www.shipwreckbeads.com
For an enormous range of beads and findings

Silver Rose Beads
Tel: 253 845 4949
www.silverrosebeads.com
silverrosebeads@silverrose.net
For an excellent selection of semi-precious beads, chain, freshwater pearls and more (much of the profit goes to charity)

UK

The Spellbound Bead Co
47 Tamworth Street
Lichfield
Staffordshire
WS13 6JW
www.spellboundbead.co.uk
info@spellboundbead.co.uk
Tel/fax: 01543 417 650
For a huge choice of beads, including Czech crystal, beading kits, findings and much, much more

The Bead Box
22 High Street
Knaphill
Surrey
GU21 2PE
01483 473609
Excellent selection of Czech crystal beads and semi precious beads

The Bead Merchant
PO Box 5025
Coggeshall
Essex
CO6 1HW
01787 221955
www.beadmerchant.co.uk
Excellent range of small beads

The Bead Shop
21A Tower Street,
Covent Garden
London
Tel: 0207 240 0931
www.beadshop.co.uk
For a large selection of beads and findings

Kernowcraft Rocks & Gems Ltd
Bolingey
Perranporth
Cornwall
TR6 0DH
Tel: 01872 573888
www.kernowcraft.com
For ear wires, including clip-ons for non-pierced ears, clasps and other findings, semi-precious beads and more

The London Bead Co
339 Kentish Town Road
London
NW5 2TJ
www.londonbeadco.co.uk
orders@londonbeadco.co.uk
Tel: 0870 203 2323
For the full ranges of Swarovski Crystals, Miyuki Delicas and more

Stitch 'n' Craft
Swan's Yard, High Street
Shaftesbury
Dorset
SP7 8JQ
www.stitchncraft.co.uk
enquiries@stitchncraft.co.uk
Tel: 01747 830666 – mail order
Tel: 01747 852500 – shop
For an excellent, broad range of beads, wire and threads including C-Lon cord

Africa

Bead Merchants of Africa
223 Long Street, Cape Town, South Africa
Telephone: +27 (0)21 423 4687
Fax: +27 (0)21 423 4791
www.beadmerchantsofafrica.com
info@beadm.com
For a good selection of beads and findings

Acknowledgments

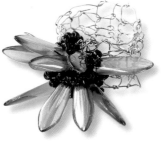

S pecial thanks to Jean, Lynn and Pat for all their painstaking pattern testing, and all at David & Charles and Spellbound for their help, support, criticisms and encouragement throughout.

About the Authors

Julie and Christine Ashford have been designing and selling beads, bead kits and beaded jewellery for nearly 25 years. When they set up their business, the Internet was not fully established, so finding suppliers almost always involved a lot of travelling. 'We have always managed to combine buying trips with an extra day or three exploring, and this always helps to feed the design process – from art galleries and museums, to the breathtaking architecture of Hong Kong and Venice, or simply walking the dogs in the English countryside, we are always looking for new ideas for designs and new beads to make them with.'

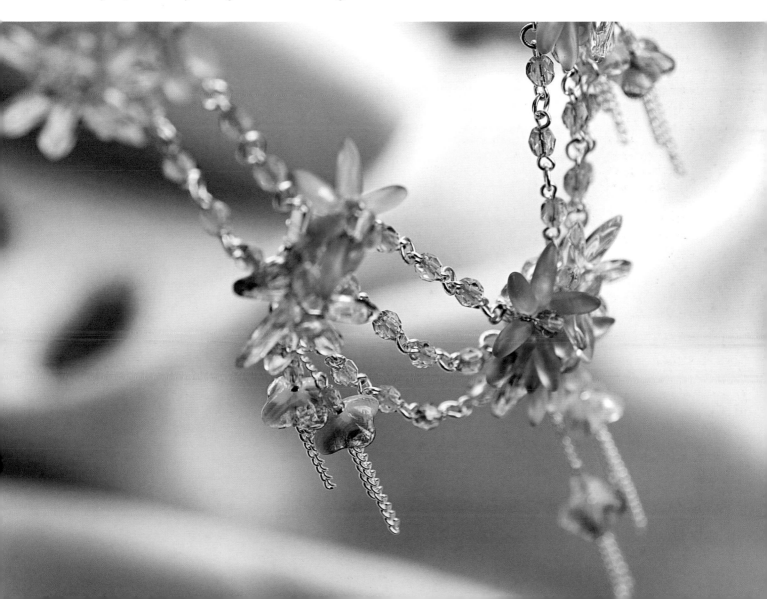

Index